Fashion
Accessories

A FIREFLY BOOK

Published by Firefly Books Ltd. 2010

First printing

First published in France in 2008 by Groupe Eyrolles as *Accessoires de mode*
English language edition first published in Great Britain 2009 by A&C Black Publishers

Published in the United States by
Firefly Books (U.S.) Inc.
P.O. Box 1338, Ellicott Station
Buffalo, New York 14205

Published in Canada by
Firefly Books Ltd.
66 Leek Crescent
Richmond Hill, Ontario L4B 1H1

Translation by Sasha Wardell
Cover design by Sutchinda Thompson

Printed in China

Publisher Cataloging-in-Publication Data (U.S.)

Gerval, Olivier.
 Fashion accessories / Olivier Gerval.
[224] p. : ill., photos. (some col.) ; cm. (Studies in fashion)
Includes bibliographical references.
Summary: Covers the creation of accessories such as shoes, handbags, hats and sunglasses from the design stage to making and manufacturing to selling and publicity. The book is filled with sketchbook illustrations, photographs and drawings that clearly illuminate all the processes involved.

ISBN-13: 978-1-55407-665-9 (pbk.)
ISBN-10: 1-55407-665-X

1. Dress accessories. I. Studies in fashion series. II. Title.
646.48 dc22 TT649.8.G478 2010

Library and Archives Canada Cataloguing in Publication

Gerval, Olivier
 Fashion accessories / Olivier Gerval ; translated by Sasha Wardell.
(Studies in fashion)
Originally published in French under title: Accessoires de mode.
Includes bibliographical references.

ISBN-13: 978-1-55407-665-9
ISBN-10: 1-55407-665-X

1. Dress accessories. 2. Fashion design.
I. Wardell, Sasha II. Title. III. Series: Studies in fashion
TT649.8.G4714 2010 746.9'2 C2010-900605-4

studies in fashion

Fashion Accessories

Olivier Gerval

FIREFLY BOOKS

Contents

Preface

The scent of emotions, a love of work and the perfection of the cut are, for me, the factors that accentuate, and inform, style. My inspiration is drawn from words, scents, images, daily sounds, and by putting them down on a blank page, they serve as the starting point for my work. But it is the sensuality of touch that determines my vision for a new season. My accessories, which reinforce a silhouette, can be objects of desire or even dreams come true, which, after being worn, become the next generation of treasured souvenirs.

The fascination I have for women's accessories has led me to concentrate on two important themes, both of which are reinvented each season: the ballet shoe and pearls. Pursuing my daydream, I am once again transported into the world of my eternal source of inspiration, Jeanne Lanvin.

Here there is a burst of plastic and metal, made into huge sparkling items of jewelry that accentuate the wrist; or the incredible "Himalayan" sandals in fuchsia pink, worn by the 2007 Winter-season woman as she walks toward the future. Last season is now redundant; the giant orchids that either floated on the shoulders of a dress or were pinned onto a lapel have been left behind. As have my shoes, even, with their vibrant colors

In this book, Olivier Gerval recounts the influence of the accessory. He describes how a belt can accentuate the waist by refining or lowering it, how the body can be lengthened or shortened, or how a shoe alters the small of the back or the curve of the leg, all of which have an effect on the proportions of a garment. He also illustrates how an oversize brooch can obscure a collar, how multiple strings of pearls can decorate a plunging neckline, or even how a bejeweled handbag, hanging from the crook of an arm and brushing against the hip, can balance the body.

Accessories can dress a silhouette up or down, either accentuating or detracting from its style, and, being the designer's signature and personality, they can complement or contradict a garment.

FASHION ACCESSORIES is aimed at anyone interested in the fashion world, whether they be aspiring students, fashion enthusiasts, amateurs or professionals, window shoppers, or even those who simply seek the adrenaline rush of the catwalk.

Alber Elbaz

Foreword

Fashion Accessories, the second book in the *Studies in Fashion* series, reveals the secrets of the accessory in the textile industry. It gives the impression of being superfluous, when, in reality, it is essential to fashion. The accessory in fact "makes" the style, placing it firmly in position in the world of designer labels, being more representative of a style than of an era.

Originally, couturiers did not design their accessories. This was done by accessory companies for the fashion houses, as is still the case with the bootmaker Massaro, for Chanel. The creation of an accessory, as we see throughout this publication, is, in effect, closely linked to its manufacturing specifications and a reliance on traditional skills, often regionally based. An example of this is found in the Isère region, which has long remained the international capital of women's footwear.

France has successfully developed the art of the accessory. The designs of Gripoix, Roger Scemama and Robert Goessens, fine garment specialists to the fashion industry, have become museum pieces today. Remember also that in the 20th century, women's footwear was French in origin, with designers such as Roger Vivier, Charles Jourdan and his prestigious brand Seducta, or Carel and Durer.

The Swiss also govern a large segment of this industry, with their monopoly on luxury clocks and watches by manufacturers such as Jaeger-LeCoultre and Omega, to name but a couple. Swatch perpetuated this tradition in the 1980s by creating more affordable, limited-edition pieces and targeting new markets. During the following decades, with the boom in the sports and leisure industry, TAG Heuer, renowned for his waterproof diving watches, enlisted photographer Peter Lindbergh, with his artistic advertising campaigns, and thus elevated the perception of his products. More recently, Hamilton, the American GI's watch brand, chose a Swiss mechanism in an attempt to adapt to market trends and offer a high-quality product.

The Swiss are a very good example of how to successfully adapt exceptional skills in the manufacturing of luxury goods to the process of mass-production.

We are also aware that Morocco is famous for its leather goods, that metal and silver-work are an important part of Asian heritage, that the use of bone and precious stones dates back to pre-Columbian civilizations, and that pearls come from Japan. One only has to travel the world to discover the abundance of materials available for accessories, originating from a variety of lands. This notion of travel, dear to the heart of the famous suitcase and briefcase maker Louis Vuitton, is just one of the characteristics of the accessory.

Nowadays, every label offers a "total look," with clothes and their accessories forming a coherent whole. The fashion house Dior, which was created in 1947, illustrates this evolution by demonstrating the important role that the accessory has played in its collections. More surprising, perhaps, is the fact that accessory labels find themselves in ready-to-wear collections. Gucci, for example, was initially an accessory label around which Tom Ford created a whole world, and which he capitalized upon – the idea being, of course, to cover every market. Prada has just recently launched a range of trainers, which incorporates street wear into their luxury ranges, thus underlining the importance the accessory holds at the luxury end of the market.

This book aims to illustrate these ideas by presenting a brief history of the accessory and a tour of the footwear world, including some distinctive designers as well as the most representative products in this sector. The different skills and techniques required for scarf, jewelry and shoe manufacture are explained, as are the color choices, pattern designs and step-by-step production stages of a variety of handbags. The book concludes with a section dedicated to the promotion of these various products.

The presence and choice of an accessory is never without effect. If the famous painting of *Olympia* in 1865 by the impressionist painter Edouard Manet (1832–83) attracted criticism, it was mainly because the subject was not entirely nude: she wears a black scarf around her neck, a large flower in her hair and a golden bracelet. She also exudes a certain arrogance. The presence of the accessories contributes to the work's shift away from the traditionally accepted representation of the nude. It underlines feminine provocativeness, as well as a lack of morals, both of which were particularly disturbing for that period. All of this is part of the courtesan world – completely different from that of the chaste and unadorned Venus upon which the painting is modeled.

If the archetype of the 19th-century "kept woman" is to be replaced (evident in Catherine Deneuve's portrayal of a high-class prostitute in Louis Bunuel's film *Belle de Jour*, for example), one notices that the use of the accessory defines a certain era. Accessories reflect economic and social evolutions as well as changes in moral values, and each possesses its own history. This is well documented in museum collections depicting the progression of accessories through the ages. A revival of the accessory allows us to understand the concept of the fashion house. For example, Didier Ludot has invented a new metier – that of vintage fashion. In his boutique at the Palais Royal, he breathes new life into the accessory with the *Lady Dior* handbag by Dior, the *Kelly* by Hermès or *the Audrey* glasses by Pierre Marly – all of which have subsequently become cult products.

Apart from the luxury image that went with them, Louis Vuitton's monogrammed luggage is full of nostalgia, reminiscent of the great transatlantic voyages and the lifestyle that accompanied them. Likewise, with Hermès and his traditional equestrian imagery we are plunged into the novels of

Maupassant and 19th century Paris. The skills associated with these accessories represent "old" Europe. Developing countries, with their new-found wealth, dream of adopting this lifestyle by looking toward the West. This is also the wish of the middle class, from Asia in particular, who possess a relatively large amount of disposable income and who strive to be different from their parents' generation. Faced with the global infatuation with designer labels, we notice the creation of distribution lines, which has become a major development in our world. This phenomenon is evident when we look at the luxury fashions in the Louis Vuitton stores on the Champs Élysées in Paris, on Omotesando Avenue in Tokyo or on Fifth Avenue in New York. These are the ambassadors of luxury and French craftsmanship, where limited-edition and mass-produced commodities jostle side by side.

Today, the accessory is closely linked to particular cultural movements. Punks, with their body piercings, demonstrated a form of "confrontational" accessory opposed to established ethical codes. In the mid-1980s, Madonna gave a new sense of meaning to the rosary by using it in a subversive context. At the same time, Alain Mikli made spectacles attractive – gone are the days when a pair of glasses conjured up a staidness and seriousness synonymous with secretaries and teachers. Glasses are now colorful, giving a new style to the face; allowing people to express another side of their personality.

This chapter illustrates these developments and the eternal reinventing of fashion, drawing from the past the concepts of tomorrow. The origins of these products are presented through different designers and labels, museum visits and a "world tour" of the shoe. Lanvin, Louis Vuitton, Loulou de la Falaise, Yazbukey, Sonia Rykiel, Christian Louboutin and Elena Cantacuzène also reveal their ideas and skills.

The history of Louis Vuitton

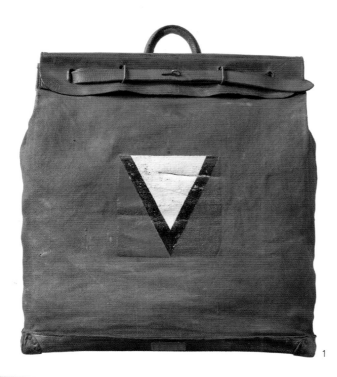

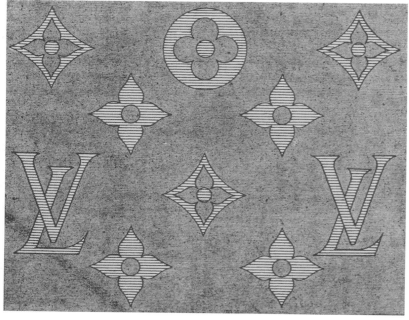

A vocation – travel

For more than 150 years the House of Louis Vuitton has epitomized French tradition and craftsmanship. Right from the beginning, it knew how to combine skill with creativity, history with modernity and tradition with innovation. In 1835, Louis Vuitton arrived in Paris and became an apprentice packager, making trunks and luggage connected with travel. In 1853, he became the favorite packager of Empress Eugénie, and a year later created his own insignia, which his successors have developed into a luxury fashion and leather goods brand.

The second half of the 19th century coincided with the introduction into Europe of Japanese art and fashion. Georges Vuitton, Louis' son, was inspired by the traditional Japanese motifs to such an extent that he created the now world-famous Louis Vuitton canvas monogram in 1896 in response. This period was also synonymous with the great transatlantic voyages and, from the outset, this brand was linked to the spirit of travel: the steamer bag, designed in 1901, bears witness to this as a cult object. This completely new product predated the "holdall" with its concept of a cylindrical travel bag that can be stored flat when empty.

An international reputation

By the beginning of the 20th century, Louis Vuitton had become established in London and New York, forging an international reputation for himself. Today, his luxury brand is found in more than 350 shops worldwide. His luggage has been linked to illustrious Hollywood stars from Cary Grant to Jennifer Lopez,

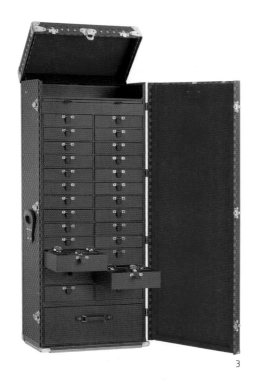

3

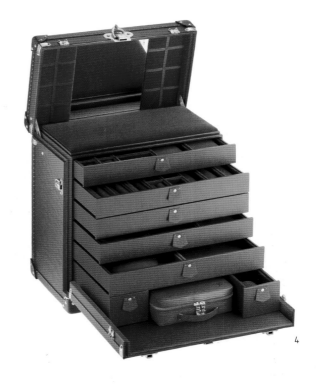

4

5

...Marlene Dietrich and Sharon ...987, Louis Vuitton merged ...nnessy to form the LMVH ...worldwide number one of ...oods – with special com-

missions giving the brand its distinctiveness. Each year the Asnières studio makes some 450 travel trunks, dog carriers, portable leather mini-bars, and so on.

...ERUNNER OF THE SOFT BAG.
...rent Bremaud/Lb Productions.

...GRAM "INTENDED FOR ALL ITEMS ...SUITCASES, BRIEFCASES" CON-...ENTICATION OF THE LOUIS ...ARK, WHICH WAS REGISTERED ...FFICE OF INDUSTRIAL PROP-...1905.
...ives.

...HECK CASE DESIGNED TO ...T 100 WATCHES, 2004.
© Phillipe Jumin/Lb Productions.

4. RED LEATHER JEWELRY CASE WITH RED MOROCCAN LINING, COMPRISING SEVERAL DRAWERS LINED WITH RED SILK VELVET. IT EVEN HAS A SECRET COMPARTMENT FOR PRIVATE CORRESPONDENCE. THIS PIECE WAS CREATED IN 2005 TO CELEBRATE THE YEAR OF FRANCE IN CHINA, AS AN HOMAGE TO CHINA'S PROSPEROUS MILLENIUM. IT WAS EXHIBITED IN SHANGHAI IN THE "CREATIVE AUDACITY" SHOW ORGANIZED BY THE COMITÉ COLBERT — AN ASSOCIATION THAT PROMOTES LUXURY FRENCH BRANDS.
© Lb Productions.

5. MINI-BAR IN SLATE-COLORED TAIGA LEATHER WITH A DARK GRAY INTERIOR, EQUIPPED WITH A BOTTLE OF CHAMPAGNE AND FLUTES.
© Collection Louis Vuitton/Philippe Jumin/Lb Productions.

Louis Vuitton's travel museum

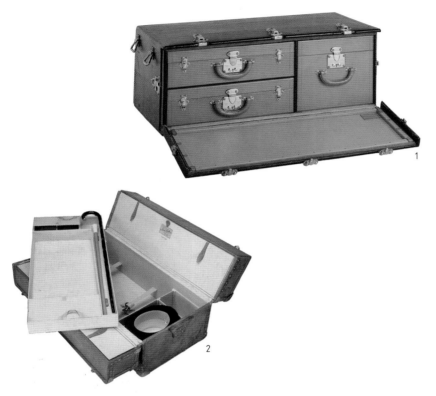

1

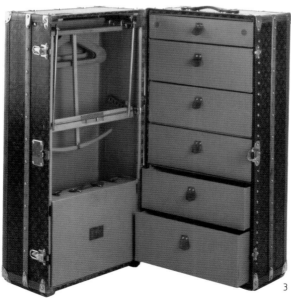

2

3

A family museum

Since 1854, all the traditions, innovations and fundamental values belonging to the Louis Vuitton brand have been gathered under one roof in the Louis Vuitton Travel Museum at Asnières. For more than a century now, Louis and his descendants have lived in this house, only a stone's throw away from the production studio that was opened in 1859. It is here that craftsmen still produce high-quality, bespoke examples of hat boxes, traveling wardrobes and vanity cases. The museum is private, however, with visits reserved for special guests and employees of Louis Vuitton only.

Another travel history

The museum is organized around the four great travel themes: sea, air, rail and road. This reflects the evolution of the different means of transport that accompanied the Industrial Revolution of the 19th century. These trunks and their accessories, which have crossed oceans and continents, are in their own right, classic luxury objects evoking a timeless aura that implicitly combines aesthetics and function. One can also admire the striped canvas trunk-bed, the leather tea-case and even the car-trunk – the *Excelski* and *Excelsior* pre-date modern car trunks. To complete the celebration of these pieces, which is entirely dedicated to travel and travelers, one wing of the museum houses the personal collection of Gaston Louis Vuitton, the founder's grandson. This contains some several thousand trunks, cases and travel items from different eras – some of which date from the end of the 14th century.

1. *EXCELSIOR* CAR-TRUNK IN VUITTONITE CANVAS, 1923.
PERFECTLY SHAPED TO FIT INTO A CAR.
© Louis Vuitton collection.

2. *IDÉALE* CASE IN NATURAL CALFSKIN, 1905. ALSO CALLED THE
PARFAITE, THIS CASE CAN HOLD FIVE MEN'S SUITS, AN OVERCOAT,
18 SHIRTS, UNDERWEAR, FOUR PAIRS OF SHOES, A HAT, THREE
WALKING STICKS AND AN UMBRELLA.
© Louis Vuitton/Antoine Jarrier collection.

3. *WARDROBE 110* IN MONOGRAMMED CANVAS, 1930. MADE
SINCE 1875, THESE CASES MEAN THE TRAVELER NEVER HAS TO
UNPACK.
© Louis Vuitton collection.

4. TRAVELING TEA-CASE IN TEXTURED LEATHER, 1926. MADE
ESPECIALLY FOR THE MAHARAJAH OF BARODA, CONTAINS EVERY-
THING REQUIRED FOR A CUP OF TEA. THE HOT PLATE, TEAPOT AND
WATER POT BREAK DOWN INTO A DOZEN PIECES THAT FIT SNUGLY
INTO ONE ANOTHER.
© Louis Vuitton/Antoine Jarrier collection.

5. STRIPED CANVAS TRUNK-BED, AROUND 1878. IDENTICAL MODEL
TO THAT OF PIERRE SAVORGNAN DE BRAZZA (1852–1905), THE
FRENCH EXPLORER WHO UNDERTOOK MANY AFRICAN EXPEDITIONS,
NOTABLY IN THE CONGO WHERE HE FOUNDED THE TOWN OF
BRAZZAVILLE IN 1880.
© Louis Vuitton/Antoine Jarrier collection.

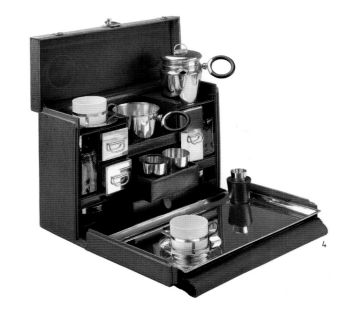

4

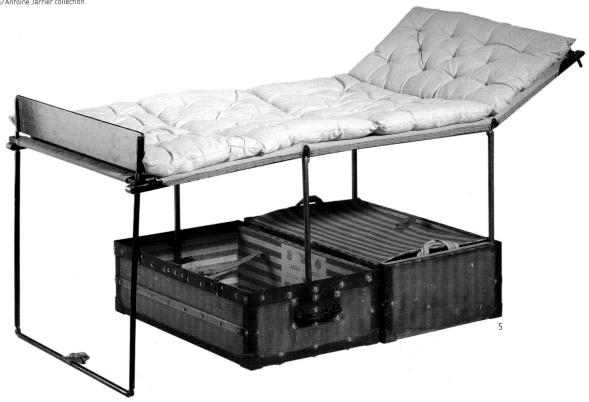

5

The history of the shoe

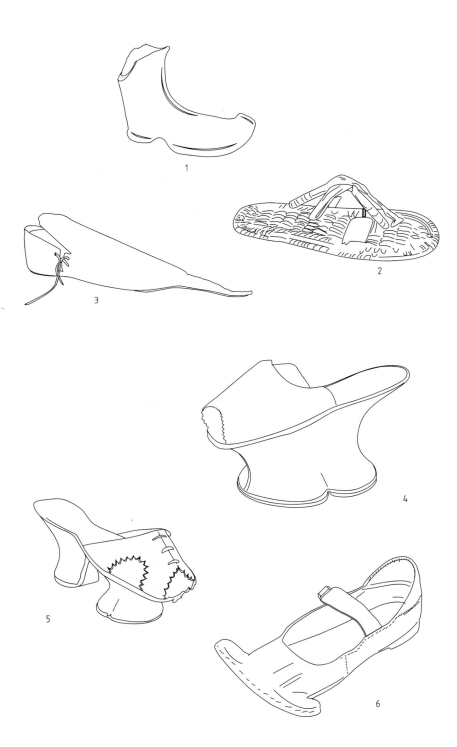

1

2

3

4

5

6

Functions and uses

A product is usually made for a specific function, with its development often reflecting the cultural and economical evolution of the society from which it originates. This development is particularly noticeable in the case of the shoe. For example, simple sandals with leather thongs have become real footwear nowadays. So much so, that they are indispensable leisure accessories, allowing a certain level of sporting performance.

Sport and leisure have become important sources of inspiration and are used more and more in shoe design, with an emphasis being placed on unisex accessories, such as the trainer or riding boot. However, it must be noted that unisex shoes have existed since the Middle Ages, with the poulaine, or pointed shoe (Fig. 3) – both men and women wore it against great resistance, for it was regarded as obscene due to the length of its point.

The sociocultural character of the shoe very quickly adopted an entirely protective function. The fact that shoes were placed alongside jewelry and other belongings in ancient burials indicates the great reverence with which these accessories were regarded. The aesthetic role of the shoe, which could alter the shape of a silhouette, was highly evident in sophisticated Italian courts: footwear of the Middle Ages became more refined shoes; the heels were embellished, becoming higher; and the fabrics were more sought after. This aesthetic quest occasionally led to extravagant models, as with the examples (Figs 16 and 17) showing mules with Cromwell and Himalayan heels from the beginning of the 20th century. This type of heel still has a place on today's catwalk.

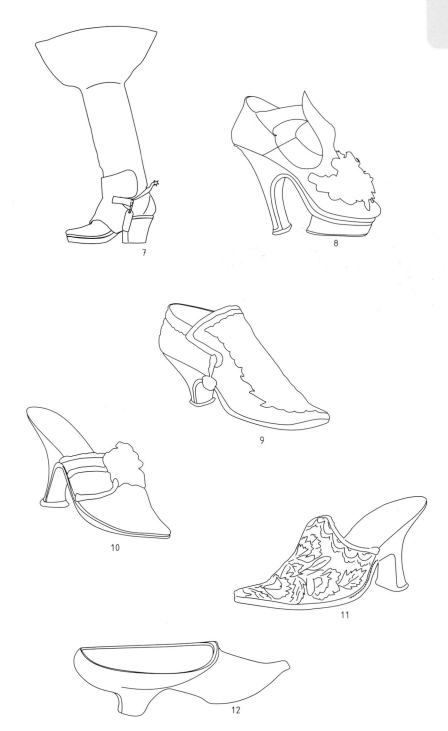

Fashion and historical models

Shape, fabric and manufacturing methods are all specific characteristics that indicate the model of a shoe. The colors used in the past were essentially natural tones, however, progress in the textile industry completely overturned this, permitting a much wider color range, as well as the possibility of using synthetic materials to imitate expensive ones. Equally, the invention of zips and elastic, allowing for better fitting for calf-length and ankle boots, contributed to the advent of new designs.

Past models, notably those that used rare or precious fabrics such as damask, or brocade embroidered with golden threads, have been a constant source of inspiration. For example, today's techniques and materials allow an Egyptian sandal (Fig. 2) or a Venetian chopine (Figs 4 and 5), to be revisited and made into contemporary accessories.

1. CLAY SHOE, AZERBAIJAN, 12TH AND 13TH CENTURY BCE.

2. EGYPTIAN SANDAL MADE FROM VEGETABLE FIBERS.

3. LEATHER POULAINE OR POINTED SHOE, LATE MIDDLE AGES.

4. CHOPINE, VENICE, 16TH CENTURY.

5. CHOPINE, VENICE, AROUND 1600S.

6. MAN'S SHOE, AROUND 1530S–1540S.

7. MUSKETEER'S BOOT, FRANCE, 17TH CENTURY.

8. WOMAN'S SHOE, ITALY, 17TH CENTURY.

9. WOMAN'S SHOE, FRANCE, 17TH CENTURY.

10. WOMAN'S MULE, FRANCE, AROUND 1720–1730.

11. EMBROIDERED MULE, FRANCE, BETWEEN 1700 AND 1750.

12. WOODEN CLOG, FRANCE, 18TH CENTURY.

Certain models, however, transcend history to become "classics" – this being the case with the ankle boot, pump, court shoe, and so on. The timeless clog has survived the ups and downs of rural life and has now entered city life, finding itself on the catwalk with Dirk Bikkemberg, for example.

Others reappear sporadically. This was the case with platform shoes, which derive their origins from the zazous, or swingers, in the 1930s, reappearing with the ska and new-wave movements of the 1980s and 1990s. In fact, the first platform shoes appeared during the Vichy regime a decree was announced that insisted that all the hair cut off in hair salons was to be gathered up and mixed with fibers to make slippers. To defy this, the young kept their hair after cutting it off and stuffed it into the soles of their shoes – hence the birth of the platform shoe!

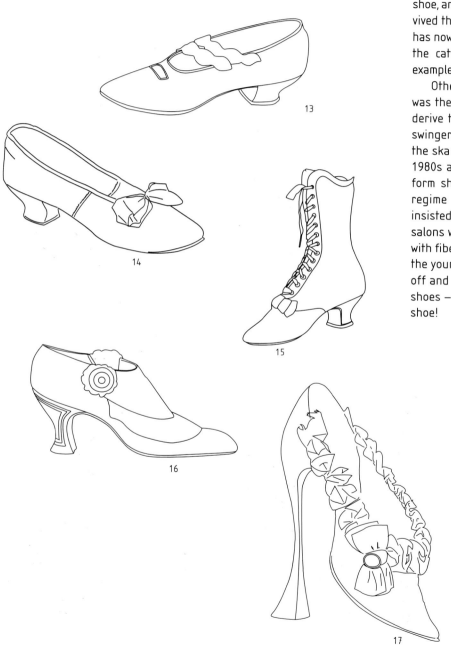

13

14

15

16

17

13. Woman's shoe, France, 19th century.

14. Bride's shoe, France, around 1900.

15. Woman's ankle boot, Paris, around 1875.

16. Evening shoe, France, 1920.

17. Mule with 8-inch (20 cm) heel, decorated with little cabochons, Vienna, Austria, around 1900.

18. Shoe designed by Salvatore Ferragamo in 1923 for Cecil B. de Mille's film *The Ten Commandments*.

19. Ballet shoe.

20. Heel-less court shoe, 1950.

21. Duc de Guise, Louis XV heel, Paris, beginning of 20th century.

22. Shoe designed by Massaro for Chanel, 1958.

23. Platform-heeled sandal, 1990.

18

19

20

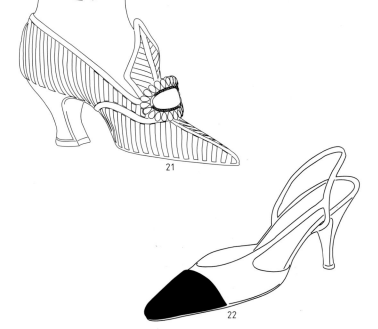

21

22

23

World shoes

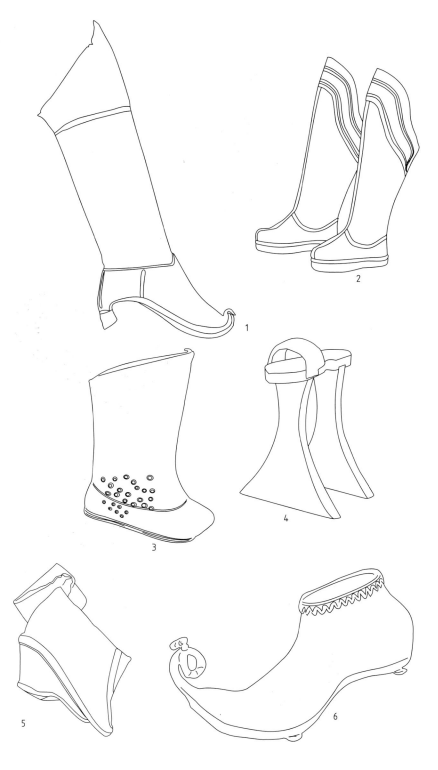

1

2

3

4

5

6

People, and their particular culture, are distinguished by their clothes and accessories. It is essential to emphasize the importance of the social context in which groups of individuals make their shoe choices, i.e. fabrics, shapes, uses, etc.

By making a "world tour of the shoe" we soon realize that there are many sources of inspiration from the past that have influenced its evolution. The West has adopted several styles from other cultures, including the moccasin (Figs. 8 and 9), which originated in the New World, the ballet shoe (Fig. 11), from China, and the babouche or Turkish slipper (Fig. 7), from Morocco.

The shoe is not only known for its practicality, but also as a symbolic accessory indicative of power and religious persuasion. Several cultures have accessories linked to rites of passage that mark milestones in one's life, such as birth, becoming an adult, marriage and mourning. With the Akan of West Africa, in Ghana and the Ivory Coast, for example, sandals inlaid with gold indicate royalty.

Particular uses

The foot has frequently played an important part in the history of civilizations with the smallness of women's feet often highly valued. The sadly infamous "bound feet" of Chinese women and the tale of Cinderella in Western culture bear witness to this. In these examples, the shoe can misshape a foot to the point of deformation in spectacular fashion!

The heel is an essential part of the shoe. Beyond its aesthetic role, the heel has a particular function, as is evident in

Figure 4. Here the heel is very high, so that the wearer does not get her feet wet once she has stepped out of the bath. This type of shoe was widespread in Turkey and other Eastern countries in the 18th and 19th centuries. In Japan, for example, the geishas also wore high-heels (Fig. 10), which protected their feet from the torrential rains.

Nowadays the Birkenstock brand, with its back-to-nature design and anti-fashion statement, is appreciated as much as a fashion item as for its original utilitarian function.

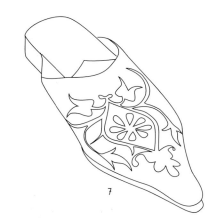

7

8

9

11

10

1. Riding boots with a deer-hoof-shaped heel, Persia, 17th century.

2. Silk Mandarin boots, Kangxi reign, China, 1662–1722.

3. Woman's satin boot, embroidered with mirror glass, China, 19th century.

4. Wooden geta shoe, Middle East, 19th century.

5. Wedding shoe, China.

6. Shoe with turned-up point, India.

7. Babouche or Turkish sandal, Morocco.

8. Woman's moccasin, North America, 19th century.

9. Man's shoe, walrus and seal, Alaska, beginning of 20th century.

10. Geisha or geta shoe, Japan.

11. Ballet shoe, China.

Charles Jourdan's shoe museum

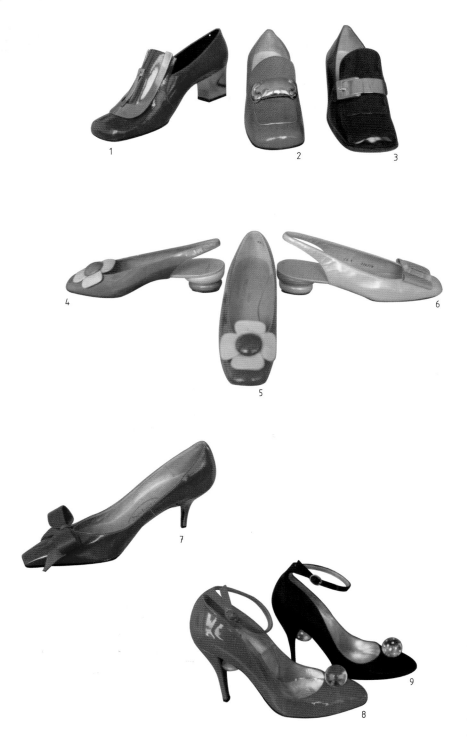

Ready-to-wear shoes

The Charles Jourdan brand, which recently disappeared, epitomized French shoe style using more geometric models than those found in Italian shoe designs. In the 1930s, Charles Jourdan created a line of ready-to-wear shoes under the name Séducta, with a logo featuring a pair of stag's antlers. In 1957, Roland Jourdan, the founder's son, launched an idea that brought him international success — that of a court shoe sporting a heel in the style of Louis XV or Charles IX, which was available in three widths, 20 colors and every size. In that same year, just one of these styles, available in every color possible, was presented in the boutique that opened in the Rue de la Madeleine, Paris. More than the product, it was the promotion of the brand that was placed in the limelight, with Dior quickly signing up the French shoe designer. This paved the way for his entrance into the *haute couture* world of the 1960s.

A flagship brand

Patrick Cox, who had been the brand's artistic director, believed that Charles Jourdan's architectural design and ground-breaking approach to color had been the two pivotal elements responsible for the success of the Charles Jourdan company. However, it should be noted that designers such as André Pérugia, Roger Vivier and Hervé Leger contributed equally to this success.

The company has kept a number of styles from this era, which are currently on show at the Charles Jourdan museum. This museum works alongside that of The International Shoe Museum in

Romans-sur-Isère, both of which pro-
mote the skilled craftsmanship of a
region that has specialized in footwear
for a long time.

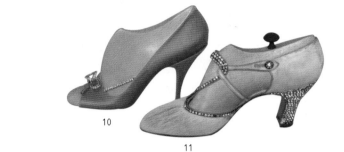

1. CHRISTIAN DIOR, 1969–1970.

2. *PUMA 1*, CHARLES JOURDAN, 1969–1970.

3. *CHARLIE*, CHARLES JOURDAN, 1969–1970.

4. *NANKIN VERT*, CHARLES JOURDAN, 1967.

5. *NIKI*, CHARLES JOURDAN, 1967.

6. *ORACLE*, CHARLES JOURDAN, 1967.

7. *AGADIR*, CHARLES JOURDAN, 1955.

8 AND 9. *ZOOM*, CHARLES JOURDAN, 2002-2003, DESIGNER
PATRICK COX.

10. MOCK-UP "7595," CHARLES JOURDAN, 1950.

11. *GRURE*, CHARLES JOURDAN, 1924.

12. *COMPENSÉE OSIER*, CHARLES JOURDAN, 1975.

13. *SANS PAN*, CHARLES JOURDAN, 1972.

14. *COMÉDIA*, CHARLES JOURDAN, 1976.

15. *GOYA*, CHARLES JOURDAN, 1976.

16. *ELVIRE*, CHARLES JOURDAN, 1976.

17. *LE POISSON DE BRAQUE*, CHARLES JOURDAN, 1955.

18. *ALICANTE*, CHARLES JOURDAN, 1980.

19. *CHRISTEL*, CHARLES JOURDAN, 1980.

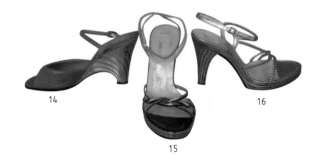

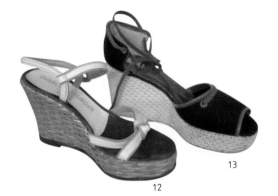

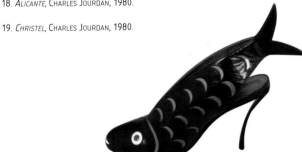

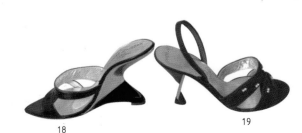

Didier Ludot and vintage bags

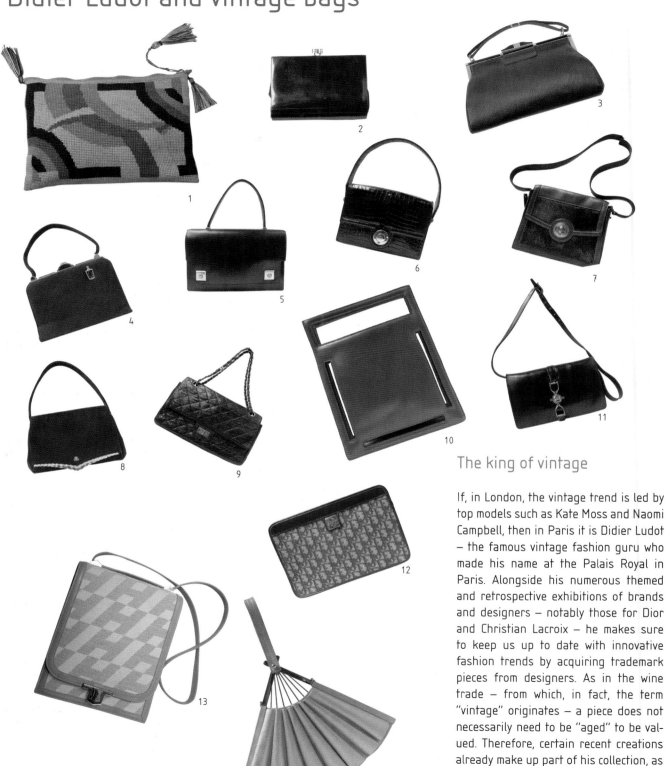

The king of vintage

If, in London, the vintage trend is led by top models such as Kate Moss and Naomi Campbell, then in Paris it is Didier Ludot — the famous vintage fashion guru who made his name at the Palais Royal in Paris. Alongside his numerous themed and retrospective exhibitions of brands and designers — notably those for Dior and Christian Lacroix — he makes sure to keep us up to date with innovative fashion trends by acquiring trademark pieces from designers. As in the wine trade — from which, in fact, the term "vintage" originates — a piece does not necessarily need to be "aged" to be valued. Therefore, certain recent creations already make up part of his collection, as is the case with recent pieces by Olivier

15

16

17

18

19

20

Theyskens for Rochas, or Viktor & Rolf's dresses. With his keen eye and love of fashion, he is able to discern those items which merit keeping.

A personal take on the accessory

Here, Didier Ludot proposes a selection of vintage bags to illustrate the evolution of this particular product. For him, "there is always a treasured side to a vintage garment: it is not an item which will grow out of fashion as it is no longer fashionable!" For Didier Ludot, the fashion accessory accompanies the garment, and its importance is such that a simple change of accessory can totally revive a look.

1. 1920S TAPESTRY CLUTCH BAG BASED ON A SONIA DELAUNAY PAINTING.
© Didier Ludot Collection, Paris.

2. 1930S RIGID BLACK BAKELITE CLUTCH BAG WITH CHROME CLASP.
© Didier Ludot Collection.

3. 1930S HANDBAG WITH THIN HANDLE IN TEXTURED BLACK LEATHER, WITH CHROME AND BAKELITE CLASP.
© Didier Ludot Collection, Paris.

5. 1940S BLACK ANTELOPE REVERBERE HANDBAG, HOUSE OF SCHIAPARELLI.
© Didier Ludot, Paris.

6. 1960S HERMÈS PIANO HANDBAG IN NAVY BLUE, ALSO CALLED FABIOLA AFTER THE QUEEN OF BELGIUM WHO PARTICULARLY LIKED THIS BAG.
© Didier Ludot Collection, Paris.

7. 1950S HERMÈS BLACK CROCODILE HANDBAG WITH GILT CLASP.
© Didier Ludot Collection, Paris.

7. 1940S HERMÈS MOTO BAG MADE FROM RECYCLABLE MATERIALS, BROWN LEATHER AND SEAL SKIN WITH AN ADJUSTABLE SHOULDER STRAP.
© Didier Ludot Collection, Paris.

8. 1950S BLACK REINDEER HANDBAG FROM GERMAINE GUERIN. IVORY AND BROWN BAKELITE FLAP WITH TWISTED BRAID TRIMMING AND MONOGRAM.
© Didier Ludot Collection, Paris.

9. 1950S BLACK LEATHER QUILTED CHANEL BAG DESIGNED BY COCO CHANEL IN 1955.
© Didier Ludot Collection, Paris.

10. 1966 RED SQUARE BAG BY PIERRE CARDIN.
© Didier Ludot Collection Paris.

11. 1967, BOX-SHAPED CELINE HANDBAG WITH SHOULDER STRAP AND GILDED HARNESS FEATURE.
© Didier Ludot Collection, Paris.

12. 1970S DIOR CLUTCH BAG IN NATURAL-COLORED CLOTH WITH MAROON-COLORED MOTIFS.
© Didier Ludot Collection, Paris.

13. 1970S HERMÈS HANDBAG WITH SHOULDER STRAP IN BEIGE LEATHER, WITH CANVAS INSIGNIA OF "LEANING H," DESIGNED BY JEAN-CHARLES BROSSEAU.
© Didier Ludot Collection, Paris.

14. 1980S KARL LAGERFELD FAN-SHAPED HANDBAG IN SILVER-COLORED LEATHER.
© Didier Ludot Collection, Paris.

15. 1980S RENAUD PELLEGRINO EVENING BAG IN BRIGHTLY COLORED DUCHESS SATIN WITH GILDED BALLET DANCER'S FEET FEATURE.
© Didier Ludot Collection, Paris.

16. 1980S BLACK BOX-SHAPED COMMODE HANDBAG, BY CHRISTIAN ASTUGUEVIEILLE FOR ROCHAS.
© Didier Ludot Collection, Paris.

17. 1990S CHANEL QUILTED CHAIN HANDBAG WITH BRIGHT BLUE GLASS SEQUINS.
© Didier Ludot Collection, Paris.

18. 1990S PRADA BOWLING BAG IN BORDEAUX-COLORED LEATHER.
© Didier Ludot Collection, Paris.

19. 2000 DIOR HANDBAG IN BEIGE AND WHITE MONOGRAMMED CLOTH, WITH NATURAL-COLORED LEATHER TRIM AND WIDE SHOULDER STRAP.
© Didier Ludot Collection, Paris.

20. 2000 GUCCI HANDBAG IN BEIGE AND ABSINTHE COTTON SATIN WITH HORSE'S BIT FEATURE IN THE FORM OF EMERALD GREEN SEQUINED SNAKES.
© Didier Ludot Collection, Paris.

Designers and their accessories

Lanvin: Alber Elbaz

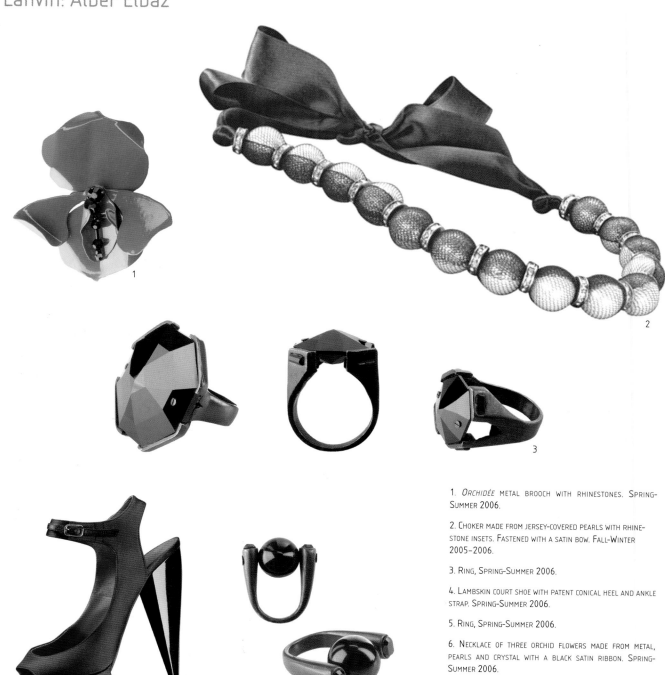

1. *Orchidée* metal brooch with rhinestones. Spring-Summer 2006.

2. Choker made from jersey-covered pearls with rhinestone insets. Fastened with a satin bow. Fall-Winter 2005–2006.

3. Ring, Spring-Summer 2006.

4. Lambskin court shoe with patent conical heel and ankle strap. Spring-Summer 2006.

5. Ring, Spring-Summer 2006.

6. Necklace of three orchid flowers made from metal, pearls and crystal with a black satin ribbon. Spring-Summer 2006.

7. Handbag with metal finishings in textured and lacquered lambskin. Maroon leather handle with Lanvin medallion and shoulder strap. Spring-Summer 2006.

8. Patent calfskin pumps. Fall-Winter 2005–2006.

A culture and a style

Alber Elbaz has been the artistic director of Lanvin since 2001. After making a name for himself in the United Sates, he came to Paris to work with Guy Laroche and Yves Saint Laurent. His belief that fashion is art and imagination, which is his principal driving force, is derived from a plethora of sources – not least from sculpture and literature. A single word – desirable – illustrates his 2001–2002 Fall-Winter collection. It is the white porcelain bodies by the Japanese sculptor from Shanghai, Liu Jianhua, which inspired Lanvin's flagship perfume Arpège. Accessories are supremely important to him. He is attracted to the color blue for a necklace or a pair of shoes, for example, because it is reminiscent of the sky in Casablanca where he spent most of his childhood. He has also been influenced by the full moon, as it signifies perpetual renewal, which has been an important theme in his work.

6

7

Harnessing influences

Couturier, but also designer, Alber Elbaz describes the stages of his creative process. In the first instance there is the solitary confrontation with the blank page and the drawing. Following that, time is spent researching, with great scrutiny, shape and form using a tailor's dummy. It was Elbaz who was responsible for the design and window dressing of the Lanvin boutique on Rue St. Honoré in Paris. His understanding of fashion, literature and sculpture has enabled him to produce accessories of great originality – the covered-pearl necklace in Figure 2 bears witness to this. Drawing inspiration from the world around him, he has designed pieces where silk birds nestle into *decolletés* and, after overhearing a conversation in which a woman explains how she concealed jewelry in her dress, he came up with the idea of covering jewelry. This is all part of the romance of haute couture. Alber Elbaz loves elegance and perfection, but above all, he loves women, and it is women to whom he will always leave the last word. For it is she who determines a style by the particular way she laces a ribbon or ties a bow.

8

Louis Vuitton and Marc Jacobs

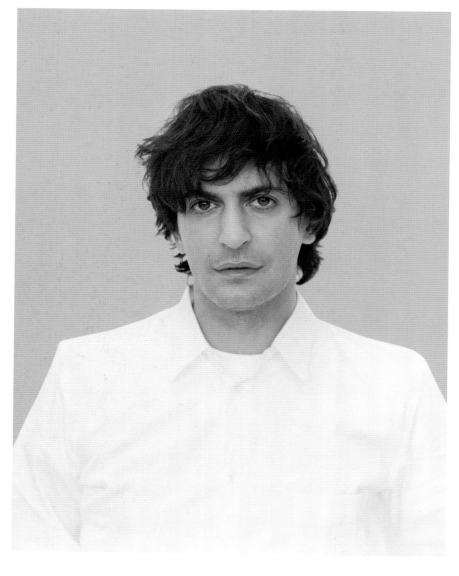

In 1898, George Vuitton, son of the founder and creator of the legendary monogram canvas, had already crossed the Atlantic and made a name for himself in America. Marc Jacobs, the creative director of Louis Vuitton since 1997, has been inspired by the spirit of travel and innovation held dear to this renowned *malletier* (leather goods manufacturer), to the point of making it a fashion in itself. His creations are the result of his dynamic yet relaxed approach to design, coupled with an in-depth knowledge of Louis Vuitton's traditional techniques. This designer, from New York, links history, culture and modernity in his collections by reliving the great transatlantic crossings that gave the brand its success.

Marc Jacobs reinterpreted the grunge-rock culture of Seattle in the 1990s, such as hip-hop and skateboarding, by introducing elements of these into the Vuitton style. He transformed a traditional object – the holdall – into a fashionable one. He rendered art accessible to everyone (just as Andy Warhol did with pop art) when he asked New York underground artist Stephen Sprouse to design a limited-edition collection featuring graffiti written over the monogrammed canvas. Jacobs also invited the Japanese designer Takashi Murakami to reproduce multicolored versions of the monogrammed canvas.

His Fall-Winter 2006-2007 collections do not only consist of a little jewelry, but also a profusion of hats, from toques to large baseball caps in the Gavroche style. He uses materials such as lacquered crocodile, mink and – for the first time in the history of Louis Vuitton – alligator skin to create original compositions, by combining and layering latex, tweed, fur (notably, leopard), satin and cashmere. Marc Jacobs doesn't hesitate in featuring men carrying handbags or shoulder bags, or creating chinchilla earmuffs bearing the initials LV.

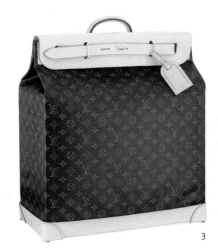

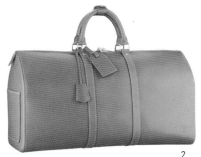

1

2

3

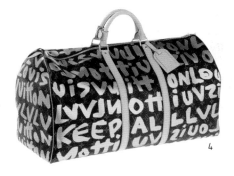

4

1. HOLDALL IN SILVER METALLIC MONOGRAMMED CANVAS.
© LB Productions.

2. HOLDALL 50 (20 x 11½ x 8 ½ INCHES, OR 50 x 29 x 22 CM)
IN NOMAD LEATHER.
© Laurent Bremaud/LB Productions.

3. STEAMER BAG (17 ½ x 20 ½ x 8 INCHES, OR 45 x 52 x 20 CM)
IN MONOGRAMMED CANVAS WITH LUGGAGE LABEL, 2004.
© Louis Vuitton.

4. HOLDALL 50 IN MONOGRAMMED CANVAS WITH SILVER GRAFFITI
AND LUGGAGE LABEL, 2001.
© Antoine Jarrier.

5. *NOÉ* IN MONOGRAMMED CANVAS WITH TWO MINIATURES ATTACHED
TO THE HANDLE, IN MANDARIN AND GREEN LEATHER RESPECTIVELY.
© Patrick Galabert/LB Production.

6. *ALMA* IN MONOGRAMMED CANVAS WITH A MINI *ALMA* IN MULTI-
COLORED MONOGRAM ON WHITE CANVAS, A MINI STEAMER BAG IN
GREEN LEATHER AND A MINI *ALMA* IN BLACK LEATHER.
© Monogram Multicolore is created by Takashi Murakami for
Louis Vuitton.
© Patrick Galabert/LB Productions.

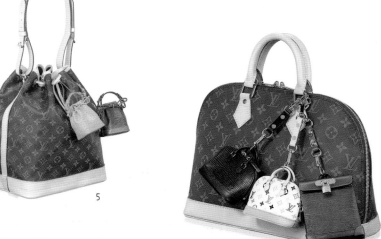

5

6

Loulou de la Falaise

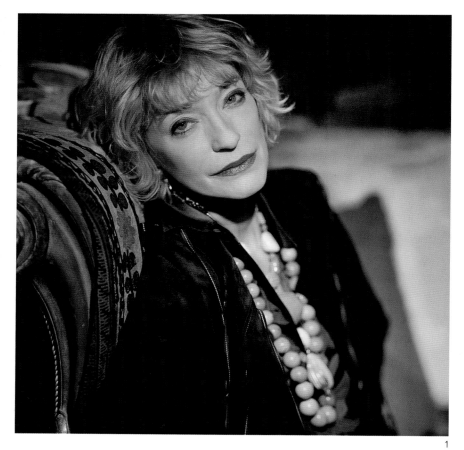

also among her favorites. She uses a combination of glass, pâte de verre and blown glass to make her costume jewellery, known affectionately as *loulouteries* by Saint Laurent. In terms of her design approach, her technique varies according to the piece in hand – "certain pieces require a drawing whereas others can be made directly," she states. She is not fond of "things which are too strict, nor principles which are too restricting." Working from the premise that false pearls are harder than cultured pearls, she embarks on a design in one of her most favored materials.

An enchanted world

With this designer we see certain colors, such as black (also a favorite with Yves Saint Laurent), as well as bright reds, blues and turquoises. The sea has been a constant theme of inspiration since her childhood. She has never forgotten the walks along the shores collecting shells, stones, leaves and flowers. With Loulou de la Falaise, gardens, lichen, bracken and even the Scottish Highlands all become potential design pieces. She likes to "surprise" with her designs, such as the small clutch bag (Fig. 6) in python skin with an ebony fastening. She derives inspiration from an eclectic mix of themes – Africa, Asia, sometimes work by Gustav Klimt, other times it is a Chinese lacquered object. "Childhood has a charming side," points out the designer, who is equally inspired by make-believe. Her logo is inspired by a wolf baying in the moonlight. She particularly likes "jewelry which evolves," because she aims to "break the images" by returning all the elements to their original function.

1

3

A game of materials

For more than 30 years, Loulou de la Falaise was Yves Saint Laurent's muse, as well as his design collaborator. She created her own label in 2003, where she acknowledged her passion for natural materials, notably coral. Stones, wood and fur are

2

Louise de la Falaise is called Loulou. Her first name could be linked to one of Louis XIV's favorites, with her surname evoking one of Alban Berg's heroines. Possessing a brilliance and multicolored facets to her personality, she is nymph-like with an androgenous body. She is impressed by everything and, reveling in the contrasts and extremes that appear, she has an innate ability to make sense of all of this. She is a mixture of exuberant elegance, aristocracy and haughtiness, evoking a surprising sensuality that is both intriguing and disturbing. This distant reserve is full of mystery. However, we must not be mistaken, for beneath this immodest veil of black lace hides a little girl who is in fact all woman.

Yves Saint Laurent

4

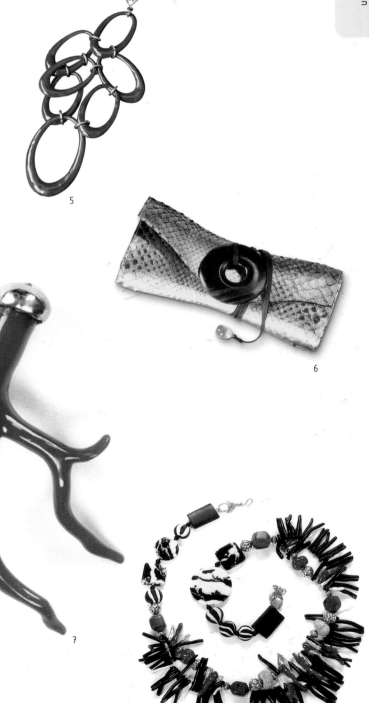

1. Loulou de la Falaise. Photo by Rose Deren.

2. Exotic wooden bracelets with parchment cuff.

3. Butterfly-shaped stone brooch.

4. Autographed homage to Loulou de la Falaise by Yves Saint Laurent.

5. Drop earring with interconnecting lacquered metal hoops, Fantasie line, 2006.

6. Python-skinned clutch bag with glossy ebony fastening.

7. Coral brooch, Fantasie line, 2006.

8. Necklace made from glass, coral, red and turquoise jasper.

Yazbukey

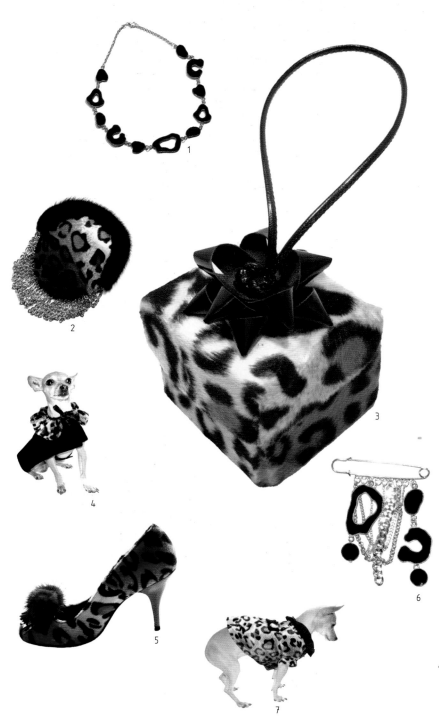

1

2

4

3

5

7

6

8

Inspired by the Orient

The Yazbukey label was created by the sisters Yaz and Emel in 2000. Yaz was born in Istanbul and Emel in Cairo. Their work is redolent of the fables of the Thousand and One Nights, inspiring a range of accessories. They organize parties with provocative themes such as "Let's get physical," "Let's get animal" and "Let's get wet." The singer and performer Björk propelled Yazbukey into the limelight when she wore their masks during her concerts.

The two sisters worked in different countries before coming to Paris, where they currently work. Yaz studied fashion design while Emel worked for three seasons with Christian Lacroix on his prints. They started off with a line of accessories that included jewelry, shoes, gloves, masks, belts and even a clothing range for dogs! Two chihuahuas with painted toenails have become their mascot, and are even presented on the catwalk during their fashion shows.

The two designers work with leather remnants, which they embroider and embellish with pearls and glass beads. They also include recyclable materials as well as crystal and Perspex.

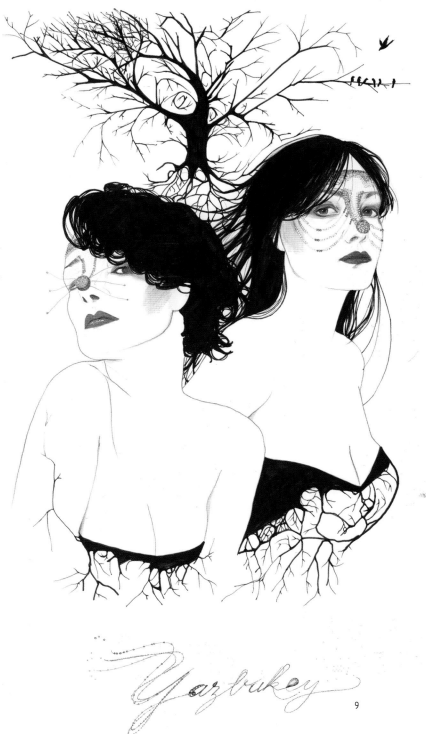

A cosmopolitan inspiration

Their concept is that every object can become an accessory. They draw inspiration from the imaginary world of *Aesop's Fables, The Wizard of Oz* and the Brothers Grimm, while films by Tim Burton and Alfred Hitchcock are also influential. The illustration of the two sisters (Fig. 9) is by the famous American fashion illustrator Cedric Rivrain. The Yaz label is sold in Hong Kong, London and Tokyo. In Paris it is marketed under the public relations company Totem. They produce two collections per year, as well as designing jeans and tee shirts advertising Absolut Vodka in Turkey, and pearl wigs for Gaspard Yurkievich.

1. Perspex and metal necklace from the Panthère collection.

2. *Bibi* from the Panthère collection.

3. Miniature bag from the Panthère collection.

4. Dog cape from the Panthère collection.

5. High-heeled fur shoes with pom-pom from the Panthère collection.

6. Metal brooch with Perspex charms from the Panthère collection.

7. Dog coat from the Panthère collection.

8. Mask from the Panthère collection.

9. Illustration of Yaz and Emel by Cedric Rivrain.

9

Sonia Rykiel: Sonia and Nathalie Rykiel

The woman's wardrobe revolutionized

Sonia Rykiel is perhaps best known for her knitwear – an essential element of any woman's wardrobe and one that Rykiel knows how to make very successfully. A committed designer, she has been instrumental in the liberation of attitudes, as well as of women. "I've placed seams on the outside, dispensed with bras, introduced dresses without hemlines, worked on the wrong side of a fabric as much as the right, removed shoulder pads, was the first person to make haute couture clothes available by mail order (3 Suisses catalog) and made stripes my trademark. It was an era without taboos," she states. Sonia Rykiel has also written a number of books on

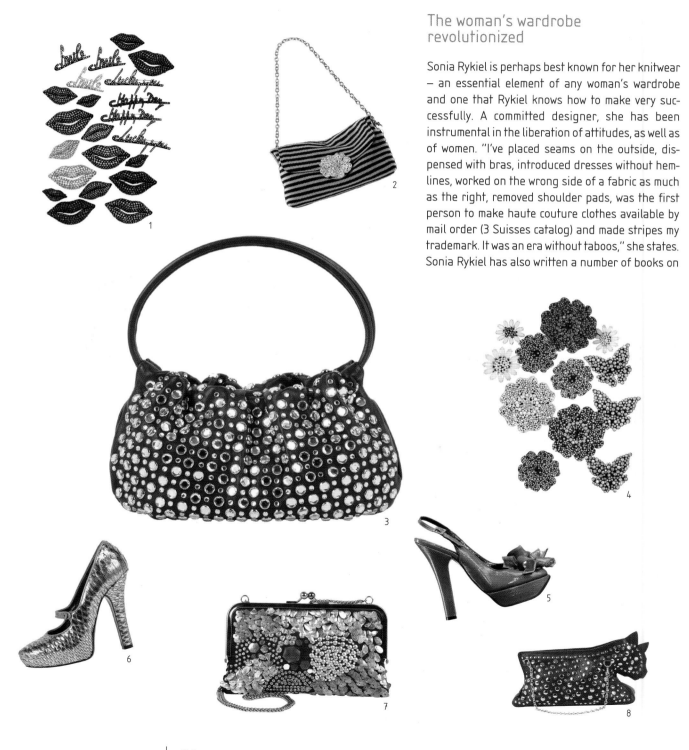

fashion, and in 1961, when she was pregnant with her daughter Nathalie, she created knitwear maternity dresses. In May 1968 she opened her first boutique in Paris, and, in 2001, both Sonia and Nathalie received a Fashion Award from film director Robert Altman for their work on his film *Prêt-à-Porter* (1994). This was an homage to a family dynasty in the fashion milieu who were known the world over. It was Sonia who inspired the theme of the film, in which she played herself.

Mother and daughter

Before becoming artistic director of the label, Nathalie directed the fashion shows. From 1987 she designed various collections, and launched Sonia Rykiel Accessories and Sonia Rykiel Shoes in 1992. A shop dedicated to women, called "Rykiel Woman," where fetish-wear found a place alongside cult designs, was opened in Paris in 2002 .

In the foreword of *Le Dictionnaire des mots et expressions de couleur* (*The Dictionary of Words and Expressions of Color*) written by Annie Mollard-Desfour, Sonia writes: "I am inspired by everything to make colors – I have brought flowers back from all over the world, found sand and coral, collected fragments of wood..."

For Sonia Rykiel Accessories it is the material that is all-important: the knitted striped handbags with glittery rivet details; the "kiss" and cat motifs made as either brooches or pins. Sequins and glitter guarantee "eternal femininity," affording women a timeless and "rive-gauche/left bank" style.

This year the company celebrates 40 years of being in business.

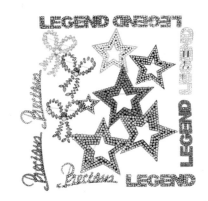

9

10

11

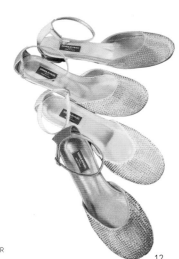

12

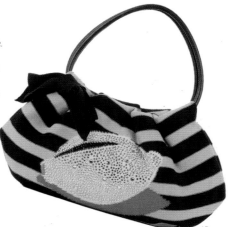

13

1. SEQUINED BROOCHES.

2. *VIOLETTA*, STRIPED KNITWEAR BAG WITH SEQUINED FLOWER CLASP.

3. SEQUINED DOMINO BAG.

4. FLOWER BROOCHES.

5. *BETSY*, PLATFORM SHOE IN GREEN PATENT LEATHER.

6. *ODILE*, PLATFORM SHOE IN GOLD PYTHON LEATHER.

7. *SENSO PICCOLO*, STUDDED SEQUINED EVENING BAG.

8. *FIFI THE CAT*, STUDDED LEATHER BAG.

9. SEQUINED BROOCHES.

10. FLOWER HAIR ACCESSORIES.

11. PERSPEX BANGLES AND BRACELETS.

12. SEQUINED BALLERINA SHOES.

13. *DOMINO*, STRIPED KNITTED BAG WITH SEQUINED LEMON MOTIF.

Christian Louboutin

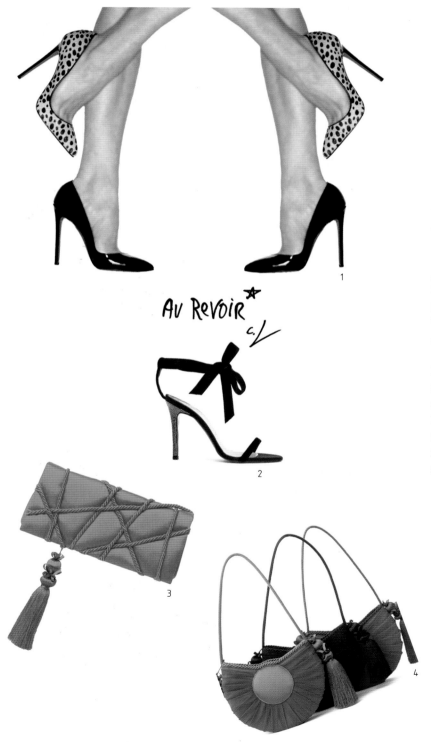

Au Revoir ★
c.L

1

2

3

4

A fascination for the foot

Born in 1963, Christian Louboutin made an early entrance into the Paris fashion scene and its nightlife. A notice forbidding women to enter a museum wearing high heels, for fear of damaging the floor, was to have a big impression on him: he was haunted by this vision and covered his schoolbooks with drawings of high-heeled shoes! Fascinated by Parisian nightlife, in particular Le Palace and the Folies Bergère, he dreamed about designing shoes for the dancers. However, he was only met with refusal, so he took apprenticeships with Charles Jourdan and Maud Frizon, and freelanced with Chanel and Yves Saint Laurent, until he met his mentor, Roger Vivier, the legendary haute couture shoe designer.

In 1992, Christian Louboutin opened his first boutique. Here his clients were charmed by the luxury of discussing, over a cup of coffee, their needs, and a privileged rapport was established. The red nail polish of one of his employees was the inspiration for his red-lacquered soles – his signature was born!

5

Au Revoir ★
Et merci à Olga de
s'être mouillée !
christian L

Women's footwear

The shoe is an integral part of body language and defines the silhouette. "I like it when women see my shoes as beautiful objects, a kind of jewel outside of fashion, standing in its own world. The shoe is not just an accessory – it is an attribute," Louboutin affirms.

For his theme "Le Love" Christian Louboutin created Les Inséparables, which is a name given to a variety of doves or lovebirds. The principle is simple: "A design in pairs: when the two feet are together the design is complete." He likes the contrast between raw materials such as cork and flax used for the thick parts of the platforms, and shiny materials used for the upper parts. He also favors exotic leathers and satins. The "classic woman" has made him appreciate the fundamental basics; he is moved by the "taste of beauty," as he puts it. "Today, I am much more interested in the shape of the line than the detail. I design very freely, then I adapt it," he says.

1. *Pigalle* STILETTO-HEELED SHOES, FALL-WINTER 2004–2005.

2. *Vamp* SANDAL, SPRING-SUMMER 2005.

3. *Cristobag* CLUTCH BAG, SPRING-SUMMER 2005.

4. *Petit Tour* BAGS, SPRING-SUMMER 2005.

5. *Neferina* ROMAN SANDAL, SPRING-SUMMER 2006.

6. *Glamazone* OVER-THE-KNEE BOOTS, FALL-WINTER 2004–2005.

7. *Accroche-moi* ANKLE BOOTS, FALL-WINTER 2004–2005.

8. *Pin-up* STILETTO-HEELED SHOES, SPRING-SUMMER 2006.

9. *Lady Macbeth* CLUTCH BAG AND *Palace* PEEP-TOE HIGH-HEELED SHOES, SPRING-SUMMER 2005.

10. *Lady Macbeth* CLUTCH BAG, SPRING-SUMMER 2005.

11. *Air France* SLIPPERS.

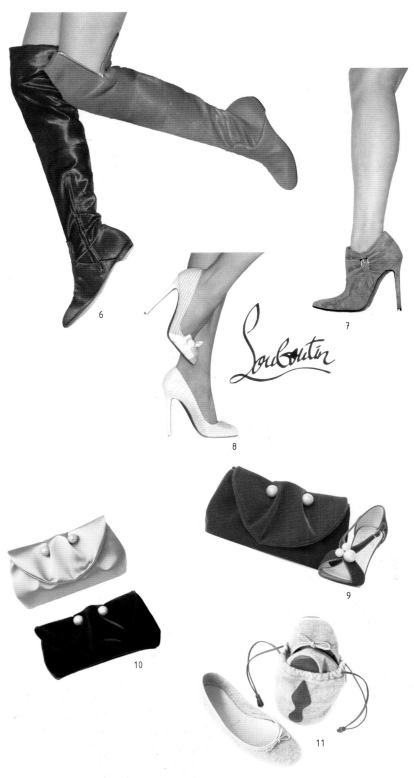

Elena Cantacuzène

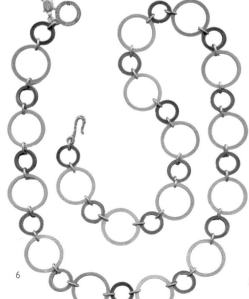

From Byzantium to Paris

Descending from one of the oldest families from Constantinople, Elena Cantacuzène derives inspiration for her jewelry from the ancient civilizations: her Keops line (Fig. 5) is reminiscent of Egypt from the time of the eponymous Pharoah (IVth dynasty, c. 2600 BC). "Everything inspires me from architecture, the shape of a stone, to the colors of the countryside," she says.

After having studied the decorative arts in Paris, she made women's accessories, giving away her first attempts to friends as gifts. Elena feels the relationship between color, form and material is paramount and considers herself a better colorist than designer. Her passion for minerals and precious stones stems from her childhood, when her father, who was a mining engineer, introduced her to the extraordinary variety of rocks that exist.

Gems and jewelry

In 1993, Elena Cantacuzène made her mark by opening a studio boutique in Paris. From that point on, each product would be made by hand, in situ, with materials coming from a variety of exotic places – turquoise from Yemen, agate from Afghanistan, horn and Macassar from Africa, red coral from the Persian Gulf, and glass and crystal from China. She strikes a perfect balance between the brilliance of

7

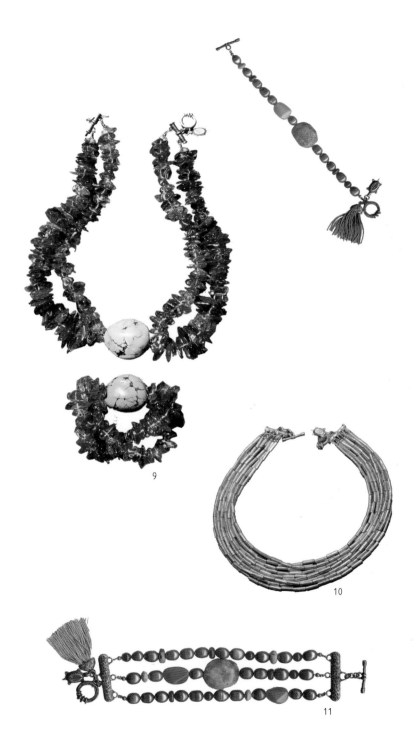

the materials and the intensity of the colors, which are heightened and diminished accordingly. The ruby turtle that is found on all the clasps has become the trademark of her designs. Elena produces a women's collection twice a year, as well as a limited edition of men's accessories. She also works to special commission, deriving great satisfaction from creating custommade, one-off pieces of jewelry using semiprecious stones. For Elena Cantacuzène, the gem becomes a veritable work of art in itself.

1. STONE AND SILVER-PLATED DROP EARRINGS.

2. STONE AND GOLD-PLATED DROP EARRINGS.

3. EXOTIC WOOD AND METAL BANGLES MOUNTED ON ELASTIC.

4. EXOTIC WOOD AND TURQUOISE RING.

5. GOLD-PLATED CHOKER WITH FOUR PEWTER, SILVER AND GOLD-PLATE BANGLES (THREE LONG AND ONE SHORT) FROM THE KEOPS COLLECTION.

6. BRONZE AND GOLD-PLATED HOOP NECKLACE.

7. GOLD-PLATE, BRONZE AND STONE DROP EARRINGS.

8. BRONZE AND STONE NECKLACE.

9. STONE AND TURQUOISE TWO-STRING NECKLACE AND BRACELET.

10. GOLD-PLATED CHOKER.

11. BRONZE AND STONE THREE-STRING BRACELET.

9

10

11

The product is an object for which function determines design, and which is duplicated after extensive market research and stringent testing for comfort, strength, quality and safety. The majority of accessories retain their initial function. The bag therefore remains a container, the shoe protects the foot, the scarf the neck, the hat the head, etc. Spectacles are, in fact, a prosthesis that either corrects sight or offers protection from the sun, or both. On the other hand, jewelry seems to have a purely ornamental function nowadays, although it originally served as a social indicator and was associated with religious symbolism.

To simplify the matter, we have classified accessories into two groups: ornamental and functional. It is clear, however, that every object is made for a specific use. In the case of historic jewelry we realize that symbolic functions preceded ornamental ones, as beliefs and superstitions were at the root of jewelry design. People regarded jewelry either as a hunting trophy or as an object that offered protection against evil spirits long before it became purely ornamental.

Technical progress, economic and social changes, and specialized knowledge all assist in the transformation and development of an accessory into a product. One can imagine, therefore, that the mastering of the stone-setting technique used in the creation of a pair of spectacles is as valuable as the work involved in manufacturing the lenses. New innovations are evident with the Oakley brand, where MP3 or Bluetooth technology has been integrated into some of its spectacle designs.

We should also note that the development of leisure activities in the 20th century encouraged wide research into sunglass design, with customized and durable frames aimed at athletes. The technological advancements of today have allowed us to create high-protection insulating materials that offer maximum comfort and originality. This evolution is as visible in bag design as it is with shoes, spectacles and scarves, with designers drawing inspiration from the military and top-level sporting personalities who, within their own fields, also favor these technical innovations.

Color, shape and material are all important in accessory design. The choice of material is directly linked with function. The insulating properties and suppleness of leather, for example, are beneficial in the creation of gloves, hats and shoes. In the past, leather dyes offered a limited palette, whereas nowa-

Chapter 2 – Products

days there is a huge range of colors, as well as fabric alternatives such as jean material.

Jacques le Corre, who we present in this chapter, shows some excellent examples of material and shape used to great effect with his reinvention of the hat.

Jewelry, as a purely decorative accessory type, is now undeniably a product for the big brands and their designers, with certain brands being specialists in this field. There are two types of jewelry: costume jewelry and jewelry proper. Perspex, metal and molded plastic or acrylic are materials that are used more and more in the costume jewelry world, as they offer more scope and freedom when designing. Thanks to these materials it is possible not only to imitate stones and pearls, but also to be able to offer to a wider audience a more accessible range of jewelry that uses unusual colors and materials not found in the natural world. Swarovski is the largest producer and supplier of synthetic stones today.

Products that become the great classics are commonly called basics. Their forms are regularly revisited, reappearing in different colors and materials, with the combination of several basic designs giving rise to new products. The designer can also offer an innovative concept by diverting the basic from its initial function. Examples of this can be seen in this chapter with Alexis Mabille's bow ties found on belts, brooches and hair slides. His inventive use of materials for accessories, such as straw ribbons on hats, plaited leather trim and contemporary materials such as overstitched denim, all demonstrate his imaginative approach. Other designs include those decorated with flowers, embroidery, jewelry, crystal or rows of pearls. Alexandra Neel, whose designs are also represented, explains how to maintain a balance between style and merchandising for an accessory collection that is both imaginative and commercial. We are also introduced to Christian Louboutin and Betony Vernon, who use fetishism in their shoes and jewelry. It is essential to be able to identify and list the basic accessory forms in order to grasp the work involved in designing and reinterpreting a form into a new product. For this reason, we begin this chapter by listing these basics.

The world of the accessory

gloves

jewelry

glasses

hats

belts

leather goods

ties

scarves

shoes

umbrellas

Accessory-making encompasses a vast range of skills as well as a string of craftspeople and technicians. We can cite, in particular, the heel maker who sculpts the heels of shoes, the foundry worker and gilder who casts the metallic parts of jewelry, the milliner who makes the hats, the watchmaker who creates the watch movements, the spectacle-frame manufacturer, the stonecutter, and so on. These craftspeople are the creators who perpetuate, each in their own way, these specialized skills.

The work involved in making a scarf, tie or bow tie depends on these very skills – the quality of the silk, its cut and the care afforded to the design are all proof of the incredible practical knowledge of the weavers, designers and tailors concerned.

Although leatherwork today is essentially industrialized, this sector of activity has been able to conserve an authenticity and a certain degree of luxury, as the big names testify. For example, Louis Vuitton and Hermès have both used their skills to successfully combine tradition and innovation in their collections, to the point where their wallets and money belts have become a sign of social distinction.

Sometimes, however, style overrides traditional skills. This is the case with the house of Prada, which started off by making its own fabric for its umbrellas, but has ultimately established this material as a genuine concept for its prêt-a-porter lines. Although the accessory appears in a variety of guises and serves many functions, it becomes at some point an undeniable part of a brand's image, thus completing its range.

The following pages present about 20 accessories, the list being far from exhaustive, as demonstrated by the Yazbukey brand, where a dog can be completely "accessorized"! They are presented in such a manner as to remove any distinction between those termed "ornamental" and those referred to as "functional."

The layouts provide a snapshot of the different forms and colorways for each product, whether it be a handbag, shoe, scarf, bow tie, pair of glasses, hat, hair accessory or piece of jewelry. The significant variety of forms and range of colors allow us to appreciate the talent, creativity and infinite generosity of the numerous contributors.

We recognize familiar designers, as well as discovering new ones such as Philippe Roucou and Kazu Huggler for their handbags, Alexandra Neel for her shoes, Alexis Mabille and Didier Ludot for their scarves and bow ties, Pierre Marly for his spectacles, Jacques le Corre for his hats and finally Betony Vernon for jewelry.

fans

bags

hair accessories

shawls

socks

tights

The bag

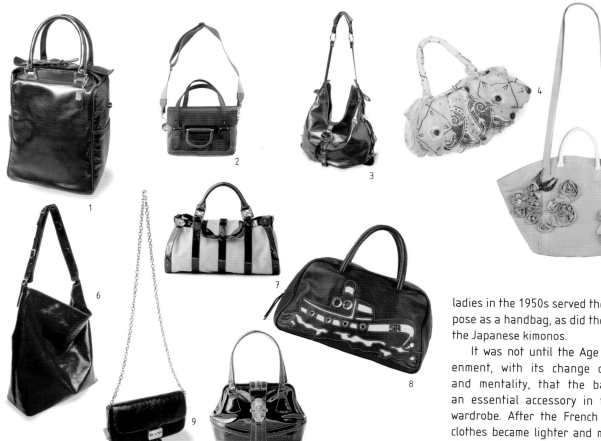

The bag is a product that is regarded as a container and it normally falls into two categories: supple and rigid. The messenger bag or saddlebag, pouch and purse are generally supple; the satchel, briefcase and tote bag tend to be more rigid. There are also backpacks, which are a derivation of the army bag, and, of course, handbags.

A little history

The oldest bag on record is one that dates back to 3,300 BC and belonged to the famous Iceman, Ötzi, whose body was found in 1991 in the Alps on the Austro-Italian border. It was a type of sack, consisting of an armature made from curved larch and hazel twigs, tied together with grasses. A calfskin belt, with a kind of pocket, was also found on his body.

In the West, the forerunner of the handbag would have been exclusively for men's use. It was worn around the waist and called a "pocket," "purse" or even "money-bag." It was not until the 14th century that women adopted them. But from the 15–18th centuries, larger dresses were the fashion, with hidden interior pockets replacing the waisted purses. Equally, muffs worn by elegant ladies in the 1950s served the same purpose as a handbag, as did the sleeves of the Japanese kimonos.

It was not until the Age of Enlightenment, with its change of lifestyle and mentality, that the bag became an essential accessory in the female wardrobe. After the French Revolution clothes became lighter and more eccentric, sometimes even using semitransparent fabrics, as worn by the famous Madame Tallien. It was during this era that interior pockets disappeared in favor of the handbag. The bag was only commonly termed a "handbag" from the beginning of the 20th century.

An accessory revisited

In this chapter we present a selection of basic models that have been reinvented by designers such as Sonia Rykiel, who was responsible for reviving the tote bag and the Boston (see photos 5, 8, 13 and 14 on these pages). Certain travel bags, such as *Grace* by Philippe Roucou (photo 3), were inspired by plumber's, messenger's and game bags.

1. Cabin luggage, *Airport* by Philippe Roucou, Fall-Winter 2006–2007.

2. Satin and textured leather handbag with adjustable shoulder strap, *Lampas* by Lanvin, Spring-Summer 2006.

3. Messenger bag, *Grace* by Philippe Roucou, Fall-Winter 2006–2007.

4. Handbag, *Chifonana* by Christian Louboutin, Spring-Summer 2005.

5. Large suede tote bag, *Gavroche* by Sonia Rykiel, Fall-Winter 2005-2006.

6. Tote bag, *Van der Rohe* by Philippe Roucou, Fall-Winter 2006–2007.

7. Boston bag, *Iron Bag* by Christian Louboutin, Spring-Summer 2006.

8. Boston bag, *Popeye*, Cruise collection by Sonia Rykiel, Spring-Summer 2006.

9. Clutch bag with chain, *Casino* by Philippe Roucou, Fall-Winter 2006–2007.

10. Rigid handbag, *Tam-Tam* by Christian Louboutin, Spring-Summer 2006.

11. Satin and crystal-studded evening clutch bags, *Venus* by Sonia Rykiel, Spring-Summer 2005.

12. Metal minaudière by Martine Boutron.

13. Mini box bags in patent leather with crystal-studded bows, *Fil Rouge* by Sonia Rykiel, Fall-Winter 2003–2004.

14. Studded handbag, *Lili* by Sonia Rykiel, Spring-Summer 2006.

15. Minaudière, *Manga* by Kazu Huggler, Fall-Winter 2005–2006.

16. Fringed clutch bag, *Louis XIV* by Christian Louboutin, Spring-Summer 2005.

17. Python skin bag, *Ginger* by Sonia Rykiel, Spring-Summer 2006.

18. Knitted basket bags, *Domino* by Sonia Rykiel, Spring-Summer 2005.

19. Knitted bag, *Domino* by Sonia Rykiel, Fall-Winter 2005–2006.

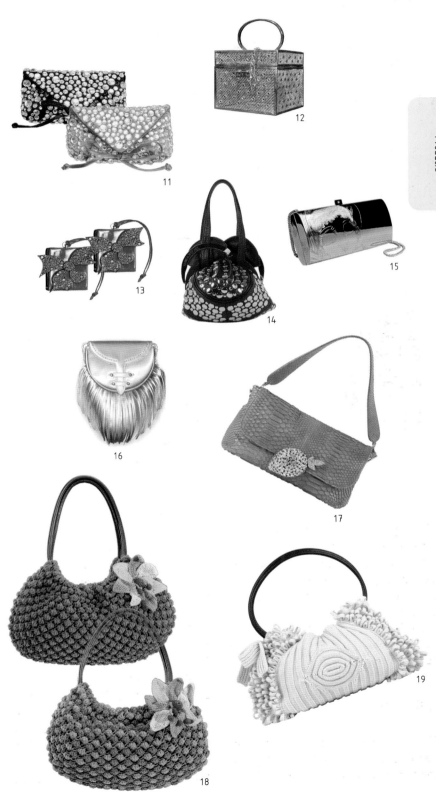

Bag designs

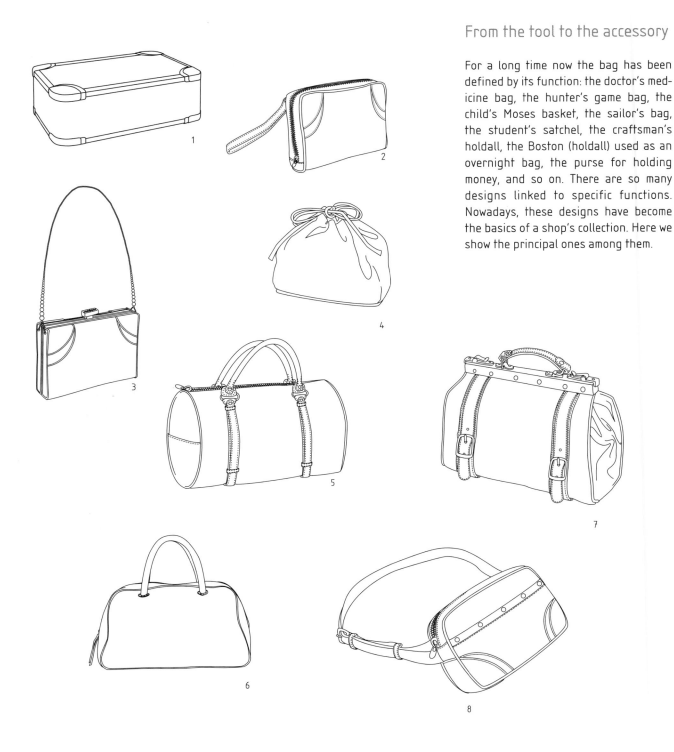

For a long time now the bag has been defined by its function: the doctor's medicine bag, the hunter's game bag, the child's Moses basket, the sailor's bag, the student's satchel, the craftsman's holdall, the Boston (holdall) used as an overnight bag, the purse for holding money, and so on. There are so many designs linked to specific functions. Nowadays, these designs have become the basics of a shop's collection. Here we show the principal ones among them.

9

10

1. SUITCASE

2. MAKEUP OR TOILETRY BAG

3. MINAUDIÈRE (RIGID EVENING BAG)

4. PURSE

5. KIT BAG

6. BOSTON OR HOLDALL BAG

7. MEDICINE BAG

8. MONEY BELT OR FANNY PACK

9. SHOULDER MESSENGER BAG

10. BOSTON OR HOLDALL BAG

11. TOTE BAG

12. BACKPACK

13. HANDBAG

11

12

13

The shoe

1
2
3
4
5
6
7
8

First steps

The shoe is known by many names: slipper, boot, sandal, trainer, and so on. In Spanish cave paintings from as early as 13,000 BC we can find depictions of a man wearing animal-skin boots and a woman in fur boots. Similarly, the Persian funeral vases of 3,000 years ago bear witness to the existence of shoes. We can follow the history of the shoe from Egyptian sandals made from plaited and sewn palm leaves, to Etruscan sandals with their split and segmented wooden soles, to the chopines, or platform shoes, of the 16th-century courtesans.

From the 17th and 18th centuries, the material from which they were made differed according to gender – men generally wore shiny or glossy leather in suede or pigskin, whereas brocade, velvet, satin, beaded or moiré fabric was the woman's prerogative.

After the Industrial Revolution, the middle class, with austere religious principles, could be found wearing sober, black shoes hidden under their long dresses. The mistresses of rich Parisians and actresses, meanwhile, such as those immortalized by Toulouse-Lautrec, lifted up their skirts to reveal high-heeled boots.

The contemporary shoe

After the First World War and women's liberation, the skirt became shorter, showing more leg, and shoes more or less open, in such a way as to define the silhouette of the foot. These shoes were accompanied by gloves and bags. And in 1947, Roger Vivier introduced the haute couture silhouettes with his New Look collection for Christian Dior.

Mary Quant and her muse Twiggy gave birth to a completely new silhouette in 1965, and Charles Jourdan with his prestigious Seducta collection produced a variety of flat shoes in bright colors with geometric patterns. At the end of the 1960s, with the beatnik movement and the return to nature, nylon stockings were rejected in favour of open-toed, wedge-heeled shoes in cork and other natural materials.

In 1971, however, Yves Saint Laurent presented his vintage collection, where he returned to the platform-soled designs of the 1940s.

1. Open-toed platform-soled patent court shoe, *Namur* by Sonia Rykiel, Spring-Summer 2006.

2. Salome shoe with conical heel by Lanvin, Spring-Summer 2006.

3. Satin pumps by Lanvin, Spring-Summer 2006.

4. Ankle boot by Sonia Rykiel, Fall-Winter 2005–2006.

5. Satin court shoe with conical heel by Lanvin, Spring-Summer 2006.

6. Knee-high boots, *Mailla Botta* by Christian Louboutin, Fall-Winter 2004–2005.

7. Moccasin-style court shoe, *Steva* by Christian Louboutin, Fall-Winter 2005–2006.

8. Satin court shoe, *Let's Go* by Christian Louboutin, Fall-Winter 2005–2006.

9. Two-tone trotter shoe with laces in patent calfskin and stainless-steel heel by Lanvin, Fall-Winter 2005–2006.

10. Satin and crystal-studded court shoe with ankle strap and stainless-steel heel by Lanvin, Fall-Winter 2005–2006.

11. High-heeled sandal, *Paramount* by Alexandra Neel, Spring-Summer 2006.

12. Sandal with ankle strap, *Bonny II* by Alexandra Neel, Spring-Summer 2006.

13. Suede mule, *Fame* by Alexandra Neel, Spring-Summer 2006.

14. Platform-soled and wedge-heeled sandal, *Capri Zeppa* by Christian Louboutin.

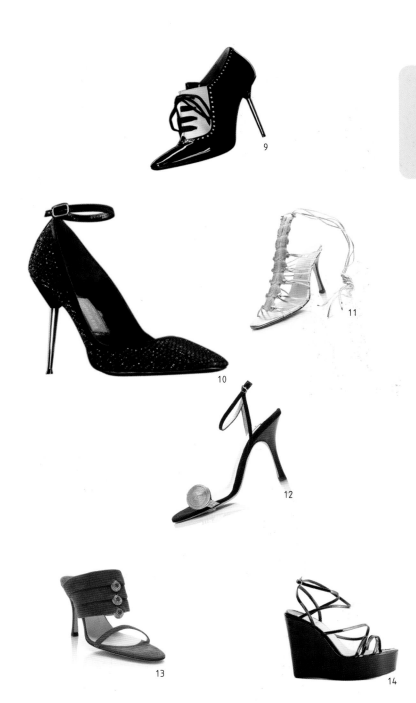

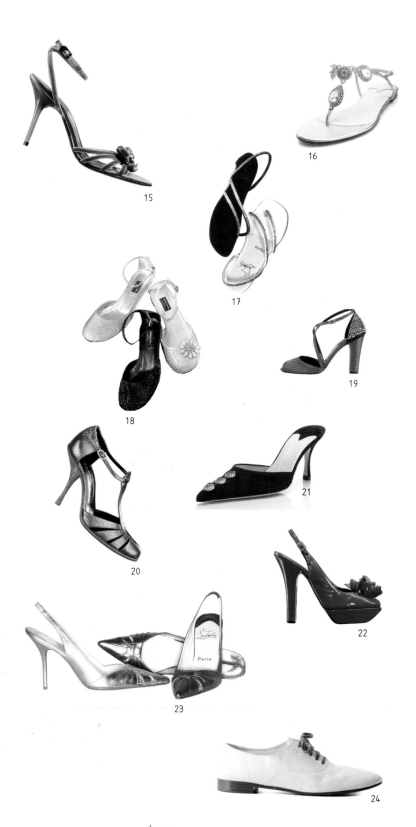

Shoes today tend to define a character, a style, or a manner more than an era. The fetishists have seized upon the stiletto heel; the moccasin, a classically English style, is often revisited; the Salome and court shoe characterize French elegance, platforms the avant-garde and thigh-high boots eroticism, with history and world cultures remaining a constant inspiration for new footwear designs.

Here we have chosen a selection of designs by Alexandra Neel, Christian Louboutin, Jeanne Lanvin and Sonia Rykiel to illustrate the basic principles.

15. Stiletto-heeled sandal in leather and velvet with ankle strap by Sonia Rykiel, Fall-Winter 2004–2005.

16. Tropézienne sandal, *Caymen* by Alexandra Neel, Spring-Summer 2006.

17. Crystal-studded strap sandals, *Star-Line* by Christian Louboutin, Spring-Summer 2005.

18. Leather and crystal-studded Salome by Sonia Rykiel, Spring-Summer 2005.

19. High-heeled Salome in patent leather with crystal-studded counter, *Navarre* by Sonia Rykiel, Spring-Summer 2006.

20 Tango shoe in iridescent leather by Sonia Rykiel, Fall-Winter 2005–2006.

21. Mule, *Light* by Alexandra Neel, Spring-Summer 2006.

22. Open-toed, patent-leather, platform-soled Salome by Sonia Rykiel, Fall-Winter 2004–2005.

23. Salome, *Metallica* by Christian Louboutin, Fall-Winter 2004–2005.

24. Leather man's shoe, *Fred* by Christian Louboutin, Spring-Summer 2006.

Shoe styles

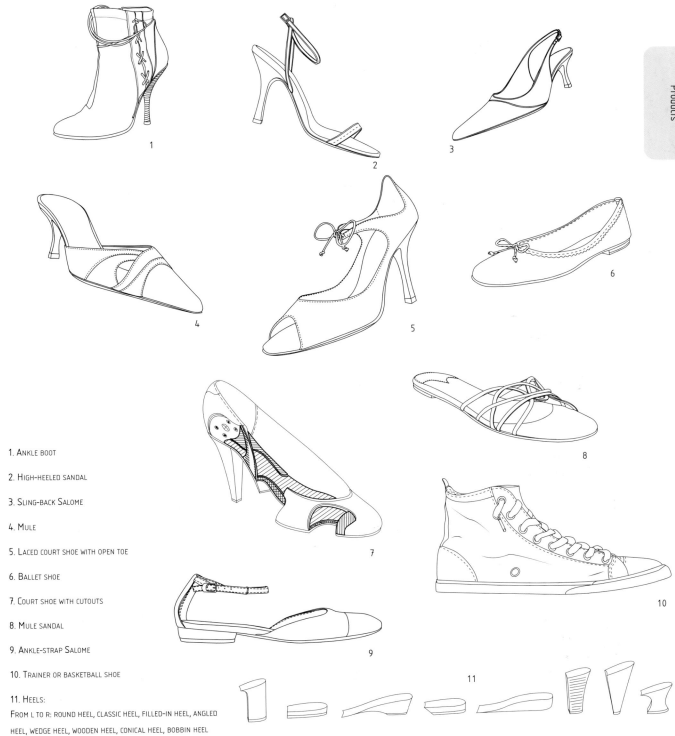

1. ANKLE BOOT

2. HIGH-HEELED SANDAL

3. SLING-BACK SALOME

4. MULE

5. LACED COURT SHOE WITH OPEN TOE

6. BALLET SHOE

7. COURT SHOE WITH CUTOUTS

8. MULE SANDAL

9. ANKLE-STRAP SALOME

10. TRAINER OR BASKETBALL SHOE

11. HEELS:
FROM L TO R: ROUND HEEL, CLASSIC HEEL, FILLED-IN HEEL, ANGLED
HEEL, WEDGE HEEL, WOODEN HEEL, CONICAL HEEL, BOBBIN HEEL

The scarf and the bow tie

1

2

3

4

Shapes and sources of inspiration

The scarf has the dual function of being both ornamental and protective. It always has a simple geometric form — triangular, rectangular or square — and can be made with a variety of finishes (rolled edge, straight edge, fringed, embroidered, etc.) and decorated with all sorts of patterns using a rich assortment of fabrics.

At the beginning of the 20th century, Paul Poiret mainly used the fabrics foulard and chiffon, both of which possessed an oriental aesthetic in his collections. In the 1920s, Sonia Delauney designed a number of scarves with geometric patterns in collaboration with the couturiers of that era, notably Coco Chanel.

The notion of the Orient and, more significantly, the idea of travel, is still associated with this accessory. The "Lawrence of Arabia" style, with his long white scarves, has inspired couturiers for decades. Illustrations of the first cars showed women dressing up their clothes with long scarves, which would either protect their hairstyle or keep their hat in place.

The 19th-century paintings of the Empress Elisabeth of Austria-Hungary show her riding sidesaddle, dressed in her shawls, illustrating the stylishness of this accessory. Continuing with the equestrian connection, the Ascot tie and the *lavallière*, or floppy necktie, are also associated with the riding world.

The revival of these accessories

The way in which the scarf is worn, or tied, is in fact the essence of style. It is hard to imagine Madame Grès without her turban. This accessory, which is midway between a hat and scarf, was inspired by a knotted scarf, thus defining its style forever. In the 1970s, during the "hippie" period, Brigitte Bardot and Claudia Cardinale wore scarves under cowboy hats in the film *The Legend of Frenchie King* (1971).

Didier Ludot's stole (Fig. 1) sends us back to the 1950s when it was usual to coordinate it with a muff. Hitchcock's women, such as Tippi Hedren and Grace Kelly, were portrayed at the wheel of a convertible, sporting sunglasses and

scarves that epitomized ultimate glamor. Today, scarves have taken on a sexy look, as with Sharon Stone's long silk versions. The scarf is a common theme in Hermès collections, as each season they revive the twill squares with their anchor patterns for the Spring-Summer collections, and the equestrian ones for Fall-Winter. These types of scarves were normally associated with the classic woman —Jackie Kennedy Onassis being a perfect example. However, to give them a contemporary slant, they can be tied around a handbag, dressed up with a piece of jewelry or worn like a bandanna. The latter, with its paisley designs, is available in numerous colors. In the 1980s, it was the accessory of choice for the Blood and Crips gangs of Los Angeles, immortalized in the film *Colors* (1988) with Sean Penn and Robert Duvall.

The scarf can also be used as another type of accessory such as a strap fastening on a handbag, or a belt.

Alexis Mabille's bow ties, shown on this page, illustrate another variation of the scarf; today, designers have also turned them into belts, cuffs, brooches and even hair accessories.

5

6

7

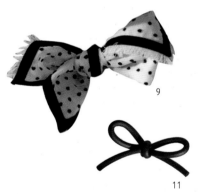
8

9

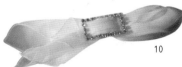
10

11

12

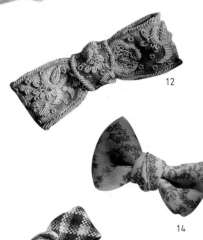
13

14

1. DIDIER LUDOT STOLE.

2. DIDIER LUDOT SCARF.

3. YVES SAINT LAURENT SCARF.

4. YVES SAINT LAURENT HEAD SCARF.

5. HERMÈS SQUARE.

6. CHANEL SQUARE.

7. CHANEL SQUARE.

8. HERMÈS SQUARE.

9. *MICK*, VELVET KNOTTED HANDKERCHIEF WITH DOTTED SWISS PATTERN BY ALEXIS MABILLE.

10. *MADONA*, ORGANZA HANDKERCHIEF WITH JEWELED BUCKLE BY ALEXIS MABILLE.

11. *KATE*, RUBBER BOW BY ALEXIS MABILLE.

12. *IGGY*, FLAT SILK BOW WITH GOLDEN EMBROIDERY BY ALEXIS MABILLE.

13. *PAUL*, CLASSIC TARTAN BOW TIE BY ALEXIS MABILLE.

14. CLASSIC CASHMERE EMBROIDERED BOW TIE BY ALEXIS MABILLE.

Eyewear

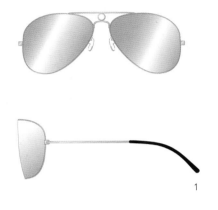

1

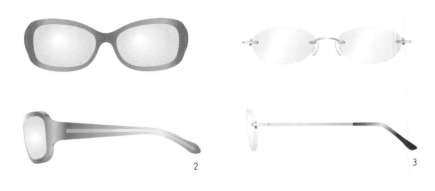

2

3

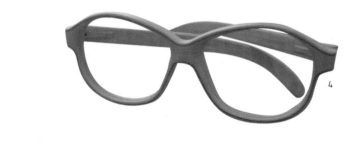

5

6

7

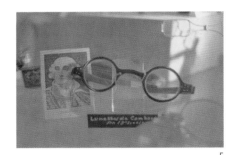

4

Pierre Marly, Georges Lissac's right-hand man in the 1960s, was the first designer to regard spectacles as fashion accessories, rather than just necessary optical prostheses. So, a new accessory was born as he proposed a range of audacious colors, along with creative designs, that took them far away from the familiar, traditional models.

The ones designed for Audrey Hepburn (Fig. 8), which she wore in *Charade* (1965), propelled spectacles into the limelight. He also designed a pair for Sophia Loren which were square with white frames, known as "Sophia Sport" – the inspiration derived from a television set. The pair designed for Michel Polnareff (Fig. 11) became the singer's trademark.

Frame materials

For a long time, horn-rim, and specifically, tortoiseshell, was the preferred material of spectacle manufacturers. This was due to its extreme lightness and the fact that it could be polished to a high finish. The lighter the color, the more expensive it was. It demanded a specific skill to produce and there are only three remaining artisans who still work this material, of which two are in Paris. Nowadays, however, it has become outlawed in most countries, with tortoiseshell being replaced by buffalo horn or synthetic substitutes.

Frames are normally made from acetate, which is a plastic that can be cut and is better quality than injected plas-

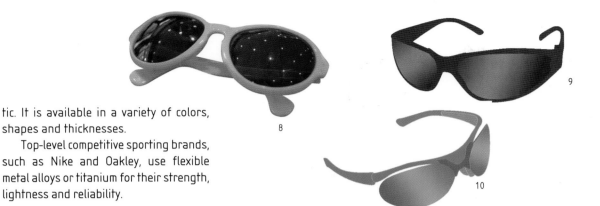

tic. It is available in a variety of colors, shapes and thicknesses.

Top-level competitive sporting brands, such as Nike and Oakley, use flexible metal alloys or titanium for their strength, lightness and reliability.

Glass technology

Brands such as Nike and Oakley are among the most innovative. They offer glass that is interchangeable, polarized, antimist and has a surface that allows water to slide off it. Oakley has even integrated MP3 and Bluetooth technology into their glasses!

There are four intensities of protection: one for resting and indoors, a tinted glass for aesthetics; classic intensity (which filters 65–70 percent of light); and maximum filter intensity of 85 percent light. To combat UV rays, polycarbonate glass is used more and more.

Shapes

Inspiration for basic shapes has come from a number of sources, such as the military – like the Ray-Ban sunglasses design for the US Air Force – or the artisan sector (like the welder's glasses in Fig. 13), or even top-level sporting competitors (Fig. 9). Highly original shapes are reminiscent of diving masks, alpine hunters' sunglasses or those of the GIs in the desert. The fly, with its multifaceted eyes, inspired the disproportionate glasses in Figure 2 which have become one of today's classics.

1. METAL-FRAMED AVIATOR GLASSES.

2. BUTTERFLY-SHAPED SQUARE GLASSES WITH PLASTIC FRAMES BY PIERRE MARLY.

3. RIMLESS OVAL GLASSES BY PIERRE MARLY.

4. WOODEN-FRAMED GLASSES, PIERRE MARLY COLLECTION.

5. TORTOISESHELL-RIMMED GLASSES, PIERRE MARLY COLLECTION PRESENTED IN HIS BOUTIQUE IN RUE FRANCOIS 1ER (PARIS 8th ARRONDISSEMENT).

6. BINOCULARS, PIERRE MARLY COLLECTION PRESENTED IN HIS BOUTIQUE IN RUE FRANCOIS 1ER (PARIS, 8th ARRONDISSEMENT).

7. ARMLESS GLASSES, PIERRE MARLY COLLECTION.

8. ROUND-SHAPED *AUDREY* DESIGN WITH CURVED GLASS, PIERRE MARLY 1965.

9. STREAMLINED COMPETITION GLASSES.

10. STREAMLINED COMPETITION GLASSES.

11. SPECTACLES WITH OVERSIZE FRAMES AND LARGE SQUARE GLASS, *MICHEL POLNAREFF* DESIGN, PIERRE MARLY 1970s.

12. U.S. AIR FORCE AVIATOR GLASSES BY RAY-BAN.

13. PLASTIC WELDER'S GLASSES. OLIVIER GERVAL COLLECTION.

14. TENNIS RACKET GLASSES BY PIERRE MARLY.

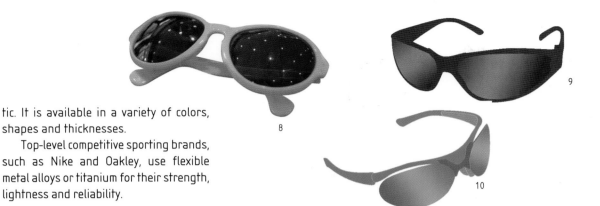

Hats and hair accessories

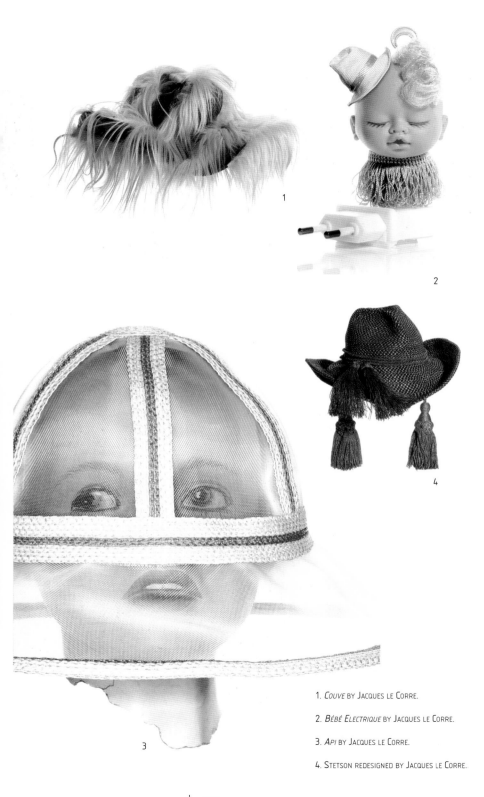

1. *Couve* by Jacques le Corre.

2. *Bébé Electrique* by Jacques le Corre.

3. *Api* by Jacques le Corre.

4. Stetson redesigned by Jacques le Corre.

Eras and moods

The hat, which for a long time was only associated with the aristocracy, now easily calls to mind swashbuckling films. Hats differentiate between the social classes of the 19th century — with the worker's flat cap and the nobleman's top hat — as well as conjure up moods. For example, the "so very British" bowler hat, or the boater-wearing picnickers on the banks of the River Marne depicted in paintings by Renoir and Manet. In the same vein, Marc Jacobs' *Gavroche*, or urchin hat, which he designed for Louis Vuitton in his 2006–2007 Fall-Winter collection, is redolent of this feeling. Coco Chanel evokes a similar mood by giving the boater a particularly feminine aesthetic. New styles are created from the lasting legacy of the hats of colonial days. The beret, for example, whether it be Basque or military, when coordinated with a tartan kilt and cardigan creates the eternal student look.

Couturiers, who established the diktat that a woman could not go out without a hat, gloves and handbag, can themselves be associated with a particular era and be a source of nostalgia. The photographs of Bettina Graziani, the famous model for Jacques Fath and Christian Dior, have immortalized the New Look style where the hat crowned the silhouette. The cloche hats of the 1920s require a particular type of elfin face, with the nose and the chin slightly turned up to give the desired effect. Jacques le Corre knew how to reinvent this accessory with his "tramp's hat" in 1988. Here, he used a colored viscose, which hides the nose, in conjunction with traditional techniques that replaced straw (Figs. 3 and 6). In his research, Jacques le Corre placed the emphasis on the material, with

plaited viscose straw in gold, silver or shiny black. Attracted to the unusual, his choice of materials for accessories are often those intended for garments, such as glossy, striped fabrics, denim or even previously unseen animal skins (e.g., metallic toad skin). He also often uses fringes of feathers. He is inspired by men's hats such as the trilby, panama, Stetson or cowboy hat, as well as various caps (gentleman farmer, military, etc.), and adapts them into women's headwear.

Infinite sources of inspiration

Today the hat is an essential part of the uniform of the religious fraternity, the army, and of employees in large stores in the United States and Japan. Military uniforms and the headwear of nuns have inspired Jean Paul Gaultier for a number of his fashion shows.

Moreover, every designer derives inspiration from the different cultures around the world, whether it be the hats of Asian rice farmers, woven Tibetan or Andean bonnets, or Russian *chapkas* (fur caps with flaps). Paris Hilton made the Stetson (Fig. 4), which developed from the Mexican sombrero, the latest "must-have" accessory.

Sport is the other major source of inspiration. The baseball cap is widely used in Jean Paul Gaultier's collections, where it is given a type of roguish charm, and by Gucci, who added his monogram, thus rendering it a luxury product. Other headwear, such as the sailor's cap or riding hat, is often revisited to accessorize a fashion show.

Beyond the hat

Hair accessories such as combs, barrettes and ribbons, simple as they might seem, can themselves become fashion accessories – the proof being the chignon pins by Odile Gilbert (Fig. 5). Another example is Robert Goosen's multicolored flower hairband, designed by Marc Jacobs for Louis Vuitton's fashion show in July 2006.

Even a hairstyle can play the role of an accessory, as the blond chignon worn by Simone Signoret in Jacques Becker's film *Casque d'or* (1932) testifies.

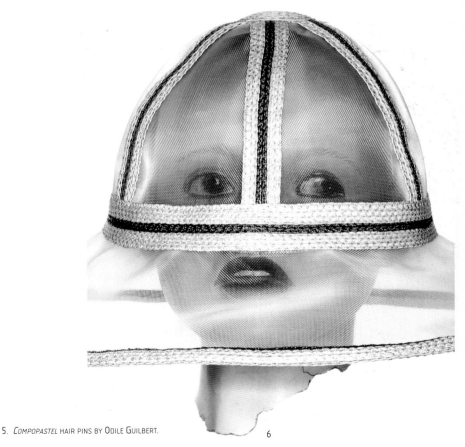

5. *Compopastel* hair pins by Odile Guilbert.

6. *Api* by Jacques le Corre.

Hat and belt designs

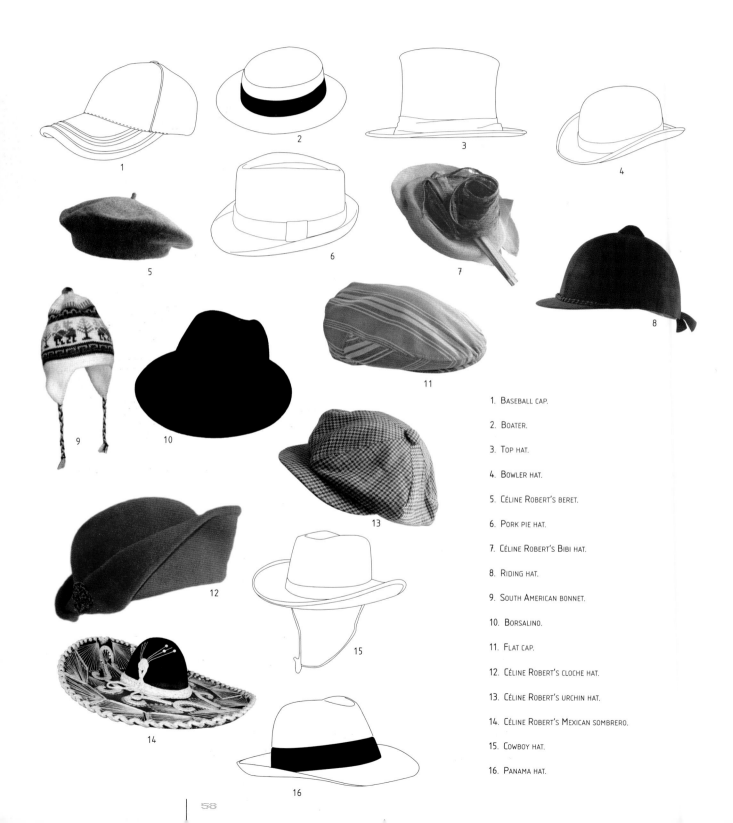

1. BASEBALL CAP.

2. BOATER.

3. TOP HAT.

4. BOWLER HAT.

5. CÉLINE ROBERT'S BERET.

6. PORK PIE HAT.

7. CÉLINE ROBERT'S BIBI HAT.

8. RIDING HAT.

9. SOUTH AMERICAN BONNET.

10. BORSALINO.

11. FLAT CAP.

12. CÉLINE ROBERT'S CLOCHE HAT.

13. CÉLINE ROBERT'S URCHIN HAT.

14. CÉLINE ROBERT'S MEXICAN SOMBRERO.

15. COWBOY HAT.

16. PANAMA HAT.

19

20

21

17

18

17. FROM TOP TO BOTTOM: WIDE BELT, SLIDING BELT AND RIVETED BELT.

18. BELT WITH ORNATE BUCKLE.

19. BELT WITH ROUNDED BUCKLE.

20. BELT WITH FINE BUCKLE.

21. CLASSIC MEN'S DRESS BELT WITH RIVETS.

Jewelry

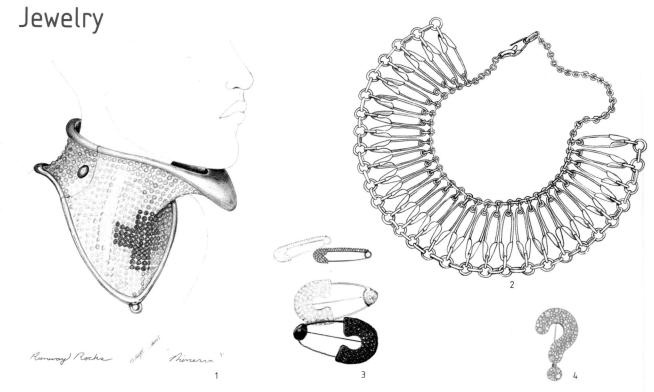

Runway Rocks

'Minerva'

1

3

2

4

5

6

The origins

The need to adorn oneself with jewelry dates back to prehistoric times: there were pendants, rings made from bone, stone or oval-shaped ivory, and jewelry made from feathers, vegetable fibers or fish bones. These types of feather and stone arrangements can be seen in the work of Elena Cantacuzène in Chapter 1 (pp. 38 and 39). Then with the mastery of metalwork around 2,500 BC, gold and copper bracelets began to be decorated with geometric patterns.

The ancient Egyptians developed the art of stone setting, wearing bracelets, tiaras, chokers and necklaces with religious symbols. Similarly, Elena Cantacuzène has been inspired by this era – she has used turtles as clasps, and adapted the scarab beetle, sacred to the Egyptians, into chokers and bangles in silver, gold and bronze. We have to wait until the Greek era, from the end of the fourth century, before a significant evo-

lution takes place, and this is when jewelry for the masses ceases and it becomes reserved for nobility and the clergy.

Raw materials and techniques

Other than stones and precious metals worked by jewelers and goldsmiths, and cultured pearls which, nowadays, originate in Japan, the principal material used for jewelry in the fashion world today is "strass," or crystal. This is a type of lead crystal, colored with oxides, that owes its invention to Georges Frédéric Strass (1700–1773). Other materials include steel; glass gilded with metal; silver or gold leaf; iron, which has been used in jewelry since the beginning of the 19th century; and Swarovski crystal, which is a synthetic form of crystal developed by Daniel Swarovski (1862–1956).

Various types of jewelry

A type of necklace known as the Rivière was in vogue at the end of the 18th century. It consisted of links of precious stones and was made famous by Alexandre Dumas' (1802–1870) novel *Le collier de la Reine* in 1849. This was a historical novel based on Marie Antoinette, the great 18th-century bourgeoisie, who reveled in this type of adornment. Betony Vernon has transformed this necklace into a fetish accessory by replacing the stones with a series of diaper pins linked together (Fig. 2). Embellished with crystals in Figure 3 by Sonia Rykiel, these pins reveal the liberated woman who wears them.

The cameo technique dates back to antiquity. It consists of carving patterns, often the profiles of men and women, onto shells in different-colored layers that are superimposed. The cameo, which was perhaps best known during the reign of Napoleon III, is now a classic. Queen Victoria particularly favored this type of jewelry, giving it an English feel. Worn as a pendant, ring or brooch, it has been adopted by contemporary designers such as Yazbukey (Figs. 14 and 16, p. 62). The use of steel by English goldsmiths at the end of the 18th century heralded the advent of large, ostentatious jewelry during the Victorian era (1837–1901), in the form of extravagant earrings, watches and other accessories that counterbalanced the somewhat somber and austere clothing of that period. This kind of jewelry appealed to a certain type of man, notably the dandy, incarnated by Oscar Wilde, and it is in this spirit that Marc Jacobs has designed men's accessories that have, up until now, only belonged in a woman's wardrobe.

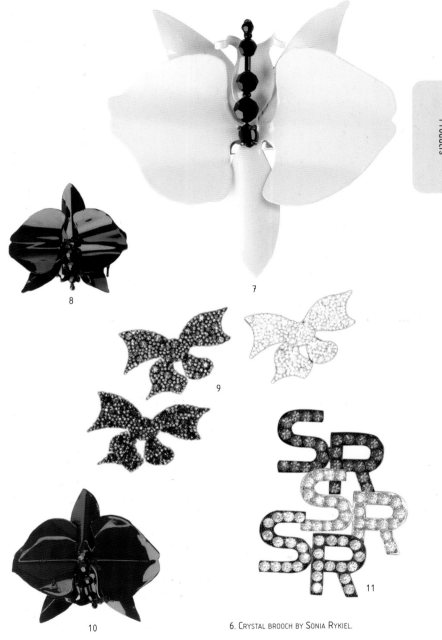

1. METAL AND CRYSTAL *SWAROVSKI* COLLAR BY BETONY VERNON.

2. *FERRÉ*, DIAPER PIN RIVIÈRE NECKLACE BY BETONY VERNON.

3. CRYSTAL BROOCHES BY SONIA RYKIEL.

4. CRYSTAL BROOCH BY SONIA RYKIEL.

5. SILVER CHOKER BY BETONY VERNON.

6. CRYSTAL BROOCH BY SONIA RYKIEL.

7. PAINTED METAL AND LUSTERED CRYSTAL BROOCH BY LANVIN.

8. PAINTED METAL AND LUSTERED CRYSTAL HAIR CLIP BY LANVIN.

9. METAL AND CRYSTAL BROOCH BY SONIA RYKIEL.

10. PAINTED METAL AND LUSTERED CRYSTAL BROOCH BY LANVIN.

11. CRYSTAL BROOCHES BY SONIA RYKIEL.

12

13

14

15

16

17

18

19 20 21 22 23

Inspirations

The Art Nouveau period, epitomized by Lalique at the end of the 19th century, used glass that had been molded, reworked and polished as the material of choice for jewelry. This style gave a degree of flexibility to rigid materials such as metal or glass. Art Deco jewelry, with its geometric patterns, drew inspiration from Africa, Cubism and the Russian Ballet.

In the same spirit as the Bauhaus, Karl Fabergé (1846–1920), heir to the famous jewelry and goldsmith family, tended to distance himself from the objet d'art in order to create a piece of jewelry that was a beautifully crafted luxury object in its own right.

The Fabergé egg is, in fact, a symbolic jewel. It was created by Fabergé for Tsar Alexander III at Easter. Each year he would design a new egg, with a different function each time – a musical box, a watch and so on. More than just a container, the object became a piece of jewelry.

The rococo period (the term being a fusion between the French word *rocaille*, meaning shells or rocks, and Barocco) occured during the court of Louis XV. It was here that the distinction was established between day and evening jewelry. The pâte-de-verre and shell-like jewelry of Loulou de la Falaise (Fig. 24) sends us back to this fantastic era.

By the same token, Yazbukey revisit Marie Antoinette's period with their costume jewelry (Figs. 12, 18 and 20), by reworking the toile de Jouy patterns of the late 18th century and producing them in pastel colors. Still with reference to this period, their multicolored perspex necklace (Fig. 13), among others, has been influenced by a resurgence of ribbons and bows.

Today, virtually every label offers some form of jewelry to complement their women's collection. Examples include Sonia Rykiel, who designs accessories that exude glamor; Alber Elbaz for Lanvin, who works fabric into metal or plastic creating veritable works of art; Yaz and Emel of Yazbukey, who revisit the jewelry of their childhood; and Betony Vernon, who creates fetish jewelry.

12. *Balloon* drop earrings by Yazbukey.

13. Garland necklace by Yazbukey.

14. Single-strand choker with cameo-style pendants by Yazbukey.

15. Choker decorated with narcissus and strawberries by Yazbukey.

16. Baroque brooch with bow by Yazbukey.

17. Single-strand necklace by Yazbukey.

18. Heart brooch by Yazbukey.

19. *Cygnes* bangle by Yazbukey.

20. Heart-shaped bangle with ribbon pattern by Yazbukey.

21. *Narcisses* ring by Yazbukey.

22. Bangle decorated with ladybugs and red fruits by Yazbukey.

23. *Narcisses* ring by Yazbukey.

24. Pâte de verre and shell wraparound necklace by Loulou de la Falaise.

25. Pâte de verre and crystal brooch by Loulou de la Falaise.

26. Tousled necklace in black, red and turquoise coral by Loulou de la Falaise.

27. Drop earring in metal with semiprecious stones of tourmaline, amethyst and citrine.

28. Bamboo coral ring decorated with an amethyst and silver ladybug.

29. Collection of multicolored lacquered bracelets by Loulou de la Falaise.

24

25

26

27

28

29

Competition between brands encourages product diversification. For example, a bag can also be a belt, a garment becomes a bag. New designs enter our consciousness subliminally, triggering a desire to acquire those that we believe have been created especially for us. This "déjà vu" impression of familiar yet different objects, that are renewed each season, is the result of meticulous work by designers. With the accessory, the designer's work is directed more toward the product and brand concept. They know how to put together everything we think we desire, in the creations with which we identify ourselves. Designers act as visionaries, knowing how to select, arrange information and anticipate our wishes, subtly making us believe we want a particular product. Eventually, we surrender, while they are already elsewhere, working on the next collection.

Working in teams, designers determine and illustrate the "story" for the new collection with the aid of visuals and mood boards. Inspirational photos are presented, along with potential materials and colors for the products. Color ranges are organized into colorways, and materials are selected and proposed for the strongest designs. Patterns can also be presented at this stage.

Designers collect, rearrange and assemble information, drawing inspiration from a variety of sources that result in new collections. Using iconographic research, they collect photos from magazines to inform shape, material and color. This is an essential part of the design process, as an image has the ability to illustrate a concept immediately. The personality of the woman – whether she is glamorous or androgynous, for example – can also emerge from these images.

The following pages offer a snapshot of the research carried out by designers while they develop a theme, which in turn defines the collection's direction. Behind the superficial aesthetic of this research is a wealth of background work: for example, Christian Louboutin's and Elisabeth Guers' mood boards, Louis Vuitton's patterns, and so on. The different materials and so forth are also rigorously and thoughtfully researched, demanding just as much work, and requiring a great deal of intuition, practical knowledge and a professional eye.

Style results from a designer's own expression combined with his or her sensitivity, vision and individual approach to shape, color, volume and fabrics. Each collection can be viewed as a film, or book into which the whole design team immerses itself. The creative director is the director, with each mood corresponding to a

part of the storyboard, which, in its entirety, allows us to understand the collection and the message it is trying to convey.

In the first instance, the creative director and his or her team reveal the essence of the story: for example, Marie Antoinette and her luxurious wardrobe. Naturally, artistic license applies for the designer is not expected to remain steadfastly true to historical fact. What is important in a collection is the detail, which is "romanticized" by the designer. It is this fantasy of condensed history that gives the collection magic, making it more than just a collection of unoriginal theater costumes. This is also why a theme completely devoid of any historical roots, such as the "British Amazon" for example, is almost simpler to develop, as it depends mainly on materials and finishes such as buckles and belts, etc.

Once the designers have decided upon a particular idea or theme, other ideas will be built around them. The creative director submits these designs to the marketing director, who will then select products that create a balance within the collection plan.

With accessories, a multitude of collections, known as lines, are proposed, which are identifiable by their materials, finishes and patterns. Contrary to what happens in the prêt-a-porter world, accessory shapes are heavily influenced by trends; the originality of these products is in the craftsmanship afforded to their manufacture, as well as the innovative use of materials and colors.

This specificity implies that the accessory designer must have a good working knowledge of the technical aspects of manufacture. In this chapter, designer Elisabeth Guers shows us the different manufacturing methods involved in the production of her shoe collections. According to her, the work of a designer can be likened to that of the tightrope walker, in that designer aims to find a balance between the expression of an idea, its production and its marketing. As trends and marketing can be contradictory, sometimes the designer must make allowances for these factors when creating a product. The creative director and the designer must clearly define their target markets before beginning to develop a collection or product. In order to do this, it is important to travel extensively, not only for inspiration but also in order to study different markets such as Paris, Tokyo, London, New York or Milan. This has certainly been the case for Elisabeth Guers, who traveled the world as she designed her collections for Jimmy Choo, Maud Frizon, Sergio Rossi, Céline and Thierry Mugler.

Moods, colors and materials

1

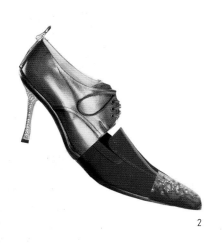

2

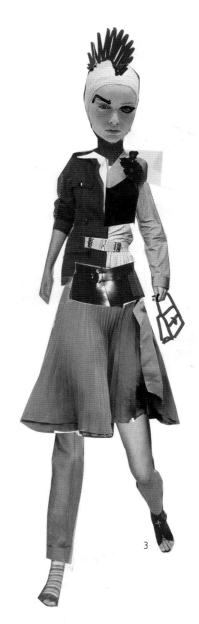

3

Inspirations

Freelance designer Elisabeth Guers clearly explains how she decides on a trend, and why she chooses the visuals, colors and materials she does.

By working on moods and colors simultaneously, she illustrates her initial color selections by means of visual mood boards. This presentation is achieved by using material samples from leading manufacturers, sourced from Italian and French trade shows.

She uses Bristol board to present her themes and colors, on which the label, season and material references are also cataloged. The mood boards she produced for Calvin Klein in 2001 (Figs. 4 and 5), and her collages of the main products for the pre-Winter season 2002–2003, are also accompanied by written descriptions.

Contrasts

The starting point for Elisabeth Guers' designs is her assessment of what will be essential products for the forthcoming season. She will then gather that information together and cut and paste it onto a silhouette. By mixing and matching this patchwork of images, the foundations of the new season's must-haves are laid down. The silhouette to the left combines punk with the somewhat conservative spirit of the small handbag, successfully demonstrating the cultural cross-referencing of these "compositions."

The caricature-like feel of these collages accentuates the themes' essence and storyboards – exaggeration being essential. For Elisabeth, there is a fine line between beauty and the grotesque, as she feels this is determined by one's

1. COMBINATION OF QUIRKY COLLAGES, MASCULINE/FEMININE, SPORT/SOPHISTICATED, HEAVY/SLICK. IT PORTRAYS A SNAPSHOT OF THE FASHION WORLD'S CONTRASTS AND FREE SPIRITS IN ONE GO.

2. MASCULINE/FEMININE COLLAGE, MOCCASIN/BROGUE, CHANEL TOE AND BEJEWELLED HEEL. HERE, AS WELL, THE ASSOCIATIONS REFER TO THE CONTRASTS WHICH INSPIRE FASHION.

3. THIS COLLAGE REPRESENTS SEVERAL THEMATIC COMBINATIONS: THE SEASON'S MAKE-UP, BELTED MILITARY-STYLE JACKET, WIDE BELT WORN ON THE HIPS, FLARED SKIRT WORN OVER DRAINPIPE JEANS WITH OPEN-TOED SHOES (IN WINTER?!).

4 & 5. THE TWO MOOD BOARDS ILLUSTRATE MONOCHROME COLOUR PALETTES, ONE IN WARM TONES, THE OTHER IN NEUTRAL TONES. THEIR RESPECTIVE THEMES BEING 'FUSION' AND 'SHADOWS'. THE COLOUR SWATCHES ARE STAPLED TO THE BOARDS WITH THE NAME OF THE FABRICS AND COLOUR REFERENCES.

4

5

culture and sensitivity. Her themes are inspired by personal desires, moods and images, as she allows herself to be guided by her instinct and senses. It is in the discrepancies between materials and proportion, that the unexpected shows itself. She is particularly drawn to the association of themes and contradictory images, such as alleged ugliness and alleged beauty; crude, almost vulgar, materials combined with an element of sophistication. She then researches different compositional elements which enable her to tell her "stories."

The theme entitled "Shadows" (Fig. 5) shows the interplay of light and dark constructed around metallic, textured and iridescent materials. In order to give the colors a feminine aspect they have been highlighted as an eyeshadow on the second board — the choice of visuals is determined by this interplay. The smooth, lustous skin of the women in these photos contrasts strongly with the hard, raw look of the other elements in Figures 4 and 5. Some of the colors from each palette will be used for the collection.

The "Fusion" theme in Figure 4 has been inspired by fire. Here, warm, orangey and coppery colors are proposed. This range of spicy tones, chosen for the pre-Winter collection of 2002–2003, is softened by some more somber tones. The colors refer to tanned summer skin tones, evoking a sensation of heat.

Elisabeth Guers tends to choose women's faces to express a particular sensuality in her collections. Due to her love of contrasts, she has selected a face that is wild, yet sophisticated, associating it with a wintry undergrowth scene (Fig. 4). This improbable link gives a certain ambiguity to the theme. The style of these very different elements — femininity on the one hand, with high-heeled shoes and a crude, "masculine" leather belt on the other — emphasizes these contrasts. The three-dimensional effect created by these objects breathes life into these boards.

Mood and sketches

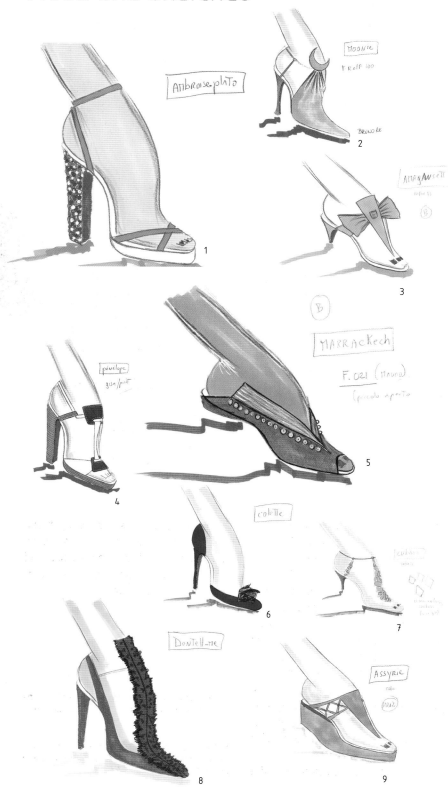

Ambroise-plato

1

Moonie
F. Rolf 100
Bruno Re
2

AmAgAnsett
3

MARRAcKech
F. 021 (mauro)
(piccolo aperto
5

penelope
4

colette
6

cutouts
7

Dentelle
8

Assyrie
9

Mood board

After preliminary research, the designer can introduce, to greater or lesser extents, elements of current affairs, musical and artistic trends, and his or her own personl interestes. This information-gathering exercise is "documented" by means of a mood board, which gradually determines the direction, mood and general feel of the collection, its lines and details. Its main aesthetic characteristics are presented here in a harmonious fashion. A balance is created on the board between empty and full spaces, images and text, and the choice of colors – every element has some significance.

Christian Louboutin's board (Fig. 10, opposite page) illustrates his interest in architectural detail. While observing elements of Islamic-style lattice or fretwork screens, he was inspired to design a shoe buckle in the same vein. Likewise, the Rolling Stones concert ticket displays an interesting color combination. The inclusion of random comments such as "PS: Call Dita before 7 o'clock," or "Go to the Rousseau exhibition before the end of June!" demonstrates how the designer draws inspiration from everyday life.

Details such as the tassel-trimmed heel and whimsical buckle contribute to the theme of the product. A small sketch of the *Robocopina* court shoe, in the bottom left-hand corner of the mood board, shows the importance of "cutouts" on the shoe. A piece of black satin, embroidered with gold thread and sequins and originating from an 18th-century mule, and a photo of leopard skin define the spirit of the materials.

Christian Louboutin chooses his favorite by encircling it with a red heart, noting next to it the necessary modifica-

10

tions. Historic references are revisited, inspirational elements are reinterpreted in a flash, and the proportions, sizes, finishes, materials and colors are all suggested.

Style and drawing

In order to personalize a product, the designer needs to find one or more original elements that will undeniably distinguish it from the competition. Christian Louboutin has, for example, chosen the color red for the soles of all his shoes. This detail has now become his trademark or signature.

Figures 1 to 9 show the importance of marker pens in the production of roughs. It is also important to have a good understanding of anatomy, so that the correct arch, or instep, is achieved when designing high-heeled shoes.

Three-dimensional roughs, which are a necessity for handbags and other leather goods, require a false perspective in order to convey a sense of depth in the illustration. With jewelry, the drawings require much more technique in order to represent each face of the object, i.e., plan, sides and underside view.

In all cases, it is important to master

the techniques of rendering light and shadow, both freehand and computer-aided. Some of the color marker and Photoshop techniques are explained at the end of this chapter.

1 TO 9. SHOE ILLUSTRATIONS MADE BY CHRISTIAN LOUBOUTIN USING A MARKER PEN, FOR HIS SPRING-SUMMER 2006 COLLECTION.

10. MOOD AND INSPIRATION BOARD 50 X 64 CM MADE BY CHRISTIAN LOUBOUTIN, FOR RODARTE'S SPRING-SUMMER FASHION SHOW IN 2007.

Themes and designs

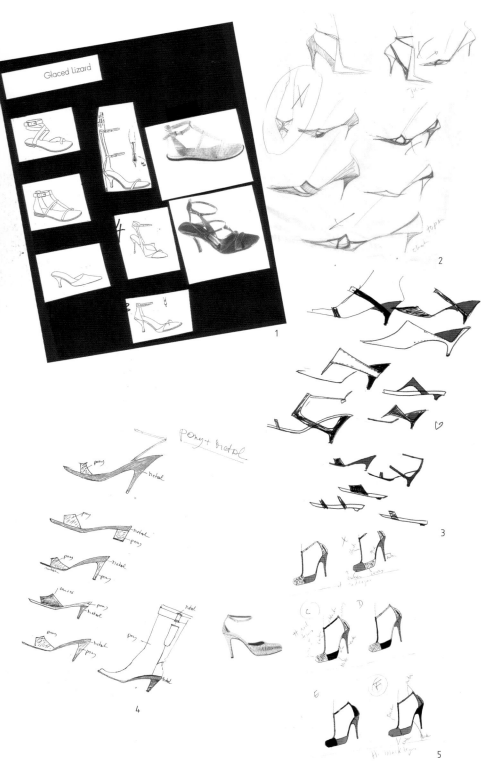

Glaced Lizard

1

Pony + metal

2

3

4

5

Elisabeth Guers uses quick, instinctive sketches as preparation for her design work. From these, a few are selected that will ultimately make up the collection plan. These sketches give a general idea of the themes that have inspired her. This type of rapid design development is an essential part of the design process, so, by working closely with the heel maker, the final shape of the shoe comes to life. Elisabeth also includes photographs as a means of research, such as those that she took of an illustration by Antonio Lopez (Fig. 8).

The technical drawings (Fig. 1) made subsequently are much tighter and colder, having lost some of this creative spontaneity.

The finished drawings do not always allow for the development of as many variants as the sketches. The design of a heel is in fact drawn as precisely as possible. The sketch is, therefore, an ideal communication tool between the designer and the craftsperson, whose close collaboration is essential for the success of the product. As the heel maker sculpts the heel, bit by bit, so the designer reworks his or her drawing; the shape evolves, influencing the designer's subconscious as it is reinterpreted in these rough drafts.

The first step when making a shoe is the production of a "last," a hand-carved wooden replica of the human foot that is then molded in plastic. A well-fitting shoe and contour of the arch, or instep, depends entirely on the skill of the lastmaker. At the same time, the heel maker makes the heel corresponding to the shape chosen by the designer. The heel can be perceived as a sculpture upon which the whole weight of the body rests. Its center of gravity and size are the determining factors for a comfortable instep.

Using the last as a guide, the pattern maker cuts out the shoe's upper and lining. A master craftsperson then stretches the chosen leather tautly over the last, positioning it tightly using nails, or using machines that have been perfected for this purpose. Finally, the sole is chosen and stuck in place.

The secret of a successful shoe lies in the close relationship between the design and the manufacture.

Developments

It is essential to have specific ideas in one's head in order to produce a successful shoe collection. For example, Elisabeth Guers confirms that "a shoe's success is directly linked to its heel: a lot of women will choose their shoes in relation to this." The heel, its height and the resulting arch are definitive factors in the look of the shoe, and a badly arched heeled shoe will not be well received. Some women prefer waisted or hourglass heels, oxfords or stilettos, whereas others prefer flat or very high heels. The height of the most contemporary heels is in the region of 1, 1 ½, 2, or 3 inches (3, 4, 5 or 7.5 cm) with the majority available in three heights. The heel sketches must therefore lend themselves to these variations. Color and material (Fig. 5) play an important part in the styling of a shoe, so it is important to try several combinations in order to arrive at the best one. The cut of the upper is also essential for the success of a beautiful court shoe, with a low cut making the foot look more elegant.

To recap, time and effort spent on researching heel sizes, and the cut of the upper, are decisive factors in a collection's success.

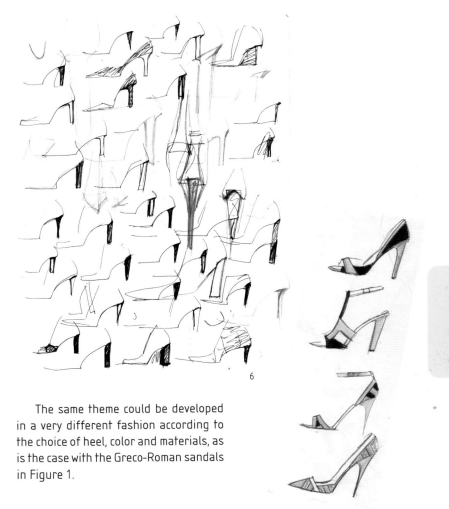

6

The same theme could be developed in a very different fashion according to the choice of heel, color and materials, as is the case with the Greco-Roman sandals in Figure 1.

7

1. Design board of technical drawings for variations of a line inspired by a Greco-Roman theme by Elisabeth Guers.

2 and 3. Research sketches of uppers and heels by Elisabeth Guers.

4. First material suggestions for uppers and heels of varying heights by Elisabeth Guers.

5. Suggested models for Calvin Klein's Winter fashion 2006, with color and material variations on the same shoe by Elisabeth Guers.

6. Quick sketch done at an Italian heel maker's in order to decide on the heel size by Elisabeth Guers.

7. Development of the theme "Jeux de bandes" on a court shoe, sandal, T-strap and spuntato (open-toed court shoe) by Elisabeth Guers.

8. Research sketches of a shoe upper inspired by an illustration by Antonio Lopez, by Elisabeth Guers.

8

The collection structure

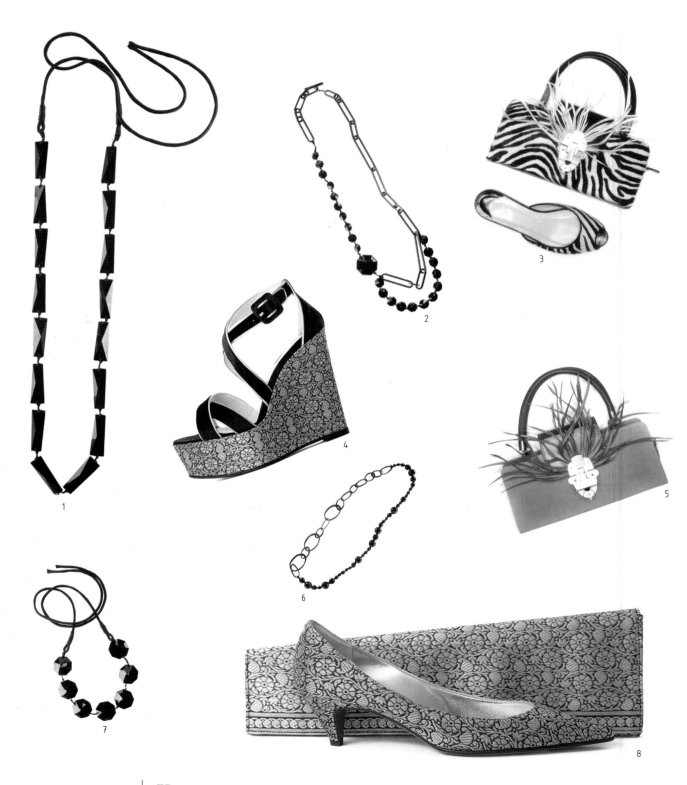

Brands and lines

Accessory brands propose complete product lines that are enriched by prêt-à-porter collections, as is the case with Hermès and Louis Vuitton, for example. On the other hand, prêt-à-porter brands such as Dior, Chanel or Yves Saint Laurent tend to use accessories to complement their clothing collections. Accessory and clothing lines follow the global direction of a brand's collections. Yet they will also have their own theme, and are developed in collaboration with artistic, marketing and commercial direction. The collections plans are established in order to propose complete, coherent ranges that respond to the brand's identity and market needs.

Designing an accessory line

Each line is designed with special attention paid to creating an original visual identity that emphasizes the details, materials, colors and patterns, whether branded or not. These are subsequently developed through all the products in the line. These are generally complete lines, such as cases, handbags, small leather goods, shoes, belts, scarves, umbrellas, glasses or jewelry, and they are often available in several colors (Figs. 3 & 5). Certain series of luxury brands are limited-edition items that make the lines more affordable, thus reaching a larger market.

Big brands such as Louis Vuitton and Chanel tend to develop their classic products in different sizes, i.e., miniature, small, medium and large.

Whether it be Lanvin with his gleaming crystal jewelry, Louboutin with his ethnic themes or Sonia Rykiel with her chic Parisian style, all the products presented on these two pages are immediately identifiable in terms of designer.

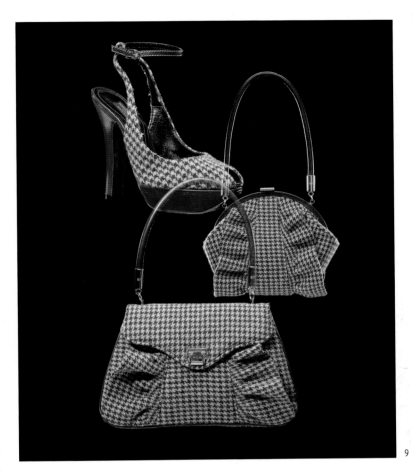

9

1. LONG POLISHED CRYSTAL AND SATIN NECKLACE BY LANVIN, SUMMER 2006.

2. PEARL, METAL AND POLISHED CRYSTAL NECKLACE BY LANVIN, SUMMER 2006.

3. FLAGADA BALLET PUMPS AND *TOTEM* HANDBAG BY CHRISTIAN LOUBOUTIN, SUMMER 2005.

4. *VIVA ZEPPA* PLATFORM SANDAL WITH EMBOSSED GOLDEN DECORATION BY CHRISTIAN LOUBOUTIN, SUMMER 2005.

5. *TOTEM* HANDBAG BY CHRISTIAN LOUBOUTIN, SUMMER 2005.

6. *ORIGAMI* PEARL AND METAL NECKLACE BY LANVIN, SUMMER 2006.

7. SATIN AND POLISHED CRYSTAL NECKLACE BY LANVIN, SUMMER 2006.

8. CLUTCH BAG AND COURT SHOE WITH EMBOSSED GOLDEN DECORATION BY CHRISTIAN LOUBOUTIN, FALL-WINTER 2005-2006.

9. CLASP HANDBAG, FLAP HANDBAG AND STILETTO IN HOUNDSTOOTH CHECK WOOL BY SONIA RYKIEL, FALL-WINTER 2004-2005.

Accessory patterns or motifs

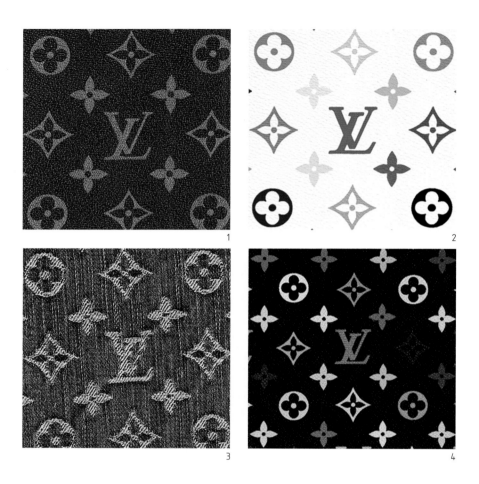

1 2

3 4

Patterns, like materials and details, are essential to the visual identity of an accessory collection. To illustrate this point, we have chosen to present the design process followed by Marc Jacobs with Louis Vuitton.

Vuitton revisited by Marc Jacobs

Marc Jacobs likes a contradiction. Beauty and ugliness complement each other in his surprising creations, and he has even been known to describe some of his models as "very good but very ugly"! His deconstruction concept, which is more or less unpredictable, provides him with the inspiration he needs before embarking on a design, i.e., a chaos of ideas and experiences. His handbags stem from a combination of several Louis Vuitton bags (of which there are only 28 examples in the world) in a style reminiscent of cubism. He disintegrates flowers, which he presses, bleaches or soaks in tea; uses butcher's wrapping paper from rue Saint-Denis in Paris for the flowers made by the feather maker Lemarié in New York; and is inspired by the dots from Japanese artist Yayoi Kusama to produce his own in the form of buttons. The material is transformed by using pattern almost as a form of alchemy.

Reinterpretations

In collaboration with Japanese artist Takashi Murakami, this New York-based designer has devised a new motif, Monogram Multicolore (Fig. 2), for the Louis Vuitton brand. This required more than 33 color pulls in order to be reproduced by the printing method (which serves as a good deterrent against any forgery). He has also taken the plaid shopping or laundry bag as inspiration for Louis Vuitton. Azzedine Alaïa has also exploited this trend with his famous pink-checked carrier bags derived from those of Tati, the large French chain store. He has developed an entire range

around this famous print, including clothes and accessories.

Marc Jacobs often works with artists, such as aluminum sculptor Sylvie Fleury who inspired him to design a handbag line. And, in his time, Yves Saint Laurent would make reference to the great artists who influenced him, such as Vincent van Gogh, Picasso, Braque and even Mondrian, who inspired his famous dress created in 1966. Beyond these complex combinations of materials and patterns, Marc Jacobs has reinterpreted the traditional Louis Vuitton printed cloth into a jean material evoking the notion of eternal youth. In this same contradictory spirit, he takes up Takashi Murakami's motif, using it on handbags and white mink muffs. Marc Jacobs maintains it is important to stay in tune with current artistic trends. "He transforms fashion into images," says his friend, New York artist Elizabeth Peyton.

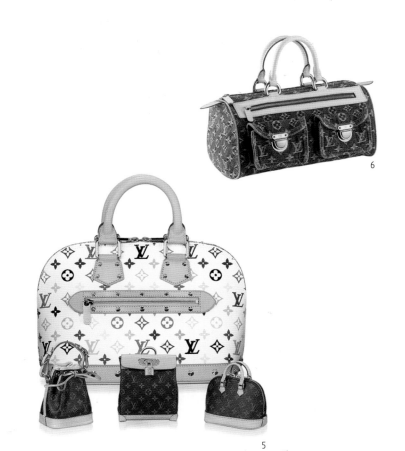

1. DETAIL OF MONOGRAM CANVAS, PRINTED MOTIF.
© Louis Vuitton archives.

2. DETAIL OF MONOGRAM MULTICOLORE , WHITE WITH PRINTED MOTIF.
© Louis Vuitton archives.

3. DETAIL OF MONOGRAM CANVAS, DENIM WITH WOVEN MOTIF.
© Louis Vuitton archives.

4. DETAIL OF MONOGRAM MULTICOLORE ON BLACK BACKGROUND WITH PRINTED MOTIF.
© Louis Vuitton archives.

5. A MINIATURE *NOÉ, STEAMER* AND *ALMA* PLACED IN FRONT OF AN *ALMA* IN MONOGRAM MULTICOLORE WHITE CANVAS WITH PRINTED MOTIF.
© Patrick Galabert/LB Productions.

6. *NEO SPEEDY* (12 x 12 ¾ x 6 INCHES OR 30 x 32.5 x13 CM) IN DENIM MONOGRAM CANVAS WITH FINISHES IN VINYL AND BRASS WITH WOVEN MOTIF.
© Philippe Jumin.

7. WHITE MINK *FANNY PACK* IN MONOGRAM MULTICOLORE, DETAIL FROM THE LOUIS VUITTON'S WOMEN'S FASHION SHOW, FALL-WINTER 2006–2007, INLAID MOTIFS.
© Louis Vuitton archives.

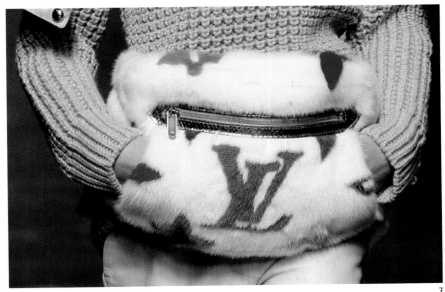

Materials

1 2 3

4 5

6 7 8

hence create new products. For example, coating, assembling, crumpling, folding, engraving, sewing, overlaying, burning, mixing, inlaying and coloring.

At the beginning of the 20th century, Mariano Fortuny was inspired by Greek chitons (a type of folded garment) in designing his famous, finely pleated silk dresses. More recently, Japanese designer Issey Miyake developed a line of handbags called Pleats Please, based on a permanent pleating technique for synthetic materials that uses a heated pressing process; the bags are perfectly flat when empty, but open like an accordion when full.

In the 1980s, Martin Margiela and Marithé and François Girbaud were among the first to consistently deconstruct their collection prototypes in order to transform them from new garments into customized ones. Today, this practice has become standard in many accessory collections.

It is possible to obtain a variety of contrasting results. Due to designers' demands, fabric suppliers have a greater tendency nowadays to pay more attention to the visual and technical finishes of a fabric. The designer destroys, modifies or deconstructs the original material, turning the fabric into an innovative concept in itself. These are the marks of a new generation, of which Marc Jacobs is living proof.

Materials

Accessories use materials that, in being transformed, can result in new and original lines. Obviously the techniques used to do this are influenced by how the materials have been used in the garments, and vice versa. An example of this could be jeans and the famous stonewash used by Marc Jacobs in his collections.

Transformations

There are a variety of technical processes to which materials can be subjected in order to alter their appearance and

Influences

The assimilation and the reinterpretation of images and ideas into new arrangements are also at the root of new concepts. Any image, whether it be of an apartment block in Shanghai at night (Fig. 13), of moss on a wall, tree bark, a

pot-pourri of petals, etc., can play a part in this process. Major events such as armed conflicts and wars can also inspire designers. Famously, Rei Kawakubo made use of this theme with her 1995–1996 Fall-Winter fashion show, causing a great scandal. It has to be noted, however, that her use of bandages was an innovative use of materials which prompted a range of totally new weaves.

Shapes, materials and patterns

The designer's talent and modern techniques have encouraged the development of new materials, such as heat-regulating fabrics used in skiwear, with patent research and development being as essential in the accessory world as it is in any other field.

A pattern is closely linked to the material. For example, leather could inspire an abstracted tire mark or a stitched headlight pattern, relating to the world of the motorcyclist (Figs. 6 and 8); a lace threaded through the leather (Fig. 3) suggests a Native American moccasin with a contemporary twist.

Certain shapes require the use of one material in preference to another. It is very important not to lose sight of the object in question, particularly in the case of shoes upon which one has to walk, for example! It is not unusual to see catwalk models being unable to walk properly due to a shoe being too heavy or too arched. This is reminiscent of the shoes Marc Jacobs designed for Louis Vuitton, where the heels were so heavy that the models lost them. Faced with this type of problem, it is essential to conduct feasibility studies and adapt the product appropriately.

9

10

11

12

13

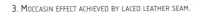

14

1. SADDLE-STITCHED LEATHER.

2. CONTRAST OF MATERIALS OBTAINED BY INLAYING A NET PATTERN ON THE SHOE UPPER.

3. MOCCASIN EFFECT ACHIEVED BY LACED LEATHER SEAM.

4 AND 5. SANDAL UPPER TEMPLATES. ELISABETH GUERS CUTS OUT DIFFERENT SHOE ELEMENTS USING FLEXIBLE CARDBOARD IN ORDER TO VISUALIZE THE EFFECT ON THE FOOT. IF THE PROPORTIONS ARE SUITABLE, THE DESIGN WILL BE GIVEN TO THE PATTERN CUTTER WITH THE CORRESPONDING TEMPLATE.

6. QUILTED LEATHER WITH TIRE-MARK-INSPIRED PATTERN.

7. QUILTED LEATHER WITH GEOMETRICALLY INSPIRED PATTERN.

8. QUILTED LEATHER WITH MOTORCYCLE-HEADLIGHT-INSPIRED PATTERN.

9. PHOTO AND MATERIAL SAMPLE BOARD RESEARCHING CRUMPLED TEXTURE AND OVER STITCHING.

10. CRUMPLED LEATHER. THIS EFFECT IS ACHIEVED BY HEATING THE LEATHER, MAKING IT MORE SUPPLE.

11. MOCCASIN-TYPE SEAM.

12. THE GLOSSY APPEARANCE OF THE LEATHER IS CONTRASTED WITH A LINE OF SADDLE-STITCH.

13. LIGHT AND SHADE CONTRAST: THIS OPTICAL EFFECT IS CREATED BY STRIPS OF LEATHER LINKED TOGETHER BY CHROME PLAQUES. THIS COMPOSITION WAS INSPIRED BY A PHOTO OF AN ILLUMINATED APARTMENT IN SHANGHAI.

14. CRUMPLED AND SEWN PIECE OF FABRIC WITH ITS INSPIRATION PHOTO.

Themes and products

YAZBUKEY JEWELRY COLLECTION 2006–2007			
TIGER	BONES AND TEETH	HEART	PANTHER
LONG NECKLACE			
PENDANT			
NECKLACE			
EARRINGS			
BROOCH			
KEY HOLDER			
DOG COLLAR			

In the following section, creative director Jean-Philippe Bouyer explains his collection plan concept. His impressive curriculum vitae involves, most notably perhaps, designing for Dior from 1989 to 1995 and then for Paco Rabanne from 2000 to 2005. At the beginning of the 1980s he worked for Charles Jourdan until the company closed, and he has also been creative director in Japan and Russia.

Analysis and definition of a collection plan

Accessory collections always respond to trends, and, of course, illustrate the seasonal themes that have already been defined by the brand. The way in which a collection is structured is determined by the collection plan. It is also the starting point for designers (contrary to prêt-a-porter). This plan is, in fact, a document that defines the composition and quantity of accessory elements.

An accessory is defined as a product, which is a response to commercial demand. The collection plan is generally established from prospective market research studies that have been carried out by the head of product development, who could also be the marketing director. These studies are based on analyses of buying and selling made at a particular brand's retail outlets. This information defines, as closely as possible, the client's profile.

The plan helps to structure and provide an overview of the collection with its various themes, lines and models and relevant manufacturing processes. It is based on different criteria relating to quantities, i.e., the number of themes, materials and items in each theme or subtheme.

COLLECTION WOMEN'S BAGS SUMMER 06

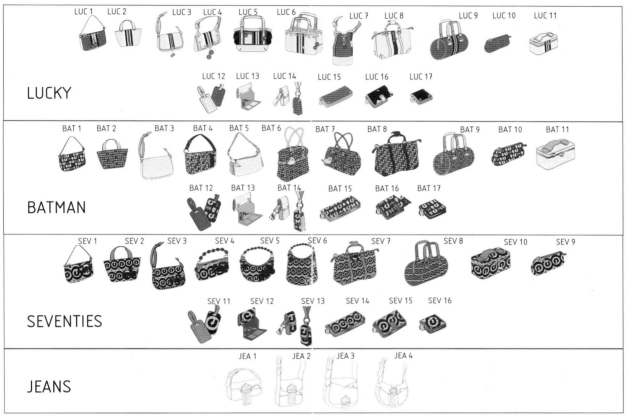

LUCKY

BATMAN

SEVENTIES

JEANS

CHARLES JOURDAN
Spring/ Summer 2006

Collection plan development

Accessory collection plans are very rigorous and continually developing. They are designed in several stages at various points along the collection's development.

First stage: a brief idea of the plan. This is done before the designer really starts work. The marketing division prepares a chart for him or her showing the product lines, i.e., shoes, bags, scarves, etc. (See illustration opposite for Yazbukey's jewelry, p. 78.) Another chart states, for each line, the number of materials and models proposed. Depending on the product, the number of colors to be used in the collection will also be indicated on this. This is particularly the case with scarves, as the precise number of color variations is often needed.

Second stage: the development of the collection plan. The plan is refined to include the material and color selections. Once chosen, these elements will assist the designer in his or her job. The collection plan is displayed in the design studio for all the team to see. It also helps to highlight other necessary aspects of the collection, such as marketing, manufacturing and sales.

Third stage: after the collection. This plan serves as a basis for the conception of a sales book or catalog. It can also be used as a presentation document for sales teams or press agencies. By offering an overview of the products, the plan can help with determining the "look" of a fashion show.*

The collection plan defines all the essential and indispensable products, giving the designer all the necessary information in order to optimize results.

* See *Fashion: Concept to Catwalk*, Chapter 1, pp. 58-59 in the same series.

Color rendering using a marker pen

Equipment

The marker pen is one of the designer's essential tools, as it allows for rapid coloring of a sketch or rough. It can be used for project presentations provided that it is used in conjunction with other techniques, such as colored pencils, paintbrushes, pens, etc. The marker pen is simple to use, resulting in good-quality work.

A large selection of colors are available, and by mixing different colors together a variety of shades can be obtained. Marker manufacturers propose neutral tones – cool and warm – for monochrome drawings. These can be used for accentuating shadows, etc. The markers are available with different-shaped interchangeable nibs, i.e., wide, fine, round, square, angled, rigid or flexible, that allow for variety and precision of line. The nibs are available in either felt or fiber. The felt ones are stronger and are used for quick coloring and flats. To obtain more detailed coloring a fiber nib is more suitable.

Specific paper known as layout paper is the most suitable for use with marker pens, as the ink does not come through the other side, nor does it bleed over the outline of the drawing.

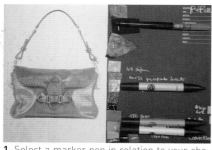

1. Select a marker pen in relation to your chosen color range. Preferably, use one with a lighter shade so that more contrasts can be given to the bag. Brush and ink will eventually be used to accentuate the shadows.

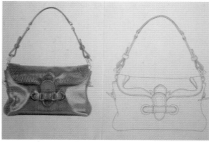

2. Using a 0.4 felt-tip pen the outline of a handbag is traced that is identical to that of a Sonia Rykiel bag. In the photo, the contrasts between the light and shade are clearly defined, which helps with understanding the volume of the bag. Use a 0.1 or 0.05 felt-tip pen for more precise areas of the drawing, i.e., details, stitches, buckles, etc. For shadows, a felt-tip pen with a thicker nib, e.g., 0.8, will give the drawing greater contrast. For this we have chosen to use ink and a paintbrush.

3. Make several photocopies of the drawing, as this will allow you to make several colorways and material tests. If a mistake is made, then the rendering can be restarted without having to retrace the outline of the bag. Incorporating the material effects is essential when designing an accessory.

4. On the original photo, the highlighted areas can be selected. In the absence of a lateral light source, try to imagine one or more coming from either the right or left of the bag, depending on the amount of contrast required. By doing this, light and shade can be added to the drawing.

5. Using a marker with a medium-size nib, mark the highlighted areas before beginning the solid areas of color.

6. Color in the bag using an angled marker. Carefully fill in the color allowing a margin on the inside of the outline so that the color does not go over the line. It is important to apply the color quickly so that a solid block of color is applied, because once the ink has dried, any overlaid colors will leave marks.

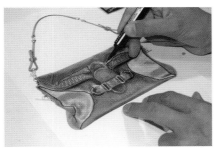

7. The first color is applied uniformly in order to obtain a good solid color. The highlighted areas will then stand out. To give a textured look to the material, place the drawing over a textured support, then apply another layer of ink over that. The texture will then appear.

8. Color in the shaded areas. For a matte finish, accentuate the shadows with opaque colors. However, if the material has a shiny finish, emphasize the highlighted areas to create the impression of shine. To accentuate the shadows, apply several layers of ink with the marker. Allow a bit of time for the ink to dry in between layers. Using complementary colors, also ac-centuate shadows. For example, to achieve a highly contrasted effect a pink can be added to a green. It is very important to be able to contrast your drawing so that the volumes can be emphasized.

9. Use a slightly darker shade for shaded areas and material effects as this will give a quilted effect.

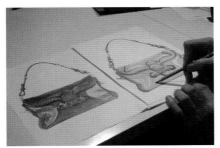

10. It is advisable to use a watercolor pencil to enhance the colors and accentuate the look of the material. Use a white one for highlights, a metallic one for details such as buckles, and use darker colors to emphasize the folds.

11. Use a paintbrush with white acrylic paint to achieve reflections from the metal finishes.

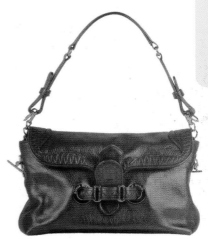

SONIA RYKIEL HANDBAG

Preparation

Before adding the color, place the drawing on a pad of rough paper, which will not only protect the table, but also allow for better absorption of the ink, avoiding any bleeding outside the drawing's outline. The designer's position is also important, as he or she should sit front-on to the table to avoid any back problems. Finally, it is possible to make a color photocopy of the drawing on photographic paper, in order to achieve greater contrast and a more realistic look.

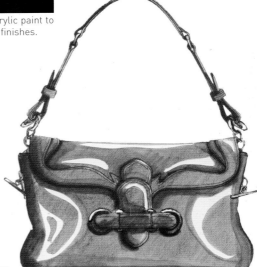

COLORED DRAWING

Example of color rendering a shoe

To color render a shoe, use the same techniques and equipment as for the handbag. The color of the heel and shape of the shoe is of utmost importance. Place the drawing over a layout pad, or a pad of rough paper, so that the marker pen can be absorbed. A color photocopy of the drawing on photographic paper will give more contrast to the finished piece.

1. Select a range of marker pens in relation to the chosen colorways. Preferably use lighter-colored ones, as these will give more contrast to the shoe. To accentuate the shadows we have used a brush and black ink.

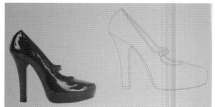

2. We have used a 0.4 felt-tip pen to trace the outline of a shoe identical to a Sonia Rykiel model. In the photo, the areas of light and dark are clearly defined. For more precision, use 0.1 or 0.5 felt-tip pens for the details. For the shadows, use a felt-tip pen with a thicker nib, 0.8 or 1.0, as this will give greater contrast. We suggest using ink and a paintbrush rather than a black marker pen. Photocopy the drawing several times so that various colorways and material effects can be tried out. If a mistake is made, then the color rendering can be started again without having to retrace the entire shoe.

3. On the original photo, select the highlighted areas. In the absence of a lateral light source, try to imagine one.

4. Using a marker with a medium-size nib, mark the highlighted areas before beginning the solid areas of color. The patent leather of the shoe requires particular attention. It is a question of enhancing the shininess of the material by studying the contrasts of light, as this will define the volume of the shoe.

5. To color the shoe use an angled marker. Carefully fill in the color, allowing a margin on the inside of the outline so that the color does not go over the line. Use a marker with a medium nib for the strap. It is important to apply the color quickly and graduate it, paying particular attention to the black and shiny areas.

6. To accentuate the shadows, apply several layers of ink with the marker. Allow a bit of time for the ink to dry in between layers. Using complementary colors can also accentuate shadows, creating strong contrast and also emphasizing the shape.

7. Watercolor pencils will enhance the colors and accentuate the look of the material. Use a white one to highlight the metal details such as buckles and fastenings, and use darker colors to emphasize the folds.

8. To make the patent leather look shiny, use a paintbrush with white acrylic paint to achieve reflections.

9. For the black, use ink and a paintbrush, not forgetting to leave the white areas, which will emphasize the shininess of the material.

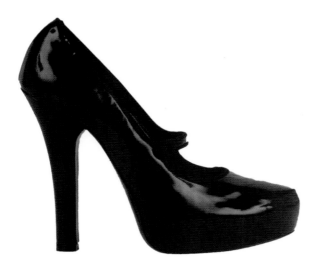

SONIA RYKIEL SHOE

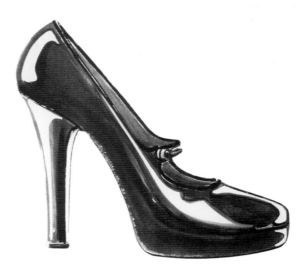

COLORED DRAWING

Color rendering using Photoshop®

Preparation

Trace the outline of the handbag, making sure that there are no breaks in the line, as this will make the work easier. Designing a bag using a computer follows the same set of rules as color rendering using a marker pen. Use a variety of different nib sizes, such as 0.5 to 0.7 for the outlines, and 0.1 to 0.3 for the details and cut. In addition to this, the material from which the bag is made can be scanned, selected in Photoshop® and applied to the image, giving a very realistic result.

1. A high-resolution scan will show all the details of the bag. Scan the drawing at 600 dpi and the materials at 300 dpi. Once the bag and the materials have been scanned, open these files in Photoshop.

2. Use the Magic Wand in the Toolbox to overlay materials onto selected areas of the handbag. Select all the areas of the bag that correspond to a particular material that you want to apply by clicking inside this area. It will become highlighted. The Magic Wand also allows you to select areas of color and tones.

3. To add another area to the selection, use the Shift key on the keyboard. A little + sign will appear next to the cursor. To reverse the operation in the case of a mistake, press the Alt key and the – sign will then appear. If you click in the selected area inadvertently, then just Deselect it. It is advisable to use the Zoom tool from the Toolbox to show all the small areas, enabling you to work them in more detail. It is possible to zoom in and out at will, then re-use the Magic Wand and finish the selection. So that it can continue to be used, your selection must be saved. This can be done by going to the Select menu and clicking on Save Selection.

4. A dialog box will appear. In the Name field, type the name of this selection, then confirm by clicking OK (Fig. 4). Repeat this process of Select and Save for the other areas of the bag.

Importing

Once the preparation has been done, the chosen material can be imported into the document. Just select the document containing the material, and open it while the bag document is also open.

5. A simple click on this image will activate the document. Select the Move icon in the Toolbox, click on it and drag the material image over the handbag document, then release the mouse button.

6 and 7. As for number 3. (Note: See highlighted/gray areas in illustration for Load Selection instructions.)

8. Then, on the keyboard, press the Remove (or Delete, or Backspace) key to remove all the material on the outside of the bag outline. The material is now overlaid on the bag, giving a more precise and realistic idea of the bag and the material it is made from.

9 and 10. Finally, to push the idea a little further, use the Density tool to give shadows and volume to the bag.

The production of an accessory involves some very specific manufacturing techniques that combine innovative technology with traditional skills. When a skilled craftsperson uses new materials and components, he or she stamps his or her trademark onto the objects, which results in highly original products. The craftsperson is, therefore, a very important component or cog in the industry. Although labor and manufacturing costs are very high in France, as in other developed countries, large luxury brands continue to use the exceptional skills and knowledge of French craftspeople in the production of their models, which, in turn, gives a certain exclusivity to the product in the eyes of the client. This policy helps to safeguard the incredible technical heritage that has been passed from generation to generation in the heart of the design studios.

Chapter 4 – Craftsmanship and manufacture

Whether it be for leather goods, shoes, scarves or jewelry, France has, in fact, kept a certain number of these ateliers alive; as precious as they are rare, they are also world-renowned archival temples. The large fashion houses to which we owe this continuing survival are Louis Vuitton, with his atelier and travel museum at Asnières in the Haut-de-Seine region; Charles Jourdan, with his shoe museum at Romans-sur-Isère, in the Drôme; and Marc Rozier, whose manufacturing studio houses at least 150 years' worth of archival material.

Equally, the up-and-coming generation of designers endeavor to integrate skilled craftsmanship into their products. This is evident with the young Japanese shoe and handbag designer Ryusaku Hiruma, whose work, and label Sak, is presented in this chapter. In the prêt-à-porter market, the Kitsuné label also uses these manufacturing skills and materials to exceptional effect.

Luxury brands are constantly researching new concepts that combine tradition with the contemporary, and one of the principal challenges of creative directors such as Marc Jacobs for Louis Vuitton, Alber Elbaz for Lanvin or Jean Paul Gaultier for Hermès is to continue to surprise and delight their public.

We have invited Louis Vuitton, Marc Rozier, Sak, Elena Cantacuzène and Charles Jourdan (one of the foremost shoe designers of the Isère, whose brand disappeared in 2007) to open their studio doors and allow us an insight into their world, which we present on the following pages.

Tradition and modernity at Louis Vuitton

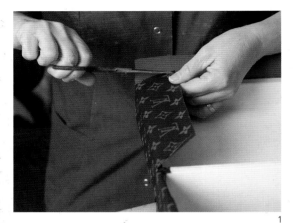

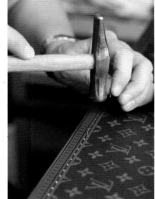

1

2

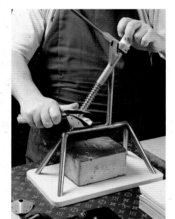

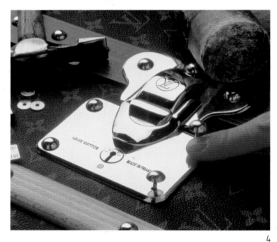

3

4

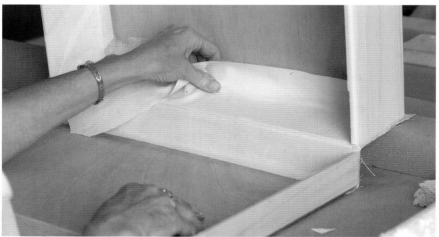

5

In the family home at Asnières, Louis Vuitton established a studio where limited-edition and specially commissioned pieces are made. This building also houses the travel museum, where the brand's one-off, signature pieces are exhibited. He organizes temporary exhibitions here, presenting his concepts, which range from architecture to design and development.

LOUIS VUITTON'S MANUFACTURING STUDIO AT ASNIÈRES

1. MONOGRAMMED CANVAS STRETCHED OVER A WOODEN FRAME. THIS OPERATION REQUIRES EXTREME PRECISION WITH THE MOTIF BEING PERFECTLY ALIGNED AT EACH SEAM OR JOIN.
© Emmanuel Layani.

2. THE ANGLES AND EDGES OF THE RIGID LUGGAGE ITEMS ARE REINFORCED BY USING LOZINE. THIS IS A PARTICULARLY STRONG VULCANIZED FIBER EXCLUSIVE TO LOUIS VUITTON. HERE THE LOZINE IS CAREFULLY NAILED IN PLACE USING A HAMMER. SEVERAL THOUSAND NAILS CAN BE USED IN THE MANUFACTURE OF A TRUNK.
© Emmanuel Layani.

3. MAKING A CASE CORNER IN NATURAL CALFSKIN.
© Antoine Rozes.

4. FIXING A BRASS LOCK ONTO A RIGID BAG. INVENTED BY GEORGES VUITTON IN 1890, THESE MULTIPLE-TUMBLER LOCKS ARE STILL IN USE TODAY. THE CUSTOMER HAS A UNIQUE NUMBER FOR THE LOCK AND CAN, IF SO DESIRED, REQUEST A SINGLE KEY THAT WILL OPEN ALL HIS OR HER BAGS.
© Jean Larivière.

5. PLACING A HINGE ONTO A RIGID BAG. THE HINGES OF A LOUIS VUITTON BAG HAVE ALWAYS BEEN MADE FROM TWO PIECES OF COTTON SEWN TOGETHER, THEN STUCK ON THE INSIDE AND OUTSIDE OF THE FRAME.
© Emmanuel Layani.

OPPOSITE: SADDLE STITCH IS DONE USING TWO NEEDLES AND THREAD COATED WITH BEESWAX. THIS IS JUST ONE OF THE TRADITIONAL TECHNIQUES STILL CARRIED OUT IN THE ASNIÈRES STUDIO. IT IS USED TO REINFORCE THE STITCHES ON THE CALFSKIN TRUNK HANDLE.
© Antoine Rozes.

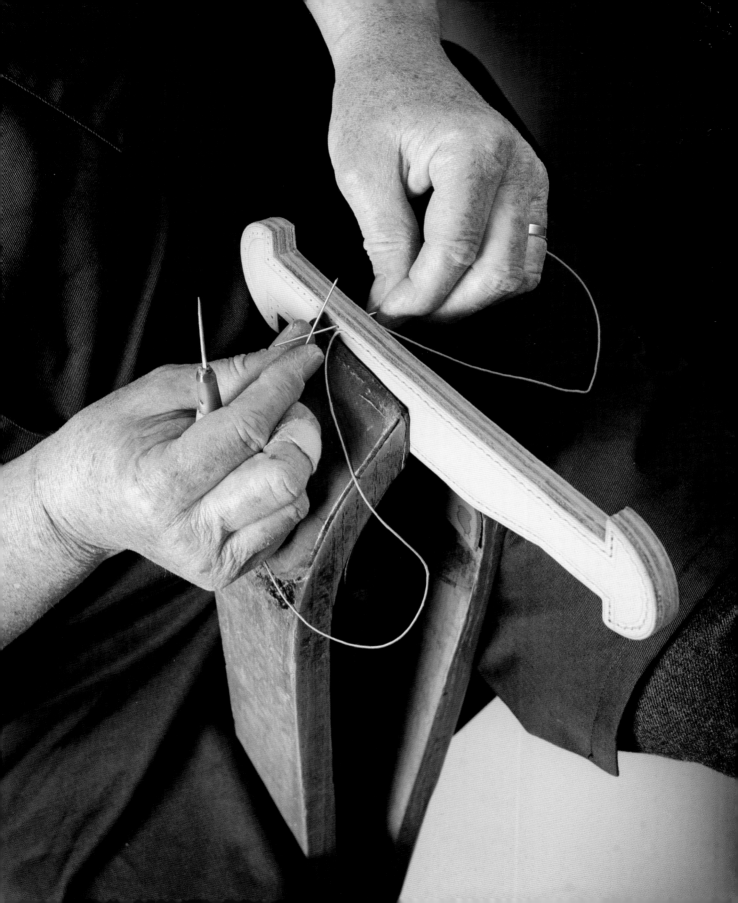

Manufacturing a *Lockit* bag

1

2

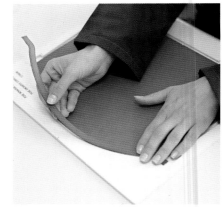

3

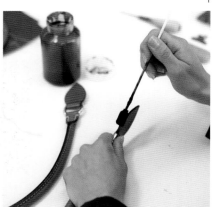

4

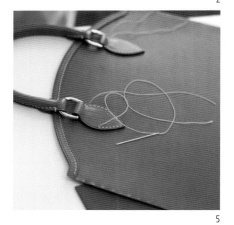

5

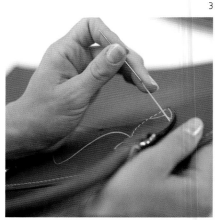

6

Continuing the tradition of handmade products, Louis Vuitton takes advantage of the brand's traditional skills, which give a certain exclusivity to the objects. Here we present some photographs that show the principal stages of making a *Lockit* handbag.

Principal stages of manufacture of a *Lockit* bag in the production studio at Asnières.

1. Cutting the leather by hand.
© Eric Leguay.

2. Assembling the base.
© Eric Leguay.

3. Assembling.
© Eric Leguay.

4. Coloring the edges.
© Eric Leguay.

5 and 6. Sewing the reinforcing piece by hand.
© Eric Leguay.

7. Burning the threads.
© Eric Leguay.

8 and 9. Final check.
© Eric Leguay.

10. Image taken from Women's Fall-Winter Accessories book showing three-quarter view of *Lockit* handbag (11½ x 11¼ x 4¾ inches or 29 x 28 x 12 cm) in caramel Nomade leather.
© Laurent Bremaud/LB Productions.

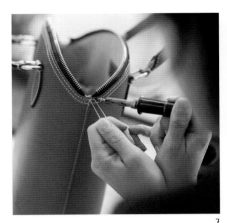

7

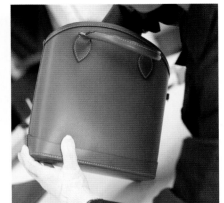

8

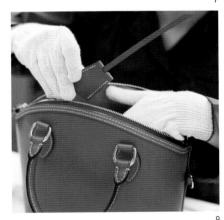

9

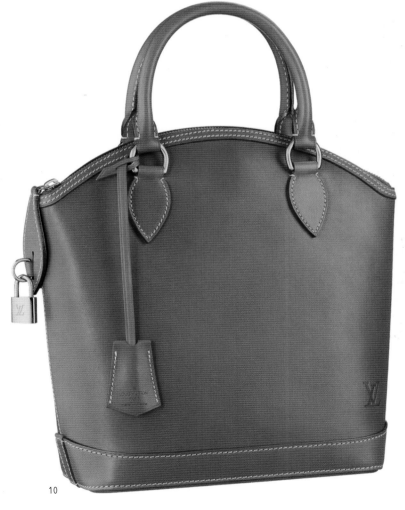

10

Details and finishing features for bags

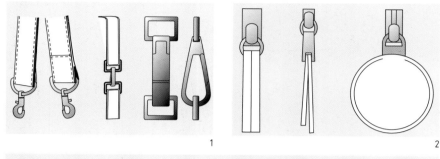

1

2

3

4

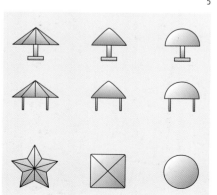

5

6

7

The various choices of finishing features, such as buckles, clasps, rivets and so on, are essential elements that need to be determined prior to any accessory manufacture. This is because these elements will define the width of straps, the length of openings and the necessary pattern shapes.

There are specialist trade shows, like Mod'amont in Paris, that designers visit each season in order to keep up to date with the latest trends and products in this field. Large companies themselves are regularly visited by manufacturing representatives who propose samples, although in an attempt to remain exclusive, certain brands will make their own easily identifiable finishing features. These are in the minority, however, as young designers tend to use standard elements for ease of restocking and to keep costs down.

1. Snap clasp or hook.
2. Zipper pullers.
3. Piping.
4. Ram rings.
5. Belt buckles.
6. Nails and rivets.
7. Detail of a shoe ring.
8. Clasps.
9. Nonadjustable shoulder strap.
10. Top stitches.
11. Handles and straps.
12. Zipper fasteners.
13. Adjustable shoulder straps.

8

9

2mm 3mm Point Scellier

10

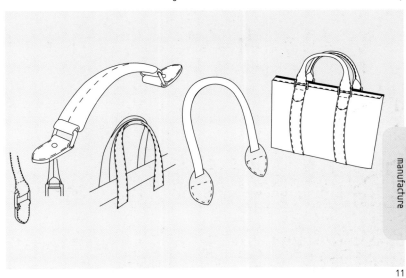

11

12

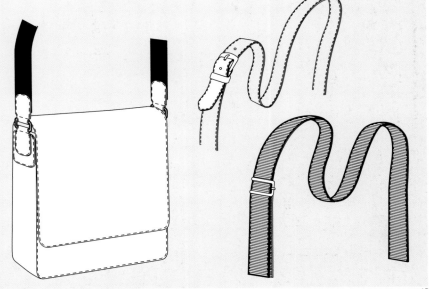

13

Industrial shoe manufacture

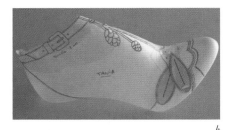

1

2

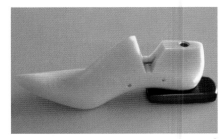

3

4

5

6

It takes an entire year to put a shoe collection together, of which six months are necessary for its manufacture. For a Spring-Summer collection, production is started the previous October so that the shoes are delivered into the shops by the end of February. And for a Fall-Winter one, production begins in April so that the shoes are delivered by the end of August.

Research and development

Using the designer's drawings, the model maker recreates the models in three-dimensions on a wooden former or last (Fig. 2). The volume of the shoe and the flat patterns are adjusted; these cardboard templates will be used to cut out the different pieces of the shoe. Once assembled, a pre-series of six pairs is made from this prototype so that the shoe can be tested on a number of people who are size 38 (U.S. size 7½). After this research has been done, any modifications needed are carried out.

Once the prototype has been passed, the shoe is produced in a variety of color and material combinations. The model maker will then "industrialize" it, which means making a range of different sizes for it. Each model has a nomenclature (Figs. 5 and 6) that includes its name, reference, number of materials, design and technical drawing of model, accessories used, linings and finishes.

The model maker must take into account the manufacturing costs involved, including labor (cutting) and materials (leather). It is also his or her job to determine the factory or cost price of each shoe, as well as manage production. This involves being in charge of the

number of hours worked in the studio, any design modifications, ordering and buying of materials, and finally, quality control. All these operations are expected to be done within very tight deadlines.

The patterns and materials are either laser-cut or made by using a water jet. A shoe is subjected to 70 operations including positioning the counter (a stiffener for the shoe's back), gluing in the lining materials, and placing the metal reinforcing bar for the sole. A finisher takes care of the sole, heel and decoration or details of the shoe. A felt-tip pen, in the same color as the shoe's material, is used to touch up the edges or outline of the shoe. The final phase of pro-

7

8

9

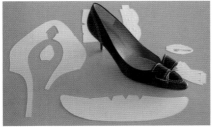

10

11

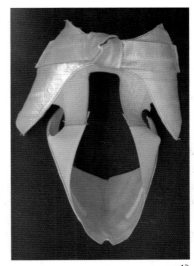

13

12

duction involves adjusting the shoe's leather upper snugly over the last. Nowadays, the majority of this is done mechanically, using automated machinery that replaces the craftsperson. However, the designer label Sak still uses these skills, which we can see on the following pages. The knowledge and supervision of these skilled technicians is essential for good shoe manufacture. This practical expertise, which is unfortunately disappearing, is increasingly sought after in luxury brand manufacture. Finally, the last stage consists of cleaning and checking the shoe, before it is carefully wrapped and put in its box.

Heel and last making

The shoe maker Charles Jourdan generally designs a line of seven different shoes from just one shape and one heel.

1. ROLLS OF LEATHER FROM WHICH SHOE PATTERNS WILL BE CUT.

2. WOODEN LAST OR FORMER. THIS PROTOTYPE WILL BE USED TO MAKE THE SHOE.

3. PLASTIC MOLDED FORMER. IT HAS A HOLE SO THAT THE HEEL CAN BE NAILED IN PLACE. THIS ONE WILL NOT BE USED FOR A HIGH-HEELED SHOE, HOWEVER.

4. PLASTIC MOLDED FORMER FOR A HIGH-HEELED SHOE, WITH DESIGNS DRAWN ON IT.

5 AND 6. TECHNICAL DRAWINGS.

7 AND 8. POSITIONING THE DIFFERENT PATTERN PIECES ON THE LEATHER.

9. STIFFENING THE DIFFERENT PIECES OF THE PATTERN THAT MAKE UP THE SHOE.

10. SHOE WITH ITS CORRESPONDING PATTERN.

11, 12 AND 13. SEWN UPPERS READY TO BE ASSEMBLED ONTO THE SOLE AND HEEL.

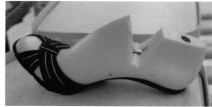

14

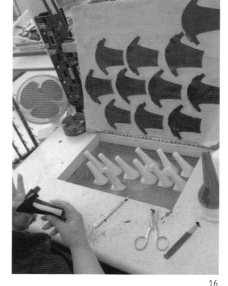

16

17

15

18

19

20

Last making is the largest and most important investment in shoe production, because it is essential to create a last for each style and subsequently each size. At the top end of the market, half-sizes are also made, which in turn increases the investment cost.

The last is initially made from hand-carved wood, then reproduced in a very strong plastic material for mass production. Each last consists of an individual instep and shoe fit. In the 1950s, lasts were made up to size 36 (U.S. size 6) whereas nowadays they go up to size 38 (U.S. size 7½). It is very important to anticipate the

manufacturing constraints while developing the prototype, taking into account the different thicknesses. For example, four thicknesses of leather are necessary for the production of a classic shoe. These can, therefore, modify the shape of the shoe in such a way that the result can be very different from the original concept. However, with tighter and tighter deadlines, there is no room for error: only one alteration is allowed per prototype. Elisabeth Guers annotates or sketches her designs in pencil on the wooden last in order to visualize the shoe. At Charles Jourdan, each last is

hand carved in the studio, listed and then placed in the archives for a period of five years. The lasts are then recycled at the end of this period.

In the meantime, the designer develops the heel prototypes with the heel maker. The ideal situation is to design them with the prototype of the wooden last, as this allows for better visualization of the general shape of the shoe and helps the heel maker adjust the heel accordingly. The heights of the most currently used heels at Charles Jourdan are ¾, 2, 2⅓, 2¾, 3⅛ and 3½ inches (2, 5, 6, 7, 8 and 9 cm).

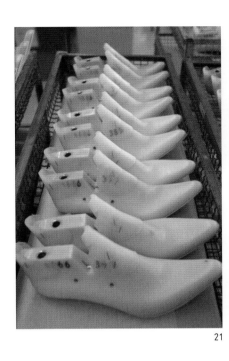

22

23

24

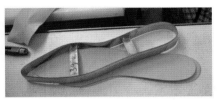

25

21

The plastic last has a vertical hole (Fig. 14) in the heel so that a nail can be inserted in order to fix the sole to the heel. A badly fixed heel will break very easily. This hole, which is placed in the shoe's center of gravity, strengthens the heel. Underneath the sole, metal plates or rods reinforce the shank or arch support. A decision is then made as to whether the last can be carried through into production.

The heel can be made from either wood or resin. The wooden one is made using a metal-brushed grinding wheel. Molds are then made of the heels, which are then cast in different alloys. Finally, a variety of finishes are proposed for the heel. This work demands great skill and a perfect understanding of the technique. Elisabeth Guers considers heel and last makers to be great virtuosos, as one of the difficulties lies in the ability to combine beauty with comfort, without compromise. The comfort of a heeled shoe, even if it is very thin, depends on the heel's center of gravity, the arch support, enough room at the widest part of the foot, and the upper. Charles Jourdan designed a particularly comfortable sole known by Italians as a "*fondo* Jourdan." This thin, curved sole allowed for the manufacture of thin yet roomy shoes.

The three distinctive elements of shoe production – the last, heel and sole – are generally made in separate studios. However, at Charles Jourdan, all the stages of manufacture have been integrated into the factory – the heels, shoe lasts and accessories are made in-house.

14. Plastic last with upper in place.

15. Sole and heel before the rod is assembled.

16. Heels with covering material.

17. Leather-covered heel.

18. Different heel finishes.

19. Choice of different heels.

20. Shoe manufacturing stage.

21. Plastic production lasts.

22. Storage of card patterns.

23. Production shanks before finishing.

24. Resin being poured into heel molds.

25. Sole die cutter.

Handmade shoe manufacture

1

2

3

4

5

6

7

8

9

10

11

Sak – a young designer label

Handmade production demands a less structured system than industrial manufacture, and depends on versatile, skilled craftspeople who are able to turn their hand to any aspect of the manufacturing process, as was the case with shoemakers at the beginning of the 20th century.

Ryusaku Hiruma is an accessory designer specializing in shoe and handbag design. In 2004, he created his first shoe collection under the Sak label and presented it in Paris. This young Japanese designer, now living in Florence, owns a collection of vintage bags and old shoes from which he recycles the leather to create new shoe styles.

He makes individual, artistic shoes that do not belong to either the ready-to-wear or industrial sectors, seeing his shoes as "works of art." In 1998, when he was working in London, his first creations were inspired by London streets and contemporary art. From 2002, Hiruma moved to Italy where he discovered the studios and knowledge of

12

13

14

15

16

17

18

Italian craftspeople, going back to the Renaissance, from which he derives enor-mous inspiration.

Ryusaku Hiruma presents his collections in Europe, the United States and Japan. His first line of handbags dates back to the 2005 Spring-Summer collection. Also in 2005, he made some shoes for American artist Vincent Gallo, which became the starting point for his 2005–2006 Fall-Winter collection.

5. Cutting out a leather shoe pattern.

6. Sewing the zipper in place. This corresponds to the area where the leather upper meets the lining upper.

7. Sewn zipper.

8. Nailing the shank to the wooden last by hand.

9. Using pliers, the leather is stretched allowing for adjustment of the final assembly on the wooden last.

10. On the wooden last, nails are fixed around the shank before assembling.

11. Shank is nailed, then glued before being fixed into place.

12. Boot's upper before assembly.

13. Nailing the leather upper onto the wooden last.

14. Shank nailed and sewn in place, before securing the sole and heel.

15. Weatherproofing and attaching the cork insole to the shank.

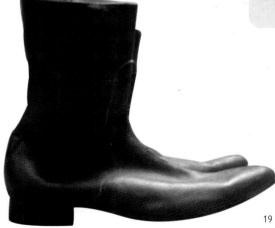

19

1 and 2. Shoes designed by Sak.

3. Tools used in shoe manufacture: pincers, pliers, callipers and hammer.

4. Corner of workbench used for shoemaking.

16. Cutting and attaching the outer sole to the shank.

17. Hammering the sole into place.

18. Adding the heel.

19. Finishing touches: coloring the sole and the heel; polishing the boot. The last is removed and the boots are finished.

Industrial scarf manufacture

1

2

House of Marc Rozier

The scarf, along with lingerie, is one of the oldest and most important items in one's wardrobe. Originally, it was reserved for the rural population. It was very popular with women who worked in the fields as it protected their hair and kept the sweat off their faces, becoming a key item of clothing. According to Eric Provent, the great-grandson of Marc Rozier, who founded the famous factory, it is the beauty of the scarf that is at the origin of the Provençal-patterned cotton *Gavroche* hat.

Founded in 1890, the Marc Rozier company began by designing little Provençal patterns for cotton prints. Four generations have continued this family tradition and expertise, and today, Eric and Didier Provent have taken up the reins of the company, which now consists of three factories: a weaving factory, a printing factory and a sewing and finishing studio. The company houses more than a century of information in its archives. Marc Rozier works with a number of couture and prêt-a-porter brands, as well as lingerie and leather goods labels such as Dior, Chanel, Vuitton, Cartier, Jean-Louis Scherrer, Sonia Rykiel, agnès b., and so on. The fashion house produces fabrics by the meter to make their collections of scarves, shawls and stoles. Marc Rozier is a specialist in all sorts of chiffon – woven, printed, flocked, devoré – as well as sophisticated jacquard-weave mixes of wool, silk, linen and cotton.

1. WEAVING TOOLS FROM THE MARC ROZIER ARCHIVES.
© Ninjin Puntjag.

2. TWILL SCARF FROM THE MARC ROZIER ARCHIVES.
© Ninjin Puntjag.

3. FINISHING THE SELVAGE OF THE FABRIC ON AN OVERLOCKER MACHINE.
© Ninjin Puntjag.

1

2

3

4

5

6

Weaving at Marc Rozier's

Design studio

The design studio (Fig. 3) creates original patterns from scratch (Fig. 5), or develops designs from already purchased material samples, for printing scarves or fabric by the meter. The motif, which is drawn in black and white or in color, is printed or woven. From the original design, colors need to be separated and a number of other choices need to be made: whether to use matte or shiny threads; whether the motif will be in the same or a different color; which tones or hues will be used (in the case of striped glossy satin or chiffon, for example).The motif must then be arranged so that it can be repeated all over the fabric to form a pattern.

Developing a woven fabric

Marc Rozier buys his thread from China and Brazil on cones (Figs. 6 and 7) and makes different weaves that are initially white, then printed in color. Weaving is a method of producing a fabric using a particular arrangement of warp and weft threads. There are three main types of weaves: plain, twill or satin. However, these constructions can be mixed to produce more sophisticated fabrics.

Weaving with different thread tensions can result in a variety of very different fabrics. For example, canvas and seersucker are both plain weaves, but one has a regular appearance, whereas the other has a puckered effect. The double ladder stitch is a very fine, open-worked weave. Graduated weaving is achieved by using different threads that get increasingly close together, thus giving the fabric a gradation of color.

The combination of colored threads gives rise to distinct fabrics such as gingham check, for example. This is a plain weave that is the result of alternat-

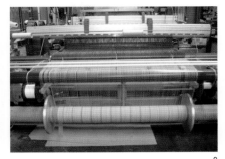

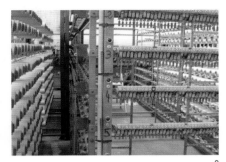

7

8

9

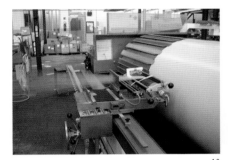

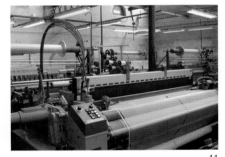

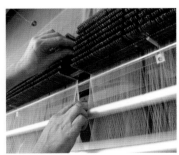

10

11

12

ing white and colored threads, producing squares of various sizes. As for motifs that are in relief, these would require a different technique such as devoré or flock printing.

The textile engineer will produce several samples using a variety of weaves and threads. This is done by trying different thread and color combinations using a computer. By using CAM (computer-aided manufacturing), the technician is able to program the type of weave required. The warp threads (Fig. 11) come down from the top, with the weft threads coming from the sides. The threads are distributed by a spool, which regulates their tension while the weaver feeds the warp from the weft threads.

1. TEXTILE DESIGN ARCHIVES.

2. PRINTED SAMPLES IN MARC ROZIER'S DESIGN STUDIO.

3. MARC ROZIER'S DESIGN STUDIO.

4. A TECHNICIAN WORKING ON A JACQUARD CARD.

5. MAQUETTES AND ARCHIVES.

6 AND 7. THREAD CONES.

8. AUTOMATED WEAVING LOOM.

9. REELS OF THREAD BOBBINS.

10. ARRIVAL OF THREADS ON THE LOOM.

11. LOOM WITH WARP THREADS.

12. AT WORK ON THE LOOM — A TECHNICIAN ADJUSTS THE COMBS, WHICH SORT THE THREADS.

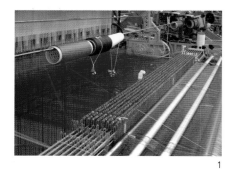
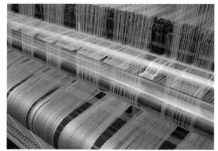
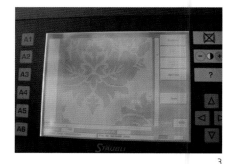

1

2

3

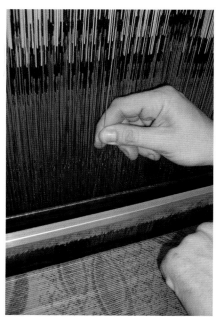

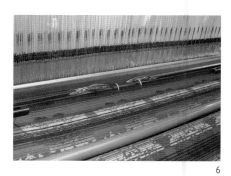

6

4

5

Normally, samples are made in measurements of 16 x 55 inches (40 x 140 cm) for small items and 24 x 63 inches (60 x 160 cm) for larger items and stoles.

Preparing the dyes

The colorist researches which dyes are to be used in relation to the season's trends. Depending on the desired quality, different types of dyes are used, with acid colors for silks, and reactive, or dispersed, colors for polyamides or synthetics.

The dyes used are in paste form. Their preparation, which requires a good knowledge of chemistry, follows a precise recipe. The dyes are prepared and mixed in a laboratory using ladles to measure the necessary quantities (Fig. 12). After

Jacquard weave

The jacquard pattern is achieved by mechanical weaving using a computer-generated perforated card on which the pattern has been punched (Fig. 4). Each row corresponds to one row of the design, which guides the warp thread so that the weft thread will lie above or below it. The fabric weave is represented

by a grid on the computer screen (Fig. 4, p. 102). The black-and-white points represent the jacquard pattern. Sample pieces are produced on the loom (Fig. 6) so that the pattern can be tested on the fabric. A control panel or screen (Fig. 3) on the machine shows the pattern that is in the process of being made. If the result is successful, the fabric will be produced in a given size and quantity.

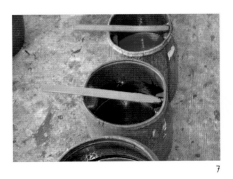

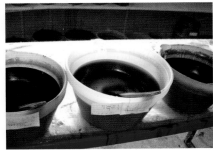

7

8

9

10

11

12

each use, all the utensils are carefully washed to avoid any chemical cross-contamination with the other colors. Nearly 400 pigments, as well as chemical products, of which the majority are in powder form, are stored.

Other than color, the dye consists of gum, different acids and thickeners, which are mixed together in a container with soft water to the right consistency and uniformity for the material. The resulting colors are then cataloged with reference codes that relate to the different ingredients and quantities used. This helps the colorist reproduce them when necessary. Color tests are carried out on samples of the material in order to establish how the dye interacts with the fabric, and also to see how it reacts to washing and drying.

1. Weft threads on a Jacquard loom.

2. Arrangement of warp threads so that a striped fabric can be made.

3. Detail of Jacquard pattern on the control panel screen.

4. Jacquard punch card.

5. Detail of the combs.

6. Producing a Jacquard pattern.

7 and 8. Preparing the dyes.

9. Dye bath.

10. Mixing the dyes using a mixer.

11. Dye tests.

12. Measuring ladles for each dye tint. By mixing them together, the desired color is obtained.

1

2

3

4

5

Printing techniques for scarves

There are a variety of printing techniques: roller, rotary or flatbed printing presses; automatic or semi; transfer or ink-jet. In Marc Rozier's factory only automatic and semiautomatic flatbed printing presses are used.

Flocking is a technique that consists of printing a glue onto the fabric, then projecting small fiber particles onto these printed areas. The motifs are normally one color. Devoré, which gets its name from the French word *devoré*, meaning "eaten," on the other hand, means that some of the surface of the fabric has a resist applied to it and other areas are either acid-etched or burned away to create the pattern. Some dyes or tints can be manually applied, as is the case with ombré chiffon, which is soaked in dye baths to give a more luxurious feel to the product.

Roller printing

Although used less and less these days, this process does allow for very neat, dis-

tinct prints, making it very suitable for small patterns or motifs. The repetition of the pattern depends on the circumference of the printing roller or cylinder. The pattern is engraved onto either a brass, copper or nickel cylinder (Figs. 4 and 5) to which the dye is applied. The excess dye is scraped off the roller's surface, leaving it in the engraved sections only.

A second cylinder is wrapped with a large blanket of soft, absorbent material, which forces the fabric that is to be printed into the engraved areas. This soft material also absorbs any excess dye. The fabric is printed by passing between the cylinders.

Rotary screen printing

This process allows for continuous printing. In basic terms, the printing dyes are inside rotary drums or cylinders. The cylinders are perforated and the dyes are forced out through these holes onto the fabric. This is not a very sophisticated technique and tends only to be used for mass-production fabric printing.

1, 2 AND 3. OLD MANUAL PRINTING PLATES.

4 AND 5. COPPER CYLINDERS USED FOR PRINTING SQUARES OF COTTON FABRIC. THERE ARE ABOUT 50 CYLINDERS SIMILAR TO THESE IN MARC ROZIER'S ARCHIVES.

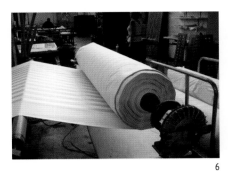

6

7

8

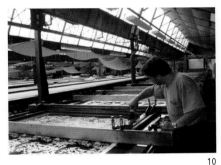

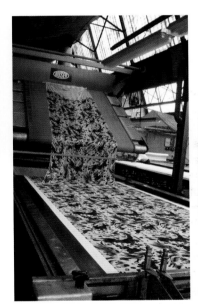

9

10

11

Automatic flatbed printing

With flatbed printing, also known as printing *a la lyonnaise* (Fig. 9), larger patterns can be achieved than with roller printing. The size of the pattern varies in relation to the screen size. The screen has a gauze or stainless-steel mesh stretched over it onto which a stencil of the pattern is applied, either manually or photochemically. The pattern areas to be printed are left open so that the dyes can be forced through onto the fabric.

The pattern will have had its colors separated, as each color requires a separate screen. The more screens there are, the denser the final pattern will become.

There are some very complex prints that require more than 20 printing screens — an example being Louis Vuitton's Monogram Multicolore (see p. 74). With automatic flatbed printing, the fabric passes intermittently along the printing conveyor belt (although it is stationary when a color is applied). The screen is raised, then lowered, and the color is applied to the mesh using a squeegee. Very fine and delicate fabrics such as chiffon must be placed on calico before-hand, which acts as blotting paper for the excess dye that seeps through. After printing, this calico material is washed and recycled.

6. Unrolling the fabric prior to printing.

7. Fabric secured on the conveyor belt prior to printing.

8. First color printed.

9. Second color screen placed on fabric.

10. Automatic printing.

11. The printed material unrolls onto the printing table.

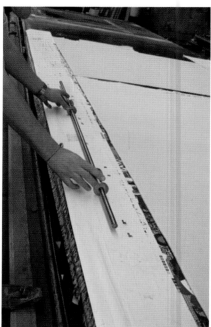

12

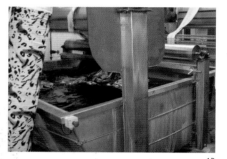

13

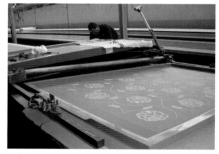

14

15

Semiautomatic flatbed printing

This technique is more for small-scale production than the others, requiring a certain amount of manual intervention. The pattern needs to be very precise in order to achieve a successful engraving. This process involves printing the fabric using wet printing dyes, rather than the paste-like ones used in the other techniques. This is why this type of printing is done as "wet on dry." However, this process can make the image less sharp. Contrary to the automatic flatbed machine principle, with this method the fabric does not move along the printing table automatically. A technician must manually move the length of fabric along the table, which measures 121.5 feet (37 meters). Two technicians are involved in this printing process – an engraver and a printer. A number of the stages are not automated. For example, the controls are manually operated, with a technician positioning the registration marks for the pattern repeats (Fig. 15), pulling the squeegee and checking that the colors are right.

Final stages

After printing, the fabric is stretched and dried. Once the colors are dry, the printed fabric is plunged into a fixing tank for a particular period of time. This depends on the quality of the material. After this operation, the fabric is machine washed in order to fix, or set, the colors, then spun and finally dried. It is at this point that a technician carries out a color control. If the pieces of fabric conform, then a finishing treatment is applied in order to stabilize the dyes.

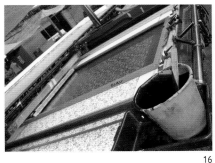

16

17

18

19

21

20

12. THE FABRIC IS WASHED AFTER PRINTING AND THEN PLACED IN DIFFERENT TANKS TO FIX THE COLOR.

13. WASHING THE FABRIC.

14. DETAIL OF A PRINTING SCREEN.

15. THE TECHNICIAN POSITIONS THE REGISTRATION MARKS WHERE HE IS GOING TO PLACE THE SCREEN.

16. COLOR CONTROL ON A SAMPLE FABRIC.

17 AND 18. MANUAL PRINTING SCREENS.

19. THE PRINTED FABRIC AFTER THE INITIAL PRINTING.

20. FINAL STAGE: DRYING THE FABRIC BEFORE ROLLING IT.

21. STORAGE AREA FOR THE PRINTING SCREENS.

Jewelry making with Elena Cantacuzène

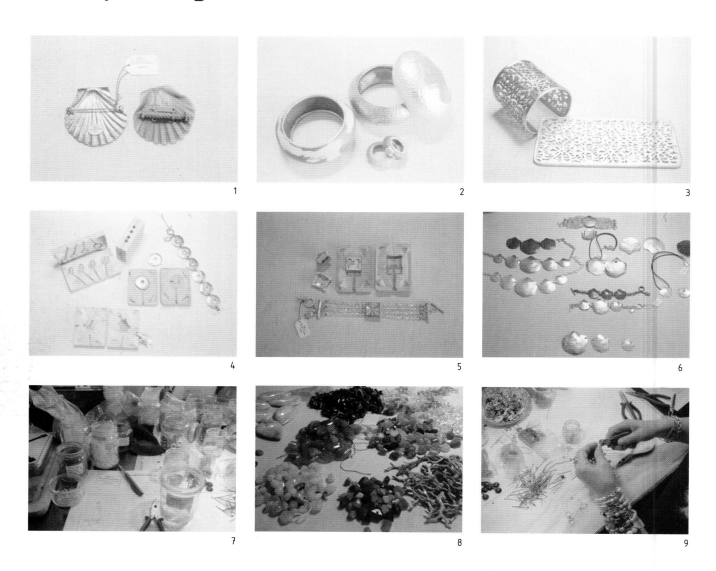

1 2 3

4 5 6

7 8 9

In collaboration with her assistants, Elena Cantacuzène designs the main pieces for her collection, which will ultimately be made into ranges. A model maker produces prototypes from her original designs, which she checks afterwards. Once approved, they are sent to a gilding foundry where a mold is made for the pilot production. Ten examples are produced in three colors (gold, bronze and platinum). Cantacuzène makes three versions of the same model in different

sizes: small, medium and large. These models will then be made into a brooch, pendant and bracelet. The sets are produced based on orders placed at specialist trade shows such as Bijorca in Paris.

Germany supplies the carved stones on demand. The shells, mother-of-pearl and wood come from the Philippines; the glass and crystal from China; and the blown glass from Murano in the Venitian Lagoon. The beads she uses the most of are made from natural and freshwater

pearls, shells, glass and plastic. For the natural and freshwater pearls Elena uses vegetable dyes with colors ranging from white to pink and golden. The pearls need to be soaked in the dyes for six months, and this obviously needs to be taken into account when orders are placed.

She lists the precious and semi-precious stones most frequently used in her jewelry as follows: amethyst, rose or smoked quartz, turquoise, rock crystal,

10

11

12

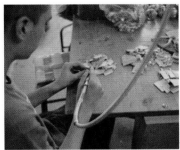

13

14

15

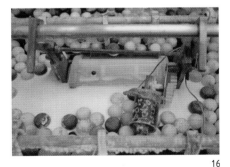

16

17

18

cornelian, green rutile, serpentine, agate, red or green garnet, chrysoprase, fossilized jasper, amber, calcite, obsidian, moonstone, chalcedony, lava, coral, opal and aquamarine. The accessories, stems, clasps, wires, and so on are supplied by different manufacturers.

1. SHELL BROOCH AND RESIN PROTOTYPE (ON THE RIGHT).

2. BANGLES AND RINGS.

3. GILDED METAL CUFF BRACELET, AND TIN PLATE PROTOTYPE BEFORE BEING SHAPED.

4. FLAT RING MOLDS (ON THE LEFT).

5. MOLDS (AT THE TOP) FOR SYNTHETIC CRYSTAL AND BRACELET.

6. SHELL FORMS WITH BRONZE, GOLD AND PLATINUM EFFECT.

7. CONTAINERS FOR GLASS BEADS.

8. GLASS BEADS.

9. THREADING THE BEADS.

10. THE GILDER PREPARING THE RESIN MOLDS.

11. MODELS AND MOLDS.

12. THE MOLD IS FILLED WITH PEWTER.

13 AND 14. PEWTER CASTS IN THE MOLD.

15. ONCE THE MOLDED PIECES ARE REMOVED, THE GILDER GRINDS OFF ANY BUMPS, ETC.

16. THE POLISHED PIECES ARE GALVANIZED WITH A PROTECTIVE LAYER OF ZINC.

17. THE POLISHED PIECES ARE SOAKED IN AN ACID BATH.

18. THE FINISHED PIECES ARE RINSED AND HUNG UP TO DRY.

Maroquinerie or leather goods usually refers to a group of products that are made from leather, such as wallets, purses and handbags, and that are covered in one way or another in order to protect the material. The shapes will vary depending on what they are required to contain, e.g. makeup bags, toiletry bags, overnight bags, etc.

Keeping abreast of the times, designers have introduced new materials such as vinyl or neoprene to either complement or at times replace leather. The techniques and basic shapes are continually revised. However, the techniques remain unchanged, and a good working knowledge of these methods greatly helps in the manufacture of particular bags.

There is a distinction between rigid and supple bags. Rigid

bags are made from materials that require very specific sewing techniques; supple ones, on the other hand, are made from leathers that can be sewn and then turned inside out. In this chapter, the rigid and supple bags are made from stiff cardboard and felt respectively; the cardboard more or less imitates rigid materials, whereas the felt, being a nonwoven material, is similar to supple leathers. The techniques and methods used in the manufacture of soft bags are close to those used in garment making.

With leather goods, the finishing stages require special tools. A style can have a smooth edge that is finished with piping (e.g., cylindrical trim), or require a particular finishing technique. Each brand has its own methods and trademark – for

example, Hermès and its saddle-stitch, or even Louis Vuitton's coated canvas items that are reminiscent of travel trunks.

In this chapter we present the basics: a tote bag and a shoulder bag with a flap. The bags with made by Fatron Hosoi in felt from the basis for the supple bags. The techniques described for the rigid bags offer great scope for a number of variations on a theme. These are explained step by step, and result in a finished prototype.

In order to understand the work involved when working with leather, we have chosen to list the process in detail. However, we have simplified certain stages for better understanding of the working methods.

Tools

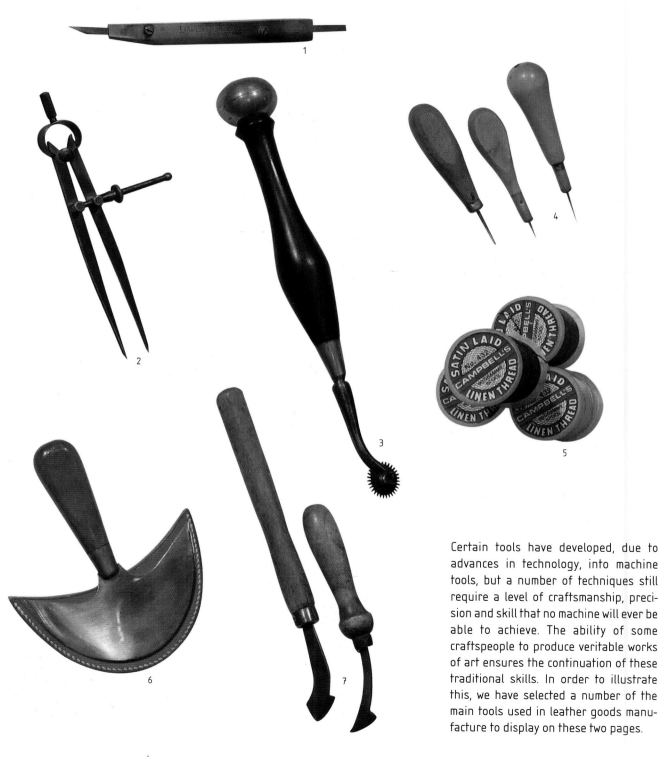

1

2

3

4

5

6

7

Certain tools have developed, due to advances in technology, into machine tools, but a number of techniques still require a level of craftsmanship, precision and skill that no machine will ever be able to achieve. The ability of some craftspeople to produce veritable works of art ensures the continuation of these traditional skills. In order to illustrate this, we have selected a number of the main tools used in leather goods manufacture to display on these two pages.

1. Leather knife.

2. Adjustable compass: tracing tool used mainly to transfer measurements.

3. Roulette: tracing tool used to mark stitch holes at regular intervals. Griffe or claw tools can also be used. They have fairly long and evenly spaced teeth. Either one or other is used depending on the type of stitching to be done.

4. Awl: piercing tool used for making holes in the leather.

5. Linen thread: used for hand stitching.

6. Head knife: cutting tool.

7. Threading irons: cutting tools that, when hot, allow the leather edges to be threaded by marking them.

8. Paring knife: cutting knife used to reduce the thickness of the leather. It is used by scratching the underside of the leather.

9. Hole punch: this cutting tool is used to remove a predetermined shape in conjunction with a hammer. It makes the necessary holes for rivets, snaps etc. It can also be used for making holes in belts and straps.

10. Bone folder: tracing tool used for finishing details and flattening stitches. Pliers have the same function.

11. Metal ruler: used for measuring and tracing lines.

12. Silver-ink pen: used on the reverse of the leather for tracing lines so that no marks show.

13. Glue pot: special glue made from a gum base, normally used by shoemakers. It is used to secure the leather pieces before stitching.

14. Crepe: rubber used to remove all traces of glue.

15. Weights: necessary for holding the pieces down.

Making card prototypes

1 – Tote bag

A prototype is the first object that is made to scale, so that the proportions of the model can be fully understood. If it is approved, it will then serve as the pattern for the bag's final manufacture.

The bag's pattern, which is illustrated here, is constructed symmetrically, i.e., we will work on half of the bag. Generally, in the case of a symmetrical bag style, the right side will be the same as the left. An asymmetrical bag is treated in the same way, but its modifications are taken into account.

In order to make it easier for the reader in the following step-by-step photos, we have labelled the top and the bottom of the bag with the letters "h" and "b."

This bag is trapezoidal in shape with stitching along the edges. It is made up of five main pieces: a front and identical back, two identical sides (or gussets) and a base. The enchapes

– reinforcing pieces where the handle buckles are attached – are drawn on the front of the bag; these show the position of the handles. The first stage of these step-by-step photos demonstrated how to make the templates that are used to make the patterns. After that, we demonstrate how the prototype is assembled.

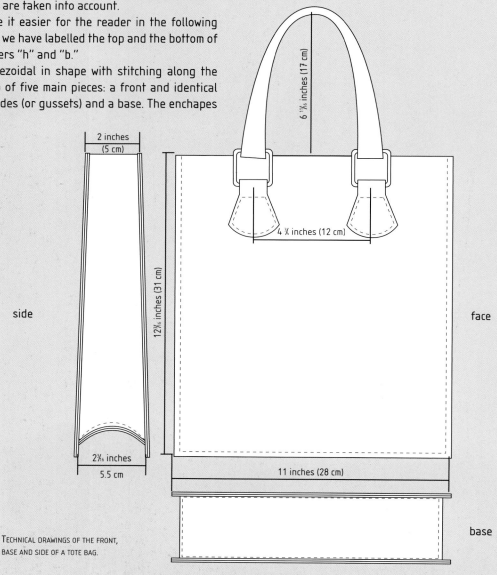

TECHNICAL DRAWINGS OF THE FRONT, BASE AND SIDE OF A TOTE BAG.

side

face

base

2 inches (5 cm)

6 ¹¹⁄₁₆ inches (17 cm)

4 ¾ inches (12 cm)

12⁷⁄₁₆ inches (31 cm)

2³⁄₁₆ inches 5.5 cm

11 inches (28 cm)

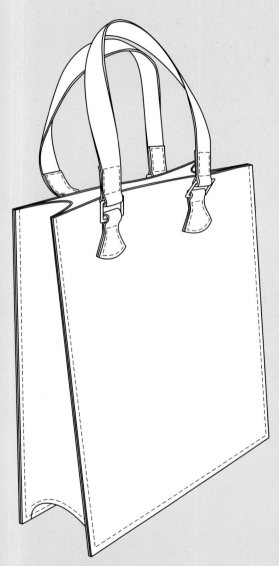

THREE-QUARTER VIEW OF BAG.

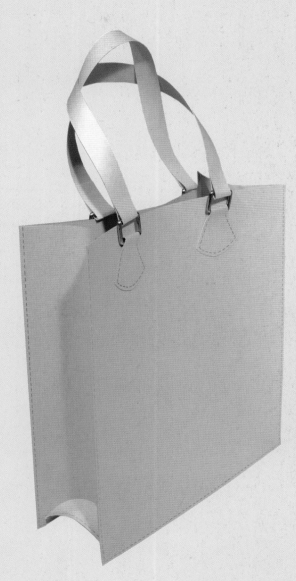

CARD PROTOTYPE.

Front template

This template, which we have called the "front," is used to make the front and back pieces of the pattern — both pieces being identical.

1. Cut a piece of card slightly larger than the dimensions of the front of the bag.

2. Using a cutter and ruler, score the vertical X axis, applying a slight pressure, to help with the folding. This axis will be the center front of the template. The letter "b" corresponds to the bottom of the bag, with the letter "h" being the top.

3. Fold the piece in two along the X axis, then in the bottom of this piece, use the cutter to make a small incision through the two thicknesses — this is called a "notch." These incisions will serve as location points for the bottom line of the template.

4. Unfold the piece of card and draw a line connecting the two incisions to make the bottom line of the template. Call this line Y. Cut along the traced line. This is a way of achieving perpendicular lines without using a set square. Line Y is perpendicular to the X axis in the center back. Place the pen point (c) at the intersection of the X and Y lines.

5. Once the card has been cut following line Y, trace half the width of the bottom of the template. Fold it again along the vertical X axis. Measure half the length of the bottom of the bag along line Y from point c, which is 5½ inches (14 cm) — for a bag with a width of 11 inches (28 cm) — and mark this point (a) with the pen.

6. From point a measure a parallel line from the X axis to the top of the bag, in this case 12³⁄₁₀ inches (31 cm), and make an incision through the two thicknesses of card with a cutter.

7. Unfold the card and, using a pen, connect the notches in order to draw the top of the template. Call this line Z. Place the pen point c' at the intersection of lines Z and Y.

8. To determine half the measurement of the top width of the front template, place a pen point (a) on line Z, being 5⁵⁄₁₆ inches (13.5 cm) from point c' (for a bag with a top width of 10⁵⁄₈ inches (27 cm).

9. Connect biro points a and a' to trace the side line of the template: this will make the front template of half the bag.

10. To cut half the template, place the ruler on line Z. Using the cutter, cut the card between points a' and c'. Remove the surplus card by cutting line X from point c' up to the top of the card.

11. Using the ruler, draw a line along the side line (a' a) and cut the card following this line.

12. Half of the front template is now done.

13. Fold along line X then fold the cut half (c a a' c') over onto the other side, cutting it off symmetrically.

14. Place the ruler onto line a a' and cut off the side.

15. Place the ruler onto line a' c' and cut along this line.

16. Open the template up: we now have the template for the front of the bag.

Enchapes pattern

The enchapes are the pieces of leather that hold the handle rings or buckles on the front and the back of the bag. Draw the enchapes onto the front of the template (Fig. 1), placing them symmetrically in relation to the center front. In this case the enchapes are trapezoidal, but they can be any shape — triangular, rectangular, etc. – depending on the design. The top part of the enchape is determined by the width of the chosen buckles.

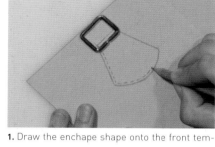

1. Draw the enchape shape onto the front template, on one side only — in this case on the left side. This shape serves as the pattern for the enchapes. It is folded in two to enclose the buckle. For a height of 2 inches (5 cm), the pattern should be twice that, i.e., 4 inches (10 cm) high.

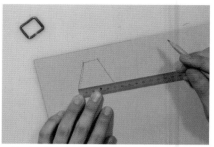

2. Mark off the measurements of the enchape (2 x 2 inches or 5 x 5 cm). These correspond to the size of the finished enchape once it is on the bag. This measurement is multiplied by two for the height, i.e., 4 inches (10 cm) high for a width of 2 inches (5 cm) wide.

3. Cut out a piece of card bigger than the finished enchape, i.e., 6 x 4 inches (15 x 10 cm) for one being 4 x 2 inches (10 x 5 cm). Place the card in the direction of its height, then, pressing slightly, use a cutter to score the vertical line V in the middle of the piece of card.

4. The horizontal line H must intersect the V line at the halfway point, and these two axes should be perpendicular to each other. To mark the H line, fold the card over symmetrically on the V line. Mark the sides with the cutter, making sure to go through the two thicknesses.

5. Treat the same way as the template for the front of the bag, i.e., once unfolded, draw a line joining the two points. This will produce the horizontal line H. The point where the two lines intersect will be the center of the card. Pressing lightly, use the cutter to mark line H. Mark o at the intersection of lines V and H.

6. To trace half the height of the enchape, fold the card along line H and make a pencil mark 2 inches (5 cm) underneath this line (for a height of 4 inches, or 10 cm). Make sure it is symmetrical in relation to line V.

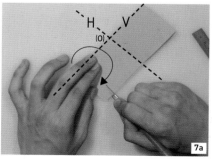

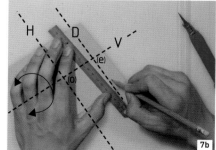

7. Unfold the card and fold it along line V. Mark this point with a cutter (Fig. 7a). Unfold, then using a pencil join up these marks. This will produce line D which corresponds to half the height of the enchape (Fig. 7b). Mark point e at the intersection of line D and the V axis.

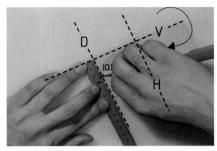

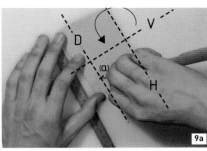
9a

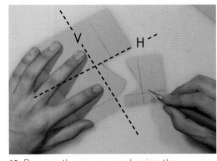
9b

8. To trace half the width of the enchape, fold the piece of card along the V axis and make a pencil mark (a) 1 inch (2.5 cm) underneath this on line D (for an enchape with a 2 inch, or 5 cm width). Make sure this point is symmetrical to the H axis.

9. Unfold the card and refold along the H axis. Use a cutter to mark point a (Fig. 9a). Unfold, then use a pencil to join up the marks: this will give you line P which corresponds to half the width of the enchape (Fig. 9b). Mark point c at the intersection of line P and the H axis.

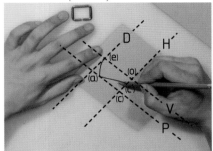

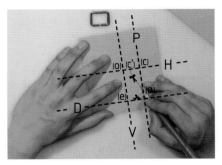

10. Axis H corresponds to the fold of the enchape, which will contain the buckle (see the result in Fig. 13). Position point c' so that line oc' is equal to half the width of the buckle, i.e., ⅜ inch (1 cm) for a buckle that is ¾ inch (2 cm) wide. In the rectangle oc'ae, starting at point e and going to point c', draw a quarter of the enchape's shape. This is then symmetrically reproduced to obtain the whole shape of the enchape.

11. Cut out a quarter of the enchape.

12. Remove the excess card using the cutter and duplicate this quarter by folding along the H and V axes.

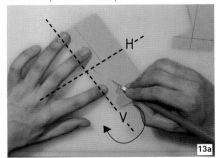
13a

13b

13c

13. Fold along the V axis (Fig.13a) then cut the second quarter symmetrically (Fig. 13b). This will give you half the enchape (Fig.13c). Fold along H axis and cut again (Fig.13d). Unfold the card (Fig.13e) to reveal the finished pattern for the enchape.

13d

13e

14. Check that the handle buckle fits comfortably into the enchape.

15. On the bag's front template, rub out the previously drawn enchape. Now the correct enchape can be traced onto the front template. To do this, place the enchape pattern onto the folded side of the template. The outline needs to be placed symmetrically so that the other half can be perfectly traced onto the other side. The slightest discrepancy is likely to set the whole bag off-balance both practically and aesthetically.

16. Fold the bag's template in half along the X axis. Then, onto the folded template, trace a straight line V' parallel to the X axis (center front of the template) at a distance of 2⅜ inches (6 cm) from it. Refold the enchape pattern along the H axis. Place the enchape pattern on the front template, carefully lining up the V axis on the pattern and the straight line V' on the front template.

17. Use a pencil to draw the outline of the enchape onto the front template.

18. Redraw the pencil lines a bit harder, if necessary.

19. Using an awl, prick out the outline of half of the template, making sure to press quite hard to ensure you go through both thicknesses of card. The crosses in the photo illustrate important points to mark with the awl.

20. Unfold the front template. On the second half of the template, place the enchape template on the awl marks and trace the outline using a pencil.

21. Redraw the pencil lines a bit harder if necessary.

Template for the sides (or gussets)

The front template is also used to construct the gussets.

1. Set the adjustable compasses, or dividers, to measure ⅜ inch (1cm).

2. Using the compasses, and being guided by the edge of the template, trace line G parallel to line Y (bottom of the template), and line J parallel to the edge of the front template. Mark point i where lines G and J intersect; this point allows you to make the base of the gusset.

3. The gusset width is 4¾ inches (12 cm) and the bag height is 12³⁄₁₆ inches (31 cm). With the front of the bag being trapezoidal, the length of the side is slightly greater than the height of the front. It is important to get the exact height of the side (which will obviously be bigger than 12 ³⁄₁₆ inches). Cut a piece of card bigger than the gusset, i.e., 6 x 13¾ (15 x 35 cm). Position the front template on this piece of card, allowing about ⁹⁄₁₆ inches (1.5 cm) on the side. From line Y on the front template, trace a pencil line S, onto this piece of card. Where the side line, and line Y intersect, mark with a pencil point (f).

4. Use an awl to prick point i, pushing quite hard in order to go through the two thicknesses.

5. Mark point I' at the intersection of line J on the front template, and line S on the gusset.

6. Remove the front template, then, on the gusset, join up points i and I' with a pencil line.

7. Place the front template back onto the gusset. At the intersection of the side line (a' a) and line Z (top line of the front template), mark point k on the gusset. Join up points k and f to trace the height of the gusset.

8. The gusset measures 4¾ inches (12 cm) wide. To con-struct this width, the vertical axis V of the gusset must be traced on. This V axis is parallel to the straight line fk. With a cutter, mark point k' 2⅜ inches (6 cm) from point k which is perpendicular to the straight line fk.

9. Using a cutter, mark point i" 2 inches (5 cm) from point i, which is perpendicular to the straight line fk. In simple terms, ⅜ inches (1 cm) has been deducted from the compass line.

10. Pressing lightly with a cutter, score the V axis of the gusset by joining up points i" and k'.

11. Following the V axis, fold the gusset in two. With the cutter, symmetrically transfer point k on the gusset onto the other half of the card.

12. Unfold, then join up the two points using a pencil line. This line will create the top of the gusset.

13. Fold again on the V axis, then, using an awl, prick through point i to the other half of the card.

14. Unfold, and join up point i and the other point created by the awl on the other side. Call this line S. At the intersection of the V axis and line S, mark a point (m). The line that passes through points m, i, i" and f shows the shape of the bottom half of the gusset. At the side and bottom of the gusset there will be an area of ⅜ inch x ⅜ inch (1 cm x 1 cm): this will be needed for the final assembly.

15. Cut away the half-drawn area, stopping at the V axis.

16. Fold in two along the V axis.

17. Cut the side of the gusset symmetrically.

18. Cut the top symmetrically.

19. Cut the base symmetrically.

20. Unfold to create the gusset.

Base pattern

To make the base pattern, cut a piece of card larger than the dimensions of the base, e.g., 13¾ x 7⅞ inches (35 x 20 cm) if the base is 11 x 4¾ inches (28 x 12 cm). Place the card vertically, then using a steel ruler and cutter, lightly score the horizontal axis H in the middle of the card.

1. Fold in two along the H axis and, using the cutter, mark off the edge of the card as is shown in the photo. Apply enough pressure to mark the two thicknesses of card.

2. Unfold and join up the two cutter marks. Press lightly to score a vertical axis V. The H and V axes are perpendicular and intersect in the middle.

3. Use the gusset to trace out the half-width of the base. This is equal to the distance between points m and i on the gusset, added to the distance between points i and i". Place the gusset onto the base, along the edge of the card, lining up the V axis on the gusset with the V axis of the base. From the V axis on the base, use an awl to transfer point i on the gusset onto the base.

4. Leave the awl on point i. Use this as a rotation point, then pivot the gusset 90 degrees clock-wise around this axis.

5. On the base pattern, mark off point i" on the gusset. Fold the base pattern in two along the H axis and mark off point i" with a cutter so that it goes through the two card thicknesses.

6. Unfold, then join these two points with a pencil. You will now have line A, which corresponds to half the width of the base.

7. Place the bottom of the front template along line A, lining up the V axis of the front and the H axis of the base. With a cutter, mark point o, which corresponds to the intersection of line J, on the front, and line A, on the base.

8. Fold the base in two along the V axis, then mark off point o with a cutter through both the thicknesses of card.

9. Unfold and join up these two marks. This will give you line B, which corresponds to half the length of the base. The area between lines A and B and the axes H and V (marked in orange on the photo) corresponds to a quarter of the base of the bag.

10. Cut out this quarter of the pattern with a cutter, making sure to stop at the H and V axes.

11. Fold the base along the V axis, cutting it symmetrically, then unfold it to obtain half of the base.

Assembling

12. Fold along the H axis and cut the other half symmetrically.

13. Unfold this to achieve the base pattern.

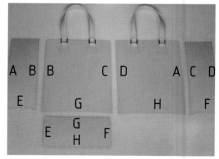

1. Using the resulting patterns, cut out a front, a back, two gussets, four enchapes, a base and two handles. Draw the top stitches ⅛ inch (0.3 cm) from each edge, then use a cutter to mark a fold inside these stitches. This photo shows the different sections of the bag and the method of assembly, i.e., part A joins with part A, B with B, etc.

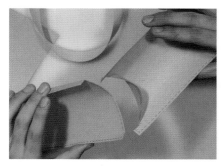

2. Stick the first gusset to the base, taking care not to attach the seam allowance of the gusset as this will be joined to the front and back pieces.

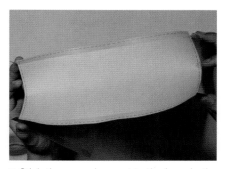

3. Stick the second gusset to the base in the same way as the first.

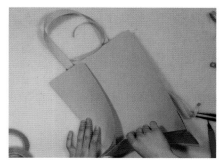

4. Stick the first gusset to the front.

5. Stick the base to the front.

6. This photo shows the gusset's seam allowance stuck against the front, with the bottom of the gusset stuck against the base.

7. Stick the second gusset onto the front. Once the gussets and the base have been stuck to the front, stick them all onto the back.

8. Some detailed photos showing how the pieces are joined to each other. The prototype is now finished.

Making card prototypes

2 – Messenger bag or shoulder bag

This bag, with a shoulder strap and flap, is generally designed for men. Working from the same template, we will make the patterns for the front and the back, and that of the flap. The front and the back are assembled underneath the bag and joined together by an inside seam. The flap is pinned and sewn onto a piece of the back. This type of bag does not have a separate piece for the base. All the pieces are assembled edge to edge, as with the previous tote bag, with the exception of the front and the back, which are joined together by an inside seam.

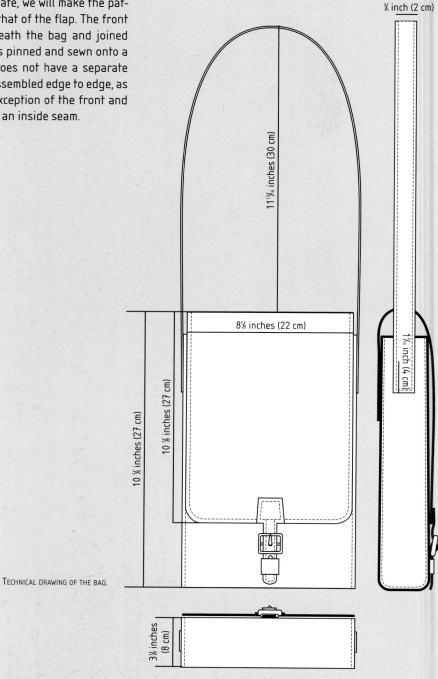

¾ inch (2 cm)

11¹³⁄₁₆ inches (30 cm)

8⅝ inches (22 cm)

10⅝ inches (27 cm)

10⅝ inches (27 cm)

1⁹⁄₁₆ inch (4 cm)

3⅛ inches (8 cm)

TECHNICAL DRAWING OF THE BAG.

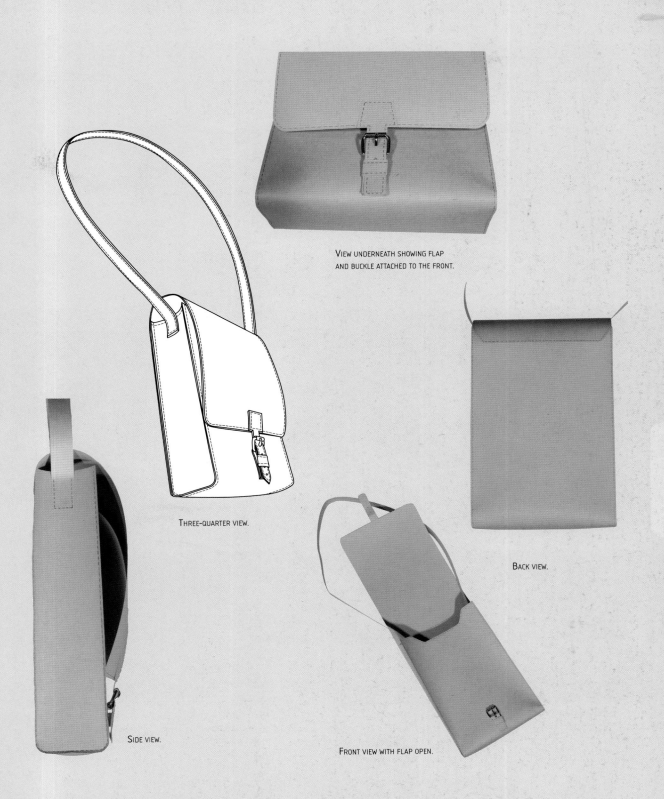

View underneath showing flap
and buckle attached to the front.

Three-quarter view.

Back view.

Side view.

Front view with flap open.

Side or gusset pattern

To make this bag, we have to start with the side, or gusset, which will serve as the basis for construction.

1. Cut out a piece of card slightly larger than the gusset, e.g., 15¾ x 6 inches (40 x 15 cm) for a gusset measuring 12⅜ x 3⅛ inches (31 x 8 cm). Lightly score the vertical axis V with a steel ruler and cutter so that the card can be easily and cleanly folded in two.

2. Fold the piece in two along the V axis and trace the line of the bottom of the gusset (called Y). Mark off the side of the piece 1³⁄₁₆ inches (3 cm) from the bottom, pressing quite hard so that the two thicknesses of card are marked.

3. Unfold. Here we have two symmetrical points. Join up these two points using a pencil, and trace line Y.

4. Fold the gusset in two along the V axis. From line Y, measure off the height, i.e., 12³⁄₁₆ inches (31 cm).

5. Mark off this point using a cutter, pressing hard enough to go through the two thicknesses.

6. Unfold, and join up these two points with a pencil. This will make the top line of the gusset, called Z.

7. On the right of the V axis, mark with a pencil the half-width of the gusset (1⁹⁄₁₆ inches or 4 cm) along lines Y and Z.

8. Join up these two points with a pencil line which we call L. This creates the half-width of the gusset.

9. Draw the curve of the base of the gusset on the right-hand side of the V axis. This curve corresponds to a quarter circle with a diameter of 1⁹⁄₁₆ inches (4 cm) at tangents to lines Y and L. We have just drawn half of the gusset.

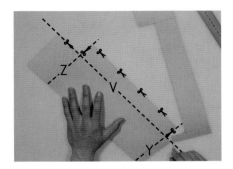

10. Cut the half that has just been drawn, stopping short of the V axis.

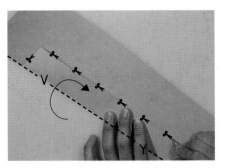

11. Fold the gusset in two along the V axis and symmetrically cut the second half of the piece, using the outline of the first half as a guide.

12. The gusset pattern is finished.

Construction template

This template will help us create the patterns of three different pieces: the front, the back and the flap.

1. We have cut a piece of card about 15¾ x 11¹³⁄₁₆ inches (40 x 30 cm) for a bag that measures 13⅜ x 8⅝ inches (34 x 22 cm). In the middle of the vertically positioned piece of card, lightly score the axis V using a cutter.

2. Fold the card in two along the V axis and use a cutter to mark off a point about 1³⁄₁₆ inches (3 cm) from the bottom on the right-hand side of the card. Press quite hard to mark through two thicknesses.

3. Unfold, and join up the two marks. This line is called X and forms the bottom of the template. Where the V axis and line X intersect, mark a point (o).

4. With a pencil, point a on line X. The distance between points o and a is equal to half the width of the bag, i.e., 4⁵⁄₁₆ inches (11 cm).

5. Along the V axis, mark point c. The distance between points o and c is greater at the top of the bag, i.e., 15¾ inches (40 cm). Point c′ is placed perpendicular to the V axis at 4⁵⁄₆ inches (11 cm) from point c.

6. Join points a and c′. We now have the line of the side of the template.

7. The front and back pieces are the same height, i.e., 12³⁄₆ inches (31 cm). These two pieces are assembled underneath the bag and make up the base. The width of the base must be divided by half between the front and back pieces, and added to the 12³⁄₆ inches (31 cm) of the height of the bag. As the sides of the bag are curved, we will use the gusset to transfer, by pivoting, the measurement of this curve onto the straight line ac′ in order to determine the height of the template. Fold the pattern of the gusset along its V axis. Place the folded gusset pattern on top of the front template. The V axis of this pattern must coincide with the X axis of the front template. Position the bottom of the folded gusset pattern against the straight line ac′. The curve is placed toward the top of the front template. Use an awl to mark off the beginning of this curve on the folded gusset, making sure to go through the two thicknesses of card.

8. The awl will act as a pivot around which we will carefully rotate the curve of the folded gusset, making the curve "roll" along the straight line ac′ C′. This operation allows us to transfer, precisely, the measurement of half the base of the bag and its height. Move the awl all the way along the curve of the folded gusset (Fig. 8a) and repeat this operation until the height of the folded gusset is aligned with the straight line ac′ (Fig. 8b).

9. With a cutter, mark off the height of the folded gusset on the template and mark point c″.

10. Fold the front template in two along its V axis. Symmetrically transfer point c″ onto the other half of the front template, using the cutter to mark the two thicknesses of card.

11. Unfold, and carry point d to the marked spot. Join points c″ and d. We now have the top line of the template. Put point d′ at the intersection of the V Axis and the straight line c″ d.

12. From point d', mark a point (e) 10⅝ inches (27 cm) along the V axis. From point c'', mark point e' 10⅝ inches (27 cm) along the straight line c'' a. Join points e and e' and extend this line up to the edge of the front template: we now have the height of the flap. This procedure is very important for the subsequent ones.

13. On the right-hand side of the V axis, draw half of the tab that will close the flap.

14. The tab will close the bag when it is passed through the buckle, once it is fixed onto the front. Place the buckle on the drawing of the tab so that its position can be determined. Now half of the front template is drawn.

15. Cut the drawn half, stopping short of the V axis.

16. Fold along the V axis and cut the second half symmetrically. The templates of the front, back and flap have now been completed. These will be used to construct the pattern pieces of the front, back and flap sections.

Front pattern

We will use the templates for the front, back and flap to trace off the patterns for these three pieces. We will add seams to the front and back pieces in order to assemble them. The other parts are assembled edge-to-edge and so do not require any extra seam allowances.

1. Cut out a piece of card measuring about 15¾ x 11¹³⁄₁₆ inches (40 x 30 cm). Using a cutter, lightly score the V axis along the center of it. Pin the template onto this piece, precisely aligning the V axis of the template with the V axis of the pattern. Using a pencil, transfer the template's outline onto the pattern. 1⁹⁄₁₆ inches (4 cm) under the top line of the pattern, trace a parallel line and then a diagonal one between these two lines. This creates half of the opening of the bag, allowing enough room to put a hand inside.

2. At the bottom of the front pattern, add a seam allowance of ⅜ inch (1 cm) so that the back and the front pieces can be assembled using an inside seam.

3. Cut out half of the piece, stopping short of the V axis.

4. Fold the piece in two and cut the second half symmetrically.

5. Think about drawing the enchape pattern and that of the tab for closing the flap. The size of the enchape depends on the buckle that is to be used. Do not forget to make a hole in the middle of the enchape for the tongue of the buckle. The position of this enchape would have been decided when the template was made.

6. For the back pattern, proceed in the same way as for the front pattern, as these two pieces are the same size. Trace a parallel line 1⁹⁄₁₆ inches (4 cm) under the top line: this will determine the position of the flap on the back. Stop this seam line 1⁹⁄₁₆ inches (4 cm) from the side and join the upper angle of the bag diagonally. Slightly curve the traced angle. At the bottom of the back pattern, add a ⅜-inch (1 cm) seam allowance so that the front and the back pieces can be joined by an inside seam.

7. We are going to use the back pattern to make the flap pattern. Cut out a piece of card about 15¾ x 11¹³⁄₁₆ inches (40 x 30 cm). Using a steel ruler and cutter, lightly score the vertical axis V along the middle of it.

8. We are going to transfer, onto the card, the outlines of the flap position that have been drawn on the back pattern. To do this, fold the card along its V axis. At the same time, fold the back pattern. Then place the back pattern onto this card, aligning the V axis of the card with the V axis of the back pattern. These two pieces must overlap each other by approx. 2⅜ inches (6 cm). The ruler can help align the two pieces.

9. To trace the top of the flap, we use the cutter to transfer the drawn outline of the top of the back pattern onto the piece of card. The straight lines and curve are pricked through. The exact shape is transferred onto the card by pricking through at different points along the form. In order to produce an identical round shape, add more points, closer together, along the curve.

10. In order to determine half the width of the flap, transfer half the width of the back pattern by marking with the cutter.

11. To determine the position of the flap seam, transfer the top of the back pattern onto the piece of card by marking with the cutter.

12. Unfold, and join up these points using a pencil; we have now produced the top of the flap. The band that has been created, known as the "attachment band," will be glued, then over-sewn. This will fix the flap to the back.

13. The width of the flap is equal to that of the back. We use the back pattern to transfer the width onto the card by marking it at its two extremities.

14. Join up these two points to trace off the half-width of the flap.

15. Here we determine the height of the flap. On the edge of the flap, transfer the necessary measurements: the attachment band of the back, the size of the gusset and the section folded over the front. We already have the measurement of the attachment band; we add on the half-width of the gusset by placing the top of the gusset pattern onto the side line of the flap.

16. Move this point ⅟₁₆ inch (0.2 cm) toward the bottom to take into account the thickness of the leather. Mark off using the cutter.

17. Fold the piece of card along its V axis and mark off again symmetrically.

18. Unfold, and join these two marks by lightly scoring the card so that it can be easily folded.

19. Fold the card along the line that has just been traced, then transfer half the measurement of the gusset by marking off with the cutter through the two thicknesses of card.

20. Unfold, then refold along the V axis, using the cutter to symmetrically transfer the point that has just been marked.

21. Unfold, and join these two marks with the cutter by scoring lightly. This line, known as S, determines the size of the gusset.

22. We are going to trace the last section of the flap by using the front, back and flap templates. Place the top of the template under line S and, using a cutter, transfer the flap measurement onto the piece of card.

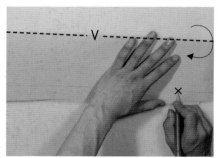

23. Fold the flap pattern in two along the V axis and symmetrically transfer the height of the flap onto the other side.

24. Unfold, and join up the two marks using a pencil line to trace the bottom of the flap.

25. Draw the curve of the bottom of the flap on one side.

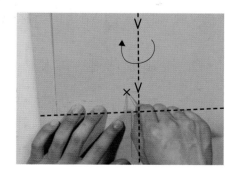

26. Fold the template along its V axis then place it on the flap pattern. Line up the V axes of the pattern and the template and make the line of the flap template coincide with that of the pattern. With the awl, transfer the outlines of the fastening tabs onto the pattern, pressing hard enough to pierce through two layers of card.

27. Draw the section where the tab is fixed onto the flap pattern, and join up these marks with a pencil line.

28. The construction of the flap pattern is finished.

29. Cut out half of the pattern, stopping short of the V axis, then fold in two and cut symmetrically to achieve the finished flap pattern.

Cutting and assembling

We now have the pattern for the bag, which consists of a back, a front, a flap, a side, a shoulder strap, a fastening tab, an enchape and a strap that goes through the buckle. We have made the pattern of a shoulder strap 27⅜ inches (70 cm) long and ¾ inch (2 cm) wide. All that is left to do is cut out the pieces and assemble them.

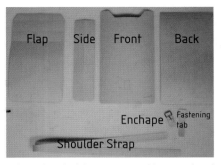

1. At each end of the strap, we add a seam band of 1⅝ inch (4 cm) in length so that the gussets can be assembled. To make the pattern for the fastening tab, the traced drawing must be transferred onto the front template. Also trace the pattern of the enchape, and transfer this onto the front template. (Note: the drawn section only represents half of the enchape, its length is twice that shown in the drawing as it is folded in two to enclose the buckle.) The strap, which measures 1³⁄₁₆ inch (3 cm) long and ³⁄₁₆ inch (0.5 cm) wide, will be fixed into the seams of the enchape.

2. With the help of the patterns, we are going to cut out the parts of the bag: two sides, a front, a back, a flap, a fastening tab, an enchape, a buckle strap and a shoulder strap. Place a weight onto the pattern while cutting, to hold everything in position.

3. Use an awl to prick out important assembly points. For example, mark the position of the enchape on the front, or the position of the fastening tab on the flap.

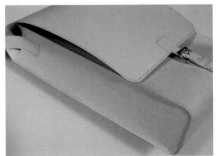

4. Cut out following the outlines of the patterns. Make a light cutter mark in the first instance, then go over this, pressing a bit harder.

5. Use glue to stick all the pieces together. To fix the fastening strap to the flap, place the buckle into the enchape, fold the two halves over and stick them together, enclosing the two ends of the fastening strap. Stick the enchape to the front, then each end of the shoulder strap to a gusset. Assemble the front and the back, then the flap and the back. The gussets are attached to the front and the back edge to edge, with the seams inside out.

6. The final piece.

Making felt prototypes

1 – Cylindrical bag

Flexible or supple bags are made in a leather that can be sewn inside out and then reversed. Felt possesses the same characteristics and is the material chosen to make this bag, which consists of four main parts: two round sides, and an identical front and back. The pattern of this bag also includes some small pieces: handles, straps and tabs. This bag is in fact a false cylinder, as its base is flat. Finishing details must also be considered: sixteen ³⁄₁₆-inch (0.5 cm) rivets, one 9⅞-inch (25 cm) zipper and four detachable rivets.

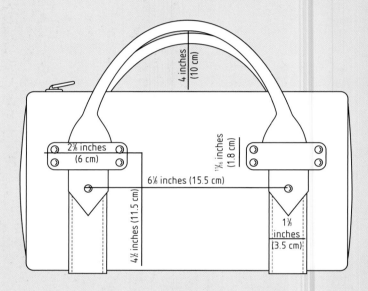

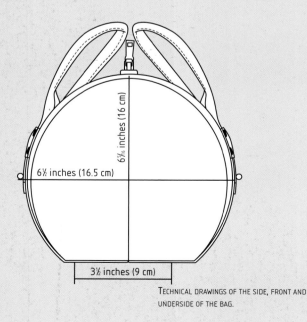

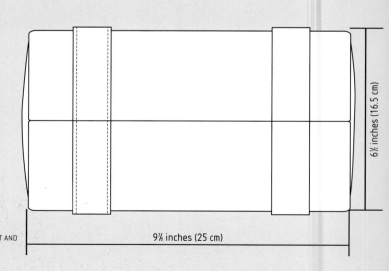

TECHNICAL DRAWINGS OF THE SIDE, FRONT AND
UNDERSIDE OF THE BAG.

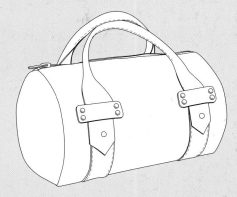

DRAWINGS OF THE FRONT AND THREE-QUARTER VIEW OF THE BAG.

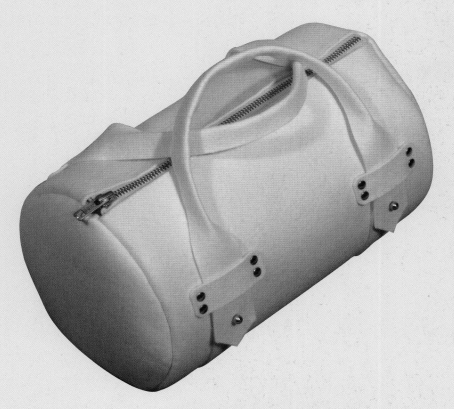

THREE-QUARTER VIEW OF THE TOP OF THE FINISHED
PROTOTYPE.

Preparation

First of all, it is most important to determine the bag's proportions by drawing the flattened shape onto the card.

Draw the flat shape of the bag onto the card. To choose a comfortable length for the handles, place your hand onto the drawing and make a fist to trace around.

Side template

The side template allows you to make the side pattern. Start by tracing the cylindrical shape of the side; add the seam allowance onto this.

1. Cut out a piece of card slightly larger than the side, e.g., 7⅞ x 7⅞ inches (20 x 20 cm) for a bag with a 6½-inch (16.5 cm) diameter. In the middle of the card, use a ruler and a cutter to lightly score a vertical V axis for the template so it can be folded in two.

2. Fold the card on its V axis. Use the cutter to make a mark on the side of the card at the bottom right-hand side of the V axis. Press hard enough to go through the two thicknesses of card.

3. Unfold. We now have two perfectly symmetrical marks. Join them up using a pencil line to trace the bottom line of the side template. We call this line A.

4. The base of this bag is flat; it is from this point that the tracing starts. On line A and right of the V axis, indicate with a pencil mark half the width of the bottom of the side — 1¾ inches (4.5 cm) for a base that is 3½ inches (9 cm). We will call this point a.

5. Fold the card in two along the V axis. On the side of the card, place a ruler perpendicular to line A and, with a cutter, mark off the height of the side, i.e., 6⅜ inches (16 cm). Press fairly hard so as to pierce through the two thicknesses of card.

6. Unfold the card and join up these two marks. This will give the top line of the side template. We will call this line R. Place a point (o) at the intersection of line R and the V axis.

7. Join points o and a by tracing an arc freehand. Its center is in the middle of the V axis, giving a diameter of approx. 6½ inches (16.5 cm). To trace this arc, start at a tangent with line R going up to point a. A French curve will give you a very good line!

8. Using a cutter, cut out this curve from point o to a, stopping short of the V axis. Use a French curve to cut out the curve properly afterward.

9. Fold the card in two along the V axis. With the dividers, measure ³⁄₁₆ inch (0.5 cm) and trace a seam allowance of ³⁄₁₆ inch (0.5 cm) following the outline of the folded half.

Front and back pattern

As the front and the back are identical, there is only need for one pattern. We will call this pattern "front pattern." Details, such as the straps and tabs, are also included on this pattern.

10. Use a pencil to transfer the outline of the folded half onto the other half of the card. We will call this line C. With a pencil, trace the seam allowance into the mark left by the dividers. This outside line is called D.

11. Unfold the card and use a cutter to cut along line D. The side template is finished.

1. Cut out a piece of card about 15¾ x 11¹³⁄₁₆ inches (40 x 30 cm) for a bag measuring 6⁵⁄₁₆ x 9⅞ inches (16 x 25 cm). Place the card vertically. Lightly score its vertical axis V using a cutter and ruler so that it can be easily folded.

2. To construct the bottom line of the pattern, fold it in two along the V axis. Mark off with a cutter on the side of the card, at the bottom, on the left of the V axis.

3. Unfold, and join the two points with a pencil line. This will make the bottom line of the front pattern. We will call this line G.

4. Now trace the side line of the front pattern. On line G and on the right-hand side of the V axis, mark off half of the length of the front — 4¹⁵⁄₁₆ inches (12.5 cm) — with a pencil. We will call this point a.

5. Use a pencil to transfer this measurement higher up on the card, perpendicular to the V axis. We will call this point b.

6. Join up these two points to make the side line of the front pattern, which we will call E.

7. At ³⁄₁₆ inch (0.5 cm) right of line E, trace a parallel line from E for a seam allowance. This new line is called F.

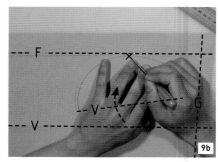

8. To determine the height of the front piece, and so that the bag assembles perfectly, we are going to proceed in the same way as for bag 2 in the previous section. Fold the side template in two. Place this template on the front piece, exactly aligning the angles of the base of the bag with lines F and G. At the start of the curve, use an awl to pierce through, at intervals, what is now three thicknesses of card.

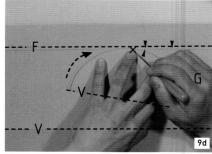

9. We can use the awl as a pivot to carefully rotate the folded template. This is done by "rolling" line D (corresponding to the side line of the bag with seam included) along line F. This operation allows the measurement of half the bottom of the bag, and the height, to be transferred exactly. Move the awl along line F and repeat this operation up to the V axis of the template, which is perpendicular to line F of the front. Mark the template and front with the cutter at regular intervals. Press fairly hard to mark all the card thicknesses.

10. At regular intervals, clip the seam allowance of the side template on the front/back pattern. This clipping will prevent any deforming of the seams when the bag is assembled. Press hard to mark through the two thicknesses of card.

11. Repeat these operations, clipping at regular intervals, at the rate of a clip every two rotations around the awl. It is necessary to mark, then pivot the template, mark again then clip with the cutter, move the template and repeat.

12. When the V axis of the template is perpendicular to line F of the front, mark for the last time with the awl. This last mark indicates the real height of the front pattern. We will call this point h.

13. Remove the side template, fold the front pattern in two along its V axis, and reproduce point h symmetrically onto the two halves of the card.

14. Fold the front pattern along its V axis. Mark off with the cutter ⅜ inch (1 cm) under line G, pressing fairly hard to mark through the two thicknesses of card.

15. Unfold it, and join the marks up with a pencil line. We have just traced the seam measurement for the bottom of the front pattern.

16. This bag is closed by a zipper linking the back and the front. We are now going to take off half of the zipper width, i.e., ¼ inch (0.7 cm). Using the cutter, mark off this length underneath line J.

17. Fold the front in two along the V axis and transfer this mark symmetrically onto the other half of the front.

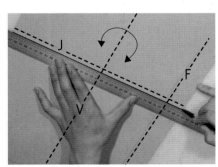

18. Unfold, and join up the pencil marks. We have just traced the line of the zipper. The front and back sections have now been completed.

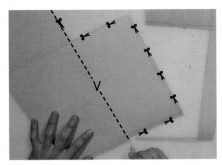

19. Cut out half of the piece, stopping short of the V axis.

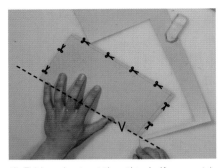

20. Fold, and cut out the other half symmetrically.

21. Cut the seam at the bottom diagonally, as this will help in the assembly and make it easy to transfer the clipped notches symmetrically onto the side.

22. Trace the position of the shoulder strap onto the right half of the front pattern. Trace a parallel line down the middle of this strap, i.e., 3 inches (7.5 cm) from the middle of the front. We will call this line S. Equally divide the width of the strap and S axis — 1¹⁶⁄ inch (1.75 cm), i.e., half of 1⅜ inch (3.5 cm). To mark off the height of the strap, trace a line perpendicular to the S axis at 6⅜ inches (16.2 cm) from line G on the bottom front. Trace this line, P, from the S axis up to the side of the front. On the S axis, place a point 5⅛ inches (13 cm) from line G on the front. This reference mark corresponds to the position of the handle fixings.

23. On each side of line P, we divide symmetrically the measurement of the height of the fastening tab: i.e., ⅜ inch (1 cm) above and below for a tab that is ¾ inch (2 cm) high. We also divide symmetrically the measurement of the width of the tab on both sides of the S axis, i.e., 1³⁄₁₆ inch (3 cm) each side for a tab that is 2⅜ inches (6 cm) wide. To curve the angles of the fastening tab, trace ⅜-inch-diameter (1 cm) circles at tangents to each angle of the tab. The center of each circle corresponds to the position of the rivets. On the front pattern, make an awl mark for the position of the four tab rivets, the fixing points for the handle on the front, and the angles that define where the shoulder strap is placed. Fold in two along the V axis and transfer these points symmetrically onto the other half. When assembling, we will transfer these points onto the felt sections in order to define the exact position of these items on the front and back pieces.

Side pattern

We are now going to make the pattern for the side which will be used for both sides.

1. Cut a piece of card about 8 x 8 inches (20 x 20 cm) for a side measuring 6½ inches (16.5 cm) diameter. Score the vertical axis V in the middle of the pattern using a ruler and a cutter.

2. Fold the card along the V axis and mark off with a cutter, ¾ inch (2 cm) from the bottom right of the V axis on the side of the card.

3. Unfold, and join the two marks with a pencil line. This will make the bottom line of the pattern. We will call this line P.

4. Fold the card again along the V axis. Fold the template in two along the V axis. Place the template onto the card, lining up precisely the V axes of the template and the card as well as line D, on the bottom of the template, and line P, on the card. Cut the card with a cutter following the outline of the template.

5. Transfer the notches of the template onto the pattern using a cutter. Press fairly hard so as to pierce through the two thicknesses of card.

6. The pattern of the sides is now finished.

7. Using the front pattern, construct the patterns for the fastening tabs, straps and bag handles. The pattern consists of a piece for the front and back, and a piece for the two sides. To make the pattern for the straps and fastening tabs, use an awl to transfer the marks of the front pattern onto the pieces of card, and cut. For the handle pattern, cut a strip of card 18½ x 1⅜ inches (47 x 3.5 cm). On this strip, transfer the drawing of the ends as it appears on the front pattern, remembering to mark the fixing point.

Cutting

The prototype of this bag is going to be made in felt. The choice of felt is important: a sewing machine needle is likely to break if a thick felt is used, however, one that is too supple will not give enough rigidity to the bag. We have opted to use a felt of 0.3 cm thickness.

1. Place the pattern onto the felt. Using scissors, cut a piece slightly bigger than the measurements of the front pattern.

2. Place a weight on top of the pattern in order to hold the felt in place.

3. Cut the felt with a cutter, carefully following the pattern outline.

4. Transfer the pattern notches onto the piece of felt.

5. Use a fabric pencil to mark the position of the rivets and strap outlines.

6. Use a fabric pencil to mark the position of the handles.

7. On the piece of felt we can see the notches and marks that we have just transferred.

8. Repeat the process for cutting the back, as this piece is identical to the front.

9. Cut out the small pieces for the tabs, as here, taking care each time to transfer the position of the rivets onto the felt with a fabric pencil.

10. We have just cut out a front, back, two sides, four straps, four tabs and two handles.

Assembly

This bag is sewn first, then reversed. We will assemble the different pieces inside out, then reverse the bag so that the stitches are on the inside, therefore invisible.

1. Stick the straps onto the front and the back so that they do not move once the sewing starts. Rubber-based glue is used by shoemakers; it can normally be found in art supply or craft stores.

2. Machine sew the straps to the front and the back, using a ⅛ inch (0.3 cm) stitch. Work slowly so that a rectangular overstitch can be made.

3. Using a hole punch, make holes for the rivets on the front and back pieces.

4. Here we have eight rivet holes and two fastening studs for the handles.

5. Using the hole punch, make holes for the rivets for the four attachment tabs.

6. Fix the attachment tabs to the front and the back with the rivets.

7. Screw the handle-fastening studs to the front and back.

8. Here we have the rivets and studs secured to the front and the back.

9. The front and the back are now ready to be assembled.

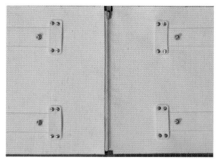

10. Glue the zipper to the front and the back

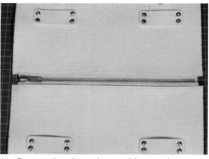

11. Secure the zipper by machine sewing.

12. Fold the front and the back, right side to right side, to assemble the two pieces inside out.

13. From this point on we work on the reverse side of the bag. Stick a side piece to the front and back, right side to right side. Use the notches to align the pieces.

14. Before gluing the second side, open the zipper slightly, otherwise it will be difficult to open it once the bag is reversed. Glue on the second side piece, remembering to use the notches to position it.

15. Sew the sides to the front and the back; choose a claw foot for the zipper fastening. Place the claw foot onto the outside edge of the seam.

16. The angle formed by the bottom of the bag and the curve is the trickiest part to sew. When the needle gets to this angle, it must be sewn into the seam. Lift up the claw foot and pivot the piece, then lower the claw foot and continue sewing. For the difficult parts, control the speed of the machine by manually moving the wheel.

17. The machine sewing is completed.

18. The seam and the zip have been left slightly open.

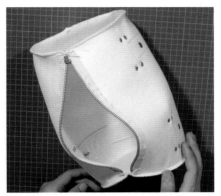

19. All that remains to be done is to open the zipper and reverse the bag again. Flatten the seams with pliers and a folder.

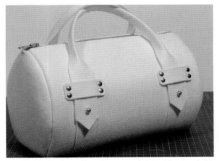

20. Fold the handles in two, right side to right side. Then glue and sew them together to form a rib, stopping 3⅛ inches (8 cm) from each end. Slide the handles through the attachment tabs and fix them to the front and the back. The bag is now finished.

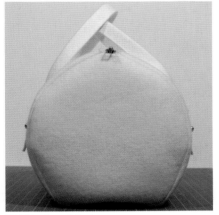

21. Side view of the bag.

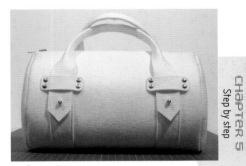

22. Front view.

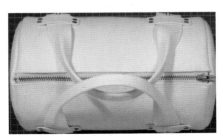

23. Top view.

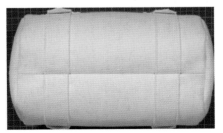

24. Underside view. The front and back straps have been incorporated into the seam between the front and the back.

Making felt prototypes

2 – Tote bag

Here is another example of a tote bag. With this bag we are going to make each side and half of the base from one piece, without a seam. The two sides and the two halves of the base are joined by a seam underneath the bag. There are five principal pieces: a front and an identical back, two sides incorporating the half base, and a handle fixed to the sides, which allows the bag to be carried over the shoulder. Finally, the trimming strips, which are topstitched onto the front and the back, are incorporated into the bottom and side seams. The technical difficulty of this bag is in the construction of the sides, which are larger at the base of the bag than at the top.

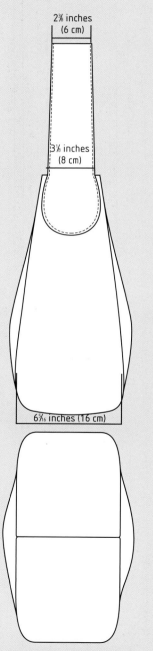

2⅜ inches (6 cm)

3⅛ inches (8 cm)

6⁵⁄₁₆ inches (16 cm)

TECHNICAL DRAWING OF THE SIDE AND BOTTOM OF THE BAG.

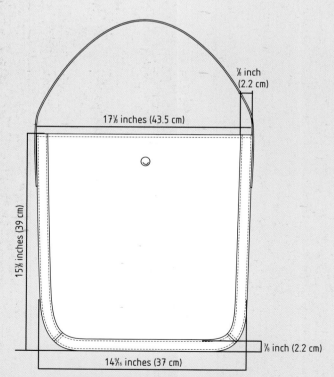

⅞ inch (2.2 cm)

17⅛ inches (43.5 cm)

15⅜ inches (39 cm)

⅞ inch (2.2 cm)

14�9⁄₁₆ inches (37 cm)

TECHNICAL DRAWING OF THE FRONT AND THE BACK.

Bottom view.

Top view.

Side view.

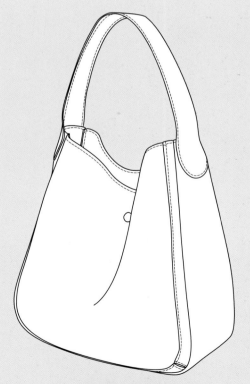

Three-quarter view drawing.

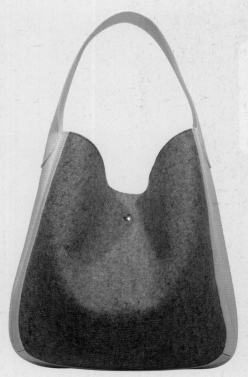

Front view.

Front and back template

This template, which we will call "front," will be used for the back as well, as the two pieces are identical.

1. Cut a piece of card slightly bigger than the front and back measurements, e.g., about 19¹¹⁄₁₆ x 19¹¹⁄₁₆ inches (50 x 50 cm) for a front that measures 17⅛ x15⅜ inches (43.5 x 39 cm). Pressing lightly, score the vertical V axis of the template using a ruler and cutter, so that the piece can be easily folded in two.

2. To trace the bottom line of the template, fold the card in two along its V axis, and using the cutter, make a mark at the bottom left-hand side of the V axis. Press quite hard so that the two thicknesses are marked.

3. Unfold the card: we now have two perfectly symmetrical points. Join these two points with a pencil. We have now traced the bottom of the template, which will call C.

4. With a ruler and pencil, mark off half the width of the bottom of the front, i.e., 7⁵⁄₃₂ inches (18.5 cm), on line c, to the right of the V axis. Call this point d.

5. To trace the top line of the template, place the ruler perpendicular to point (d). Use pencil to mark the height of the front, i.e. 39 cm from line C. Call this point 'e'.

6. Fold the template along the V axis with the cutter and transfer point e onto the other half of the template.

7. Unfold, and use a pencil to join up the two cutter marks, making the top line of the template. We will call this line F.

9. Use a pencil to trace the side line of the template, joining up points g and d. Call this line R.

10. Draw a rounded pencil line on the base of the template. Use a French curve to trace a softer curve. We have now traced half the front shape.

11. We are now going to cut out half of the template using a cutter or French curve as a guide.

12. Cut around line F starting at the V axis following around line R to line C up to the V axis on the other side. Remove the excess card.

13. Fold the template in two along the V axis and transfer the outline of the cut half using a pencil.

14. With dividers or a compass, measure ³⁄₁₆ inch (0.5 cm) from this line for the seam allowance onto the second half of the template, using the cut side as a guide. This seam line is called J.

15. Cut along line J using a ruler and cutter for the straight parts. Mark off the curve with a cutter and go over it several times to cut it out.

16. Unfold the template and turn it over so that line J is on the left-hand side of the template. The front template has now been completed.

17. Draw the bands of stitching detail onto the right half of the template where there is no seam allowance. With a compass or dividers, measure ⅞ inch (2.2 cm) and trace the width of this band using the outline of the template as a guide. To make it easier and more economical to cut out this band, we are going to fold it in two. Trace out this cutting line, K, onto half of the curved base.

18. Draw the top stitches ⅛ inch (0.3 cm) from the band. Place the snap fastener onto the V axis so that the front can be attached to the back, thus marking its position on the template. We now have the front and back sections of the pattern.

Side template

The two sides of this bag are identical. The difficulty in their construction lies in the fact that they start from the center of the underside of the bag, and that they are larger at the bottom than at the top. Before making the pattern for the sides, we must make a template in just one piece, which includes the two sides and the base of the bag. We will call this template the "side template."

1. Cut a strip of card about 51 x 9⅞ inches (130 x 25 cm) for a bag that measures 15⅜ x 14⁷⁄₁₆ inches (39 x 37 cm). Use a ruler and cutter to mark off the template's vertical axis V along its length.

2. Fold in two along the V axis.

3. Mark the side of the card with the cutter halfway along the strip, i.e., 25½ inches (65 cm) for a length measuring 51 inches. Press hard to pierce through the two thicknesses of card.

4. Unfold, and use a ruler and cutter to join up these two marks, which make the template's horizontal axis R.

5. Fold the card along the R axis. We are now going to trace four lines parallel to the V axis. On the card's edge, mark point n with the cutter, 3⅛ inches (8 cm) above the V axis. Press fairly hard to mark through the two thicknesses of card.

6. Mark a second point (m) with the cutter, 1⁹⁄₁₆ inches (4 cm) above the V axis. Press fairly hard to mark through the two thicknesses of card.

7. Mark a third point (p) with the cutter, 3¹¹⁄₃₂ inches (8.5 cm) above the V axis. Press fairly hard to mark through the two thicknesses of card.

8. Mark a fourth point (o) with the cutter, 1¾ inches (4.5 cm) above the V axis. Press fairly hard to mark through the two thicknesses of card.

9. Unfold the template. We now have points m', n', o' and p' symmetrical to points m, n, o, and p in relation to the R axis. Join up m and m', n and n', o and o', p and p'. Line mm' corresponds to half the width of the height of the side. Line oo' corresponds to its seam allowance. Line nn' corresponds to half the width of the bottom of the side. Line pp' corresponds to its seam allowance.

10. The width of the side will get progressively smaller from the bottom to the top of the bag. The base of the bag has the same width as the bottom of the side. We are now going to construct this shape. To do this, fold the side template in two along its R axis. Fold the front template along its V axis. Place the front template onto the side template, carefully aligning the V and R axes of the two pieces. Equally, align line J of the front template with line pp' of the side template.

11. Place the awl on line R of the front template, right at the beginning of the curve. Notch this point with a cutter. The awl acts as a pivot point around which we can carefully rotate the folded template, "rolling" along line J of the front onto line pp' of the side. This process helps create the exact curve of the bag, as well as the height of the side.

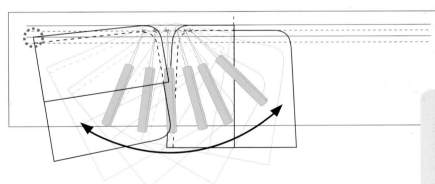

12. On this diagram, we have shown the transfer of the outline of the front template onto the side template.

13. Move the awl along line R of the front template so that it "rolls" on top of line pp' of the side.

14. Place a notch in the middle of the curve at the top of line K. Press fairly hard in order to mark the front and side pieces.

15. Move the awl along line R of the front template so that it "rolls" on top of line pp' of the side.

16. Pivot the front template until line J crosses line oo' of the side template. Notch the end of the front curve. Press quite hard to pierce the card for the front, then mark the front and side pieces. This point is important when assembling later.

17. With a pencil, mark the intersection of lines J and oo'. This point (x) determines the exact height of the side template.

18. With a pencil, mark the end of the front template's curve on line pp' of the side. Call this point y. Use a pencil to join points x and y using the front template as a guide.

19. We have now traced the shape of the side.

20. Unfold the side template and fold it along its V axis. With a cutter, transfer point x symmetrically onto the other half of the template.

21. Unfold, and join the two marks with a pencil. We now have the top line of the side.

22. We have drawn a quarter of the side template shape.

23. Cut out this quarter of the template.

24. Fold the template in two along the R axis and cut it symmetrically, copying the outline of the first quarter.

25. Unfold the template.

26. Fold the template along its V axis and cut it symmetrically again, copying the outlines of the first half.

27. Fold the template in two along its R axis. With a compass, measure ³⁄₁₆ inch (0.5 cm) to trace a seam allowance using the outline as a guide.

28. Use a pencil to go over the compass mark.

29. Fold the template along its R axis. Transfer symmetrically the notches of the curve.

30. The four notches are visible.

31. Fold the template along its V axis and transfer the notches symmetrically. The gusset, or side template, has now been completed.

Making front pattern

We are now going to make the pattern for the front and back pieces from the template.

1. Cut out a piece of card slightly bigger than the front measurements, e.g., 19¹¹⁄₁₆ x 19¹¹⁄₁₆ inches (50 x 50 cm).

2. Using a cutter and ruler, mark off the V axis of the pattern, scoring lightly to mark the fold.

3. Fold the pattern along its V axis. Place the front template, which is also folded on its V axis, onto the piece of card, carefully lining up the V axes. Position a weight on top of these two pieces.

4. Cut along line F using the outline of the template as a guide.

5. Cut out the side, the curve and the underneath in the same way.

6. Transfer the notches of the template onto the card.

7. Remove the template and correct the badly cut notches, as it is not easy to cut through two thicknesses of card in one go.

8. Unfold the card.

9. Place the front template onto the card, lining up the two V axes precisely. With a pencil, transfer line R of the template for the seam allowance. Use an awl to mark the position of the snap fastener.

10. The front pattern is now finished.

Making the side pattern

It is possible to cut out just one piece for the two sides and the underside of the bag. However, the size of the material can restrict this, as is the case with crocodile skin and *shagreen* (a type of sharkskin), which are smallish in size. We are therefore going to cut out two pieces, which will be joined by a seam underneath the bag.

1. Cut out a piece of card slightly bigger than the side template folded on its R axis, i.e., 25½ x 7⅞ inches (65 x 20 cm).

2. Use a ruler and cutter to mark lengthwise the pattern's vertical axis, V.

3. To trace the bottom line of the side, fold the pattern along its V axis and use a cutter to mark the edge of the card on the bottom left-hand side of the V axis, ¾ inch (2 cm) from the end of the card.

4. Unfold, and join up the two marks with a pencil. This will make the center line of the underside of the bag. Call this line D.

5. To include the seam allowance, fold the pattern again along its V axis. Then mark off ⅜ inch (1 cm) beneath line D using a cutter, making sure to go through both layers of card.

6. Unfold, and join up these two marks with a pencil line.

7. We have just traced the seam allowance, allowing us to assemble the two halves of the side.

8. Fold the pattern in two along its V axis. Fold the side template of the bag along its V axis. Place the template onto the pattern, lining up their V axes precisely, as well as the D axis of the template and line R of the pattern.

9. Cut the pattern out using the template as a guide.

10. Remove the template and unfold the pattern.

11. Cut the pattern's seam-allowance line.

12. Cut diagonal angles on the seam, as this will prevent any problems to do with thickness when assembling the bag.

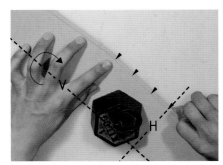

13. Fold the pattern in two along its V axis. Fold the template in two along its V axis. Reposition the template on the pattern, making sure to align their V axes, as well as the R line of the template and the D line of the pattern. Transfer the notches of the template onto the gusset or side.

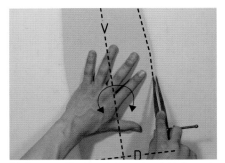

14. Remove the template and unfold the pattern. Using a compass or dividers, measure ³⁄₁₆ inch (0.5 cm) to trace the seam allowance.

15. Use a pencil to re-mark the compass line: the pattern that will be used to cut out the two side pieces is now finished.

Making the handle pattern

The handle of this bag, which is sewn to the two sides, allows it to be worn on the shoulder. We will use the side template to construct its pattern.

1. Draw the position of half of the handle where it sits on the side template. Use a French curve to achieve a perfect arc.

2. Cut a strip of card about 35½ x 6 inches (90 x 15 cm). Use a ruler and cutter to mark the pattern's vertical V axis lengthwise.

3. Fold the pattern in two along the V axis and, on its edge, place a mark halfway along the length of the card with a cutter.

4. Unfold, and join up the two marks using a ruler and a cutter in order to find the horizontal R axis.

5. Fold the side template along its V axis. Fold the handle pattern along its V axis. Place the side template on top of the pattern, lining up their V axes precisely. (The ruler helps to line up these two pieces.) The far edge of the side template must be placed 12⅝ inches (32 cm) from the R axis of the pattern.

6. Use an awl to mark off at regular intervals (approx. every ½ inch) the position of half of the handle. Press fairly hard to ensure you mark through the four layers of card.

7. Remove the side template but do not unfold the pattern. On this pattern, join up the awl marks with a pencil.

8. On the R axis of the pattern, use a pencil to mark half the width of the handle, 1³⁄₁₆ inch (3 cm) from the V axis. Connect this point with the edge of the curve. We have now drawn a quarter of the bag's handle.

9. Cut out this first quarter.

10. Fold the pattern onto its R axis and cut it out symmetrically to create half of the handle.

11. Unfold, and fold the pattern along its V axis. Cut it out symmetrically.

12. The handle pattern is now finished.

13. The pattern can be placed onto the side template to check that its position is correct.

Making the side trimming strip pattern

The bag's side trimmings will be glued and then topstitched onto the front and the back of the bag. The side seams will therefore have three thicknesses: the front or the back, the trimming strip, and the side. We will begin with the pattern of the strip for the front and back sections.

1. Place the front template onto a piece of card so that the exterior outline of the strip can be traced.

2. Use an awl to mark the width of the strip on line K of the front. Press fairly hard in order to go through the layers of card.

3. With the awl, mark point g on the front template.

4. Cut the strip pattern using the front template as a guide.

5. Using the compass, plot the width of the strip, including its seam, i.e., 1⅟₁₆ inch (2.7 cm) — this allows ⅞ inch (2.2 cm) for the width of the strip and ³⁄₁₆ inch (0.5 cm) for the seam).

6. Transfer this measurement onto the side strip pattern.

7. Redo the compass mark with a pencil.

8. Join up the awl marks using a pencil, to create line K on the pattern.

9. Set the compass to ³⁄₁₆ inch (0.5 cm) and trace the size of the seam onto the outside edge of the pattern.

10. Redo the compass mark with a pencil. Cut along line K and the inside of the strip.

11. Draw the top stitches at ⅛ inch (0.3 cm) intervals on the inside of the strip.

Making the pattern for the bottom of the trimming strip

The bottom of the front and back strips are divided in two by the symmetrical V axis on the front of the bag. We can therefore construct half its pattern and then transfer it symmetrically, which was impossible with the side strip.

1. Cut out another strip of card about 15¾ x 4 inches (40 x 10 cm). Use a cutter to mark the horizontal R axis on the bottom front strip pattern.

2. Fold in two along the R axis. Use a cutter to mark the edge of the card that is opposite to the R axis. Unfold, and join up these marks with a pencil; we have now traced line B on the bottom of the pattern.

3. Fold the front template in two along its V axis. Fold the bottom strip pattern along its R axis. Place the front template onto the strip pattern, very carefully lining up the template's V axis and the pattern's R axis, as well as the bottom line of the template and line B of the pattern.

4. Use a pencil to transfer the curve of the template at line K up to line B, stopping at the notches of the curve.

5. Use an awl to plot the width of the trimming strip from line K on the template onto the pattern, starting on the outside line.

5b. Do the same on the inside line.

6. Remove the template and join up the marks with a pencil.

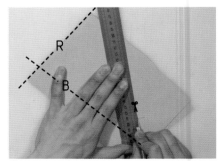

7. Use a cutter to cut out this line, pressing quite hard to ensure you go through both layers of card.

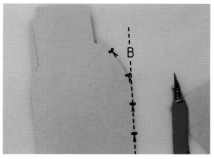

8. Cut the curve as well as line B up to the R axis.

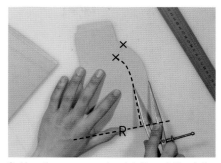

9. Use the compass to plot the width of the strip, including the seam. Transfer this measurement (1⅟₁₆ inch, or 2.7 cm) using the cut outline as a guide.

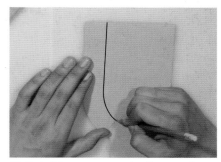

10. Redo this compass mark with a pencil.

11. Cut it out.

12. On the front template, measure the seam allowance, i.e., ³⁄₁₆ inch (0.5 cm).

13. Transfer this measurement onto the bottom of the pattern.

14. Go over this mark in pencil.

15. Unfold. The trimming strips are now finished. This photo shows the top stitches and the added seam allowance for joining them to the sides.

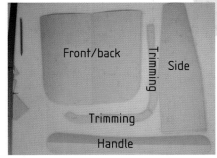

16. The bag's pattern is now finished. We have made patterns for the front and back pieces, the two sides, the handle, the two trimming strips for the bottom of the front and back, as well as four trimming strips for the sides of the front and back. Even for a bag that appears fairly simple, the pattern making can be quite involved and relatively time consuming.

Cutting and assembling

This bag is sewn first, then reversed. We will assemble the different pieces inside-out, then reverse the bag so that the seams are on the inside and therefore invisible. Different colored felts can be used.

1. Place the bottom trimming strip pattern onto a piece of felt using a weight to secure it. Cut around the pattern's outline. Cut a second piece from this pattern and repeat for the four side trimming strips.

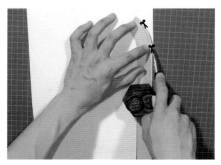

2. Place the handle pattern onto a piece of felt and cut it out. (Be careful not to place the pattern on the selvage.)

3. Cut out the front and the back. Use a fabric pencil to mark the position of the snap fastener on the felt.

4. Transfer the pattern notches onto the pieces of felt.

5. Cut out the two sides.

6. Transfer the pattern notches onto the pieces of felt.

7. Use a fabric pencil to mark the position of the handles on the felt so that they can be correctly positioned when assembling.

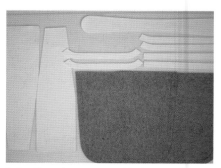

8. In all, we have cut out 11 pieces: a front, a back, two sides or gussets, two bottom trimming strips, four side trimming strips and a handle.

9. With a hole punch and a hammer, make a hole for the snap fastener on the front and back. It is strongly recommended to place something underneath the felt so as not to mark the table.

10. The hole punch and the hammer will make a neat hole for the snap fastener and prevent the fabric from being distorted during assembly.

11. Fix the socket part of the snap fastener onto the underside of the back piece. This fastener is fixed by a rivet, however, there are other types that can be clipped into position. Fix the ballpart of the snap fastener onto the front, on the reverse side.

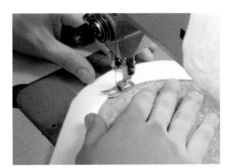

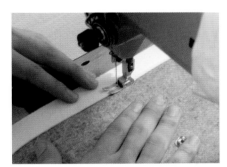

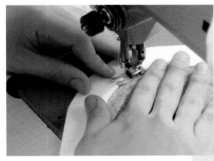

12. Glue the trimming strips onto the front and back pieces. This rubber-based glue can be easily found in art supply and craft stores. Machine stitch the strips onto the front and the back using a ⅛-inch (0.3 cm) length stitch.

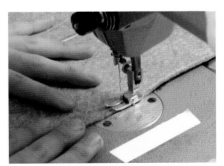

13. Stitch the top of the front and back.

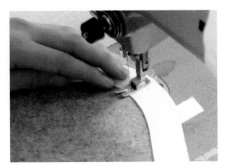

14. Stitch each side of the cutout sections.

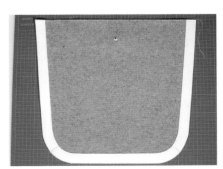

15. The trimming strips have now been successfully joined to the front and back.

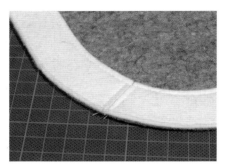

16. Detail of the trimmings and stitches.

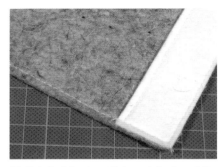

17. Detail of the top stitches at the top of the front and back.

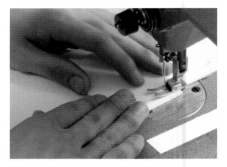

18. Glue the handle onto the sides, and assemble it all using the machine, with a ⅛-inch (0.3 cm) stitch along the edge.

19. Detail of joining the handle to the side.

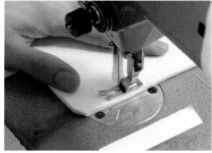

20. Glue the seams inside out underneath the sides, and machine sew them. The handle and the two sides will form a single piece.

21. To assemble the front, back, sides and base, glue the pieces right side to right side, taking into account the assembling notches.

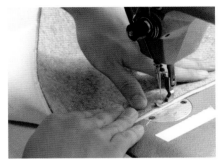 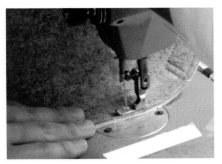

22. Sew the sides and the base to the front and the back. Choose a claw foot for the zipper fastening. Place the outside edge of the claw foot on the outside edge of the seam. The curved part of the bag is the most difficult to sew, so use the machine wheel manually to control the stitch speed.

23. Detail of the base seam.

24. Detail of the reverse of the handle seam. The sewing has been completed. All that remains to be done is to reverse the bag so that the seams are on the inside. Flatten the seams with a bone folder.

Making felt prototypes

3 – Toiletry bag

This bag, which is a rounded rectangular form, is fastened by a zipper. It is made up of a front piece, with a pocket, a back piece, a side or underneath piece, a top piece with a zipper, and a shoulder strap. To make its pattern, we will use the same method as followed for the previous cylindrical bag and tote bag.

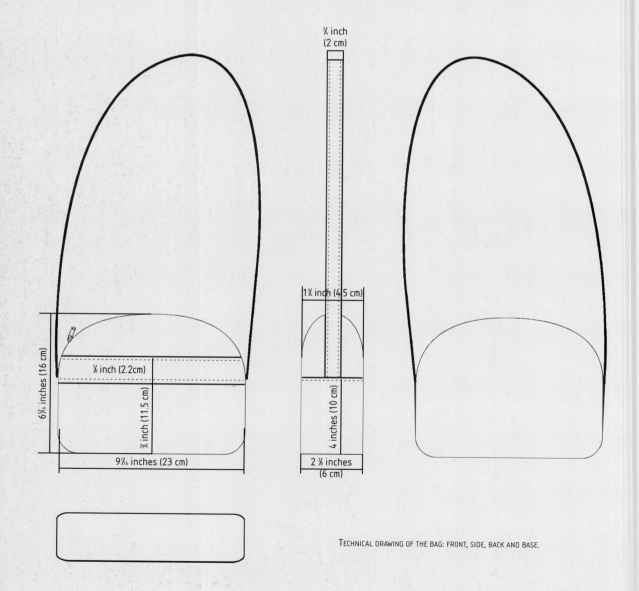

TECHNICAL DRAWING OF THE BAG: FRONT, SIDE, BACK AND BASE.

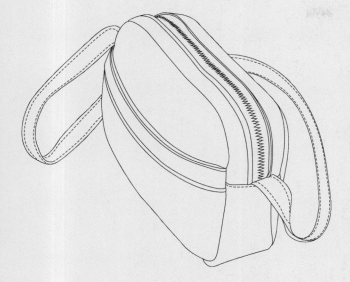

THREE-QUARTER DRAWING.

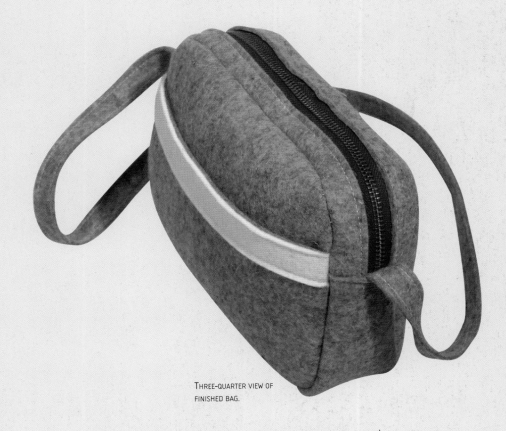

THREE-QUARTER VIEW OF
FINISHED BAG.

Front template

This template, which we will call the "front," is used to construct the back and the front (which are identical) as well as the front pocket. It is necessary to begin by drawing the front shape first, then adding the seam allowance.

1. Cut a piece of card slightly bigger than the front of the bag, i.e., about 11¹³⁄₁₆ x 7⅞ inches (30 x 20 cm) for a front measuring 9¹⁄₁₆ x 6⁵⁄₁₆ inches (23 x 16 cm). In the centre of the card, use a ruler and cutter to mark the vertical V axis of the template, placing it widthways.

3. Unfold the template: we now have two marks that are perfectly symmetrical in relation to the V axis. Join up these two marks with a pencil to trace line A, the bottom of the template.

4. To trace the template's top line, fold again along the V axis. Place the ruler perpendicular to line A on the edge of the card, on the right-hand side of the V axis. Use a cutter to mark a point 6⁵⁄₁₆ inches (16 cm) from line A. Press fairly hard to pierce through the two layers of card.

5. Unfold the template and join up the two points with a pencil. We have now traced line C, the top of the front template.

6. Now trace half the width of the template. On line A, and right of the V axis, use a pencil to mark half the width of the front, i.e., 4¹⁷⁄₃₂ inches (11.5 cm) for a front of 9¹⁄₁₆ inches (23 cm). Repeat this process on line C.

7. Join up these two points to achieve line D, which is the side of the front template.

8. Draw the curves of the side. A French curve helps to trace a softer curve.

9. To give the bag a softer look, we are going to draw the shape by rounding the top and the side. The tracing will go slightly over lines C and D, by a maximum of ³⁄₁₆ inch (0.5 cm).

10. Cut half of the card, stopping short of the V axis.

11. We are now going to add the seam allowance. Fold the template in two along the V axis. Set the compass to ³⁄₁₆ inch (0.5 cm), and trace the seam allowance onto the other half, using the outline of the half-cut card as a guide.

12. Start at the top and work toward the bottom along the V axis.

13. Use a pencil to trace the outline onto the other half.

14. We have cut the second half with a cutter following the seam allowance mark.

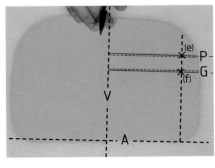

15. We will now draw the pocket and trim strip (which is glued onto this pocket) onto this template. Fold the template along the V axis. On the edge of this card, mark off with a cutter point e, 4¹⁷⁄₃₂ inches (11.5 cm) above line A and perpendicular to this line. Unfold the template and, placing the ruler onto these two marks, trace the top of the pocket, line P, onto half of the template, stopping short of the V axis. Fold the template again, and ⁷⁄₈ inch (2.2 cm) under point e, mark off point f. Unfold the template and, placing the ruler on these two marks, trace the width of the trim, line G, onto half of the template, stopping just short of the V axis. Draw the top stitches, measuring ¹⁄₁₆ inch (0.2 cm) on the inside of lines G and P. The template of the front, back and pocket is now finished.

Pocket pattern

To make the pocket pattern we need to use the front template, where the pocket position has been drawn, and add the outline to this.

1. Cut a piece of card about 12 x 6 inches (30 x 15 cm) for a pocket measuring 9¼₆ x 4¹⁷⁄₃₂ inches (23 x 11.5 cm). In the middle of the card, use a ruler and cutter to score the vertical V axis of the pattern in a widthways direction.

2. Fold the pattern in two along the V axis. Fold the front template in two along the V axis. Place the front template on top of the pattern, carefully aligning the two V axes. Transfer a mark on the far right of line P, pressing fairly hard to go through the four layers of card. Call this point K.

3. Use a cutter to cut through two thicknesses of card following the line of the template's seam allowance. Start from line P and stop at the end of the bottom curve. Call this point j. Mark a notch in the card, without removing the excess.

4. Remove the front template. Unfold the pattern. With the aid of a ruler and cutter, cut out the bottom of the pocket, joining point j with its point that is symmetrical to the V axis. Cut the top, joining point K with its point that is symmetrical to the V axis.

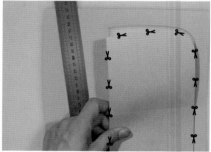

5. We have now cut out the front pocket pattern.

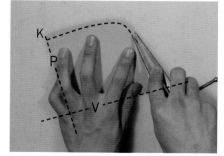

6. Fold the pattern in two along its V axis. Use a compass set at ³⁄₁₆ inch (0.5 cm) to trace off the seam allowance starting at point K, using the edge of the card as a guide. With a cutter, transfer a line onto the pattern ⅞ inch (2.2 cm) under line P on the far right of line G.

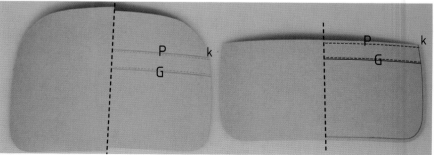

7. Unfold the pattern and join up the two marks with a pencil, stopping at the V axis — as on the template. This will trace line G onto the pattern. Redo the seam allowance mark with a pencil.

8. The pocket pattern is finished. It can now be placed on the front template to check that it is the correct size.

Front pattern

We use the front template, then add the seams to trace the front pattern.

1. Cut a piece of card about 12 x 8 inches (30 x 20 cm) for a front of 9¹⁄₁₆ x 6⁵⁄₁₆ inches (23 x 16 cm). Use a cutter to score the V axis in the center of the card.

2. Fold the pattern in two along its V axis. Fold the front template in two along its V axis. Place the template onto the pattern, carefully lining up the V axes of both the pattern and the template. Cut it out with the cutter using the template's outline as a guide.

3. It may take several attempts to cut through the two thicknesses together.

4. Remove the template. Set the compass to ³⁄₁₆ inch (0.5 cm) and trace the seam allowance, using the edge of the card as a guide.

5. Redo this marking with a pencil. The pattern of the front and back pieces is now complete. We now have the exact measurements of the template and the pattern.

Side template

The side of the bag is the most complicated piece to make. As with the previous tote bag, the bottom of this bag is slightly bigger than the top. The two sides and the base are made from one piece, which begins at the top of the pocket band. The top is made from two pieces that will be held together by the zipper. Therefore, we will make a one-piece template that will include the top, sides and underside pieces.

1. Cut a strip of card that is longer than the total measurements of the top, the sides and the base, i.e., 35½ x 6 inches (90 x 15 cm) for a bag of 9⅟₁₆ x 6⅟₁₆ x 2⅜ inches (23 x 16 x 6 cm). Score the center of the card widthways using a ruler and a cutter. This becomes the vertical axis H of the template.

2. Fold in two along the H axis. Use a cutter to mark off the center of the width on the edge of the card opposite the H axis.

3. Unfold, and score a line between these marks with a cutter. This will trace the vertical V axis.

4. Fold the card along the H axis. We are going to trace four lines parallel to the V axis. On the edge of the card, mark a point (m) with a cutter 1³⁄₁₆ inch (3 cm) above the V axis. Press fairly hard to mark the two layers of card. Mark off another point (n) 1⅜ inch (3.5 cm) above the V axis. Again, press fairly hard in order to go through the two layers of card.

5. Place the cutter at a third point (o), ⅞ inch (2.25 cm) above the V axis. Press hard again to make sure the two layers of card are marked. Then mark off a fourth point (p), 1³⁄₃₂ inch (2.75 cm) above the V axis. Press hard again.

6. Unfold the template. We now have points m', n', o' and p', which are symmetrical to points m, n, o and p in relation to the H axis. Join m to m', n to n', o to o' and p to p'. Line mm' corresponds to half the width of the bottom of the side. Line nn' corresponds to its seam allowance. Line oo' corresponds to half the width of the top of the side, and line pp' corresponds to its respective seam allowance.

7. Fold the side template along its H axis. This axis corresponds to the middle of the underneath of the bag. On the right-hand side of this axis, put a pencil point on line pp'; call this point k. 6 inches (15 cm) to the right of the H axis, put a pencil point on line nn'; call this point k'. Join up points k and k'; this line (kk') corresponds to the place where the bag widens.

8. Fold the front template along its V axis. Place this template onto the side template, lining up the V axis of the front template precisely with the H axis of the side template, and the seam allowance line of the front template with line pp' of the side template. Place the awl on the front template's outline. Use the awl as a pivot around which the front template can be "rolled" along the side template, along lines pp', kk' and nn'.

9. Move the awl along the front template's outline so that it "rolls" along line pp' of the side. At the top of point k, notch the two pieces with a cutter. Press hard to mark through the four layers of card. This notch will act as a reference point when attaching the front and the back pieces to the sides.

10. From this point, pivot the front template along line kk'.

11. In the middle of the curve, notch the two pieces with the cutter, pressing hard enough to go through the layers.

12. At the top of point k' on the side template, notch the two pieces with the cutter. Press hard, to go through the four layers.

13. From this point, "roll" the front template along line nn'.

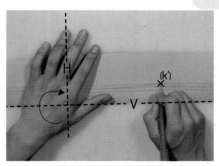

14. Mark a notch at the beginning, in the middle and at the end of the bottom curve.

15. Mark a notch at the position where the V axis of the front template is perpendicular to line nn' of the side template. This point, which we call q, corresponds to the middle of the bottom of the bag. This includes the measurements from the H axis and point q that correspond to the half-width around the bag.

16. Remove the front template. Unfold the side template and fold it along the V axis. Transfer point k' with a cutter and point q symmetrically onto the other half of the card.

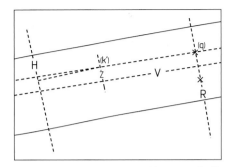

17. Unfold, and join point q and its symetrically opposite point (on the other side of the V axis). Trace a line that is the middle of the base and call it R.

18. Join point k' and its symetrically opposite point (on the other side of the V axis). This point corresponds to the outside of the zipper. Call this line Z.

19. To trace the width of the zipper, set the compass to its width. Fold the template in two along the V axis. Use the compass to trace the half-width of the zipper between the H axis and line Z. Turn the template over and repeat the process on the other side, then unfold.

20. Draw the zipper and its top stitches in pencil on the template.

21. The construction of the side template has now been completed.

22. Fold the card in two along the H axis and cut out half the template, following the exterior outlines, stopping just short of the H and V axes. Unfold, and fold along the V axis, then symmetrically cut out the second half of the template.

23. Unfold. We have now cut the outlines of the template.

24. Fold the template along the H axis and transfer the notches symmetrically.

25. Unfold, and fold along the V axis to transfer the notches so that they are perfectly symmetrical. The template is now finished.

Side: top pattern

This piece consists of the top and the sides up to the join.

1. Cut a piece of card about 13¾ x 4 inches (35 x 10 cm). Mark lengthways, with a cutter, the V axis of the pattern, in the center of the card.

2. Fold in two along the V axis and mark off the center of the piece on the edge of the card.

3. Unfold, and join up the two marks with a cutter so that the H axis of the top pattern is scored.

4. Fold along the V axis. Place this template onto the side template pattern, folded on its V axis, carefully lining up the H and V axes of the two pieces.

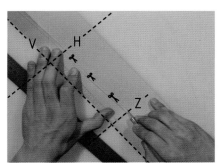

5. Use a cutter to transfer the outline of the side template. Start at the H axis and stop at line Z.

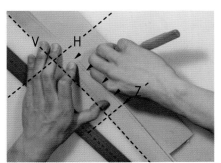

6. Transfer the notches of the template onto the top pattern.

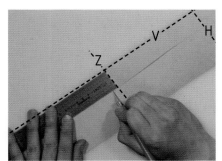

7. Add a ⅜ inch (1 cm) seam allowance to line Z that allows the top and side pieces to be joined.

8. Unfold, and use a cutter to cut out the seam line starting at the V axis.

9. Cut out the first quarter, stopping at the V and H axes.

10. Fold along the V axis. Transfer and cut this quarter symmetrically onto the other half of the card. Unfold, and fold along the H axis. Symmetrically transfer and cut the second half of the pattern.

Side: side and underside pattern

We use the top and side template, onto which we add the seams, in order to trace the side and underside patterns.

11. We now have the top piece of the bag. With the compass set at ³⁄₁₆ inch (0.5 cm), add the seam allowance using the edge of the card as a guide, then go over this with a pencil. Set the compass to ¼ inch (0.7 cm) and trace the lines of the edge of the zipper on each side of the V axis. Go over this again with a pencil to indicate the zipper, the top stitches and line Z.

12. Fold along the H axis and cut the line on the edge of the zipper. We have now cut out the half-width of the zipper on the top pattern. Unfold. The top pattern is now finished.

1. Cut out a piece of card about 23⅝ x 6 inches (60 x 15 cm) to trace the bottom and sides of the bag. In the center of the card, use a cutter and ruler to score, widthways, the H axis of the pattern.

2. Fold the pattern in two along the H axis. Use a cutter to mark off the center edge of the card.

3. Unfold, and join up the two marks with a cutter to score the V axis of the pattern.

4. Fold the side template in two along its V axis. Fold the pattern along its V axis. Place the side template on the pattern, carefully lining up the two axes. Align line R on the template with the H axis of the pattern.

5. Cut the pattern out using the template outline as a guide. Start by cutting at line Z on the template and stop at line R. Use a cutter to mark off the outside of line Z on the template, pressing hard enough to go through the two layers of card. Call this point s.

6. Use a cutter to transfer the notches of the template onto the pattern.

7. Remove the template. Unfold, and cut the line between point (s) and its symmetrically opposite point on the other side of the V axis, stopping short of the V axis.

8. Cut out a quarter of the pattern, stopping at the V and H axes.

9. Fold along the H axis. Transfer and cut this quarter symmetrically on the other side of the card.

10. Unfold, and fold along the V axis. Transfer and cut out symmetrically the second half of the pattern.

11. Fold along the V axis, transferring the notches symmetrically. Unfold. Fold along the H axis and transfer the notches symmetrically again.

12. Set the compass to ³⁄₁₆ inch (0.5 cm) to trace the seam allowance, and draw the top stitches on. The pattern has now been completed, as well as the pattern pieces that form the sides.

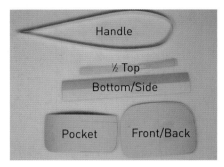

13. We now have a pattern for all the pieces: the front and back, the pocket, half of the top, and one for the underside and sides. All that is left to do is to make a pattern for the strap and another for the top band of the pocket. The strap is a strip of 32⅜₂ x ¾ inches (82 x 2 cm). Make the pocket band pattern by transferring the measurement of this band onto the front template.

Cutting and assembling

We cut out the pieces of the bag from felt, then assemble them with their right-sides together. At the end, they are reversed so that the seams are on the inside. Use the assembling notches to line up exactly.

1. Begin by cutting out the base and side pieces.

2. Once the outlines have been cut, transfer the pattern notches onto the piece of felt.

3. Cut out the top piece. Reverse the pattern and cut a second piece.

4. Once the outlines have been cut, transfer the pattern notches onto the piece of felt.

5. Cut out the pocket piece, transferring the pattern notches onto the felt.

6. Cut the front and the back, then mark the notches.

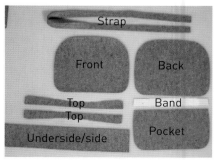

7. We have cut out eight pieces: a front, a back, an underside/side, a pocket, a band, two tops and a strap.

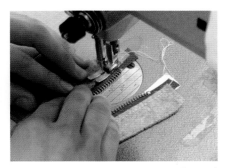

8. Glue the band onto the pocket, then stitch the two pieces ⅛ inch (0.3 cm) from the edge. Stitch the top first, then the bottom. (It is not necessary to stitch the sides of the band, as they will be included in the side seam.)

9. Glue the zipper to the two top pieces.

10. Stitch the top to the zipper ⅛ inch (0.3 cm) from the edge.

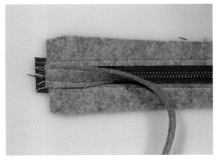

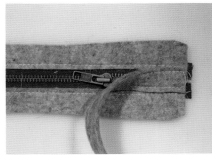

11. After having stitched the strap ⅛ inch (0.3 cm) from the edge, glue it onto the top piece, wrong side onto the right side of the top.

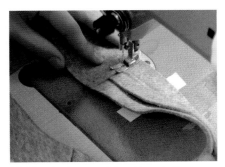

12. Glue the bottom of the side onto the top so that the ends of the strap can be hidden. Stitch them in place ⅛ inch (0.3 cm) from the edge.

13. The assembly of the band that encircles the bag is finished.

14. Detail of the inside topstitching.

15. Detail of the outside topstitching.

16. We are now going to join, on the wrong side, this encircling band to the front and the back. Glue the seam allowances onto the front and back. Assemble the two pieces, right sides together, using the assembly notches as guides. (Before gluing the back, slightly open the zipper, otherwise it will be difficult to open once the bag has been reversed.)

17. Glue the seam allowances onto the back piece. Attach the back to the band, right sides together, using the assembly notches as guides.

18. The bag is assembled inside out and the zipper is slightly open.

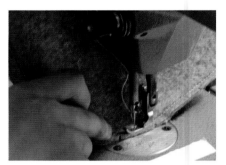

19. Use a claw foot to join the band, the front and back, and the zipper fastening. Place the outside of the claw foot on the outside edge of the seam. The curve of the bag is the most difficult part to sew, so use the sewing machine wheel manually to control the speed.

20. The bag is now assembled.

21. Completely open the zipper and reverse the bag. Use a bone folder and pliers to flatten the seams and soften the curve of the bag.

22. Front view of the bag.

23. Side view.

24. Back view.

25. Top view.

Making leather prototypes

Small tote bag

This leather bag is particular, in the sense that it is made up of two identical pieces each consisting of a front or a back, as well as a side and half of the base. These two pieces are assembled from the base on a diagonal.

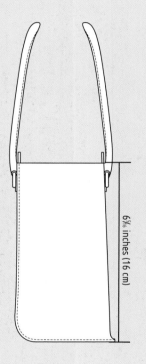

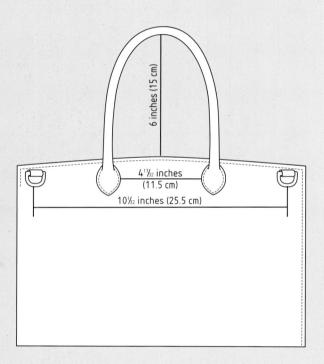

TECHNICAL DRAWING OF THE FRONT, SIDE AND UNDERSIDE VIEWS OF THE BAG.

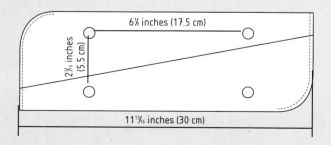

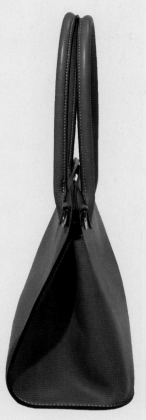

SIDE VIEW OF BAG.

DRAWING OF THREE-QUARTER VIEW OF THE BAG.

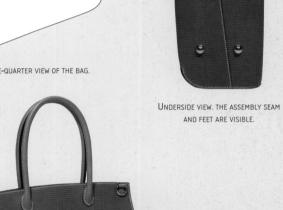

UNDERSIDE VIEW. THE ASSEMBLY SEAM
AND FEET ARE VISIBLE.

THREE-QUARTER VIEW OF CLOSED BAG.

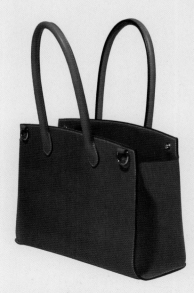

THREE-QUARTER VIEW OF OPEN BAG.

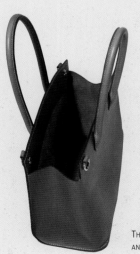

THREE-QUARTER VIEW OF TOP OF OPEN BAG
AND INTERIOR.

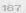

Principal stage of manufacturing

Do some sketches, choose one, then make a small-scale model of it. If it works, then it will be possible to scale up and manufacture.

1. Work begins by researching the shape through a series of drawings on paper. We are going to use the one in the center of the photo for our bag.

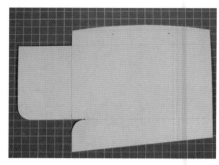

2. We then make a mini pattern at a ratio of about 1:10 of the normal scale.

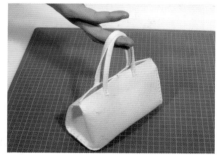

3. From this mini pattern we make a mini prototype in felt. This helps us gauge the possible difficulties we might encounter when making the full-size one. It also enables us to see the bag's proportions and rectify them if necessary.

Making a curved template

To help with the bag's construction, we will make a curved template which assists with tracing the bag's curves.

1. Cut out a piece of card about 7⅞ x 7⅞ inches (20 x 20 cm). Use a ruler and cutter to score the V axis along the center of the card.

2. Fold the curved template in two along its V axis. Mark off in the center of the edge opposite the V axis. Press hard enough to go through the two card thicknesses.

3. Unfold, and join up the two marks to trace the template's H axis.

4. Set the compass to 1⅜ inch (3.5 cm) (this measurement corresponds to the R radius on the template).

5. Place the compass point at the intersection of the H and V axes. On the H axis, right of the V axis, transfer the radius measurement. Call this point a. Transfer the same measurement onto the V axis below the H axis; call this point b.

6. Place the compass (still set at 1⅜ inch, or 3.5 cm) onto point b and trace an arc right of the V axis. Place the compass onto point a and trace an arc below the H axis. These two points intersect at a point which we will call c. This point is the center of the template's curve. Place the compass on point c and trace an arc, D, connecting points b and a. Trace a straight line with a pencil passing through point c and the point where the V and H axes intersect. This line cuts arc D in its center; call this intersection point e.

7. Cut out a quarter of the circle along the V and H axes. Use a pencil to mark points a, b and e.

Making the template for the length

We will now make the template for the flattened-out length, which will be used to precisely construct the straight and curved sections, so that they can be perfectly assembled. This template corresponds to the length of arc D when it is flattened out.

1. Cut out a piece of card about 7⅞ x 7⅞ inches (20 x 20 cm). Trace a straight line, A, 1³⁄₁₆ inch (3 cm) from the edge. It is onto this straight line that we are going to transfer the length of arc D.

2. To do this, mark on line A a point (b') 1³⁄₁₆ inch (3 cm) from the edge. Place the curved template on line A, carefully lining up point b of the curved template and point b' of the straight line A. Place the awl on point b. Use the awl as a pivot around which the curved template can be "rolled" along line A. Move the awl along gradually.

3. Repeat this process until point e of the template is at a tangent with line A. Transfer point e onto line A. Call this point e'.

4. Continue to "roll" the curved template on line A up to point a on the template. Transfer point a onto line A using a pencil. Call this point a'.

5. Cut the whole length of line A using a cutter.

Pattern making

The pattern, including the seam allowances, is made from the template.

6. We have just made two templates, one with a curved part and the other with a straight part, and both have three reference points: the beginning, the middle and the end. The measurement between points b and a of the curved template is equal to the measurement between points b' and a' of the other template.

1. Cut out a piece of card about 27½ x 19¾ inches (70 x 50 cm). In the center of the card score its vertical V axis widthways using a ruler and a cutter.

2. Fold along the V axis. Mark with a cutter, on the opposite edge to the V axis, at roughly a quarter of the height of the piece of card, i.e., about 4¹⁵⁄₁₆ inches (12.5 cm) from the bottom.

3. Unfold, and join the two marks with a pencil to trace line F. This corresponds to the bottom line of the bag.

4. We are going to make the side line of the front, which we will call G. At the bottom left of the V axis, mark with a cutter half the measurement of the width of the front, i.e., 6 inches (15 cm), perpendicular to the V axis.

5. Mark this 6-inch (15 cm) measurement with the cutter onto the top left of the V axis.

6. Join these two marks with a pencil to trace line G.

7. Place the curved template on the right of line G, under line F.

8. Use a pencil to transfer the outline of arc D of the template onto the pattern: draw a pencil line onto the pattern between points b, e and a of the template.

9. Use the awl to mark point e on the pattern.

10. Mark point b on line G. We call this point h.

11. Mark point a on line F. We call this point i.

12. Remove the curved template. We are going to transfer the length of arc D onto line F using the straight template. Place this template onto line F, aligning point i with point a' of the straight template.

13. Use an awl to mark points e' and b' of the template onto line F. Call this last point j.

14. Place a point (o) onto line F, 2³⁄₁₆ inches (5.5 cm) to the left of the G axis.

15. Transfer this measurement to the top left of the G axis.

16 Join these two marks with a cutter in order to score the K axis. This is the vertical axis of the pattern's side section.

17. Fold the card along the K axis. Use the cutter to mark the ends of line G so that the half-width of the side on the half-folded card can be transferred.

18. Unfold, and join the two marks up with the pencil. We have just traced line P of the pattern's side section.

19. Draw the curve of the side section of the bag. Place the curved template to the right of line P and above line F.

20. Use the awl to mark point a of the template onto line P of the pattern. Name this point q.

21. Use the awl to mark point e of the template onto the pattern.

22. Mark point b of the template onto the F line of the pattern. Call this point r. The curve of the side section of the bag is now drawn.

23. The two sections of the bag are assembled diagonally. On the pattern, one side of the underneath section must be drawn longer than the other. Draw the larger side of the underneath section. On line F, use the compass to set the measurement between the side's K axis and point j.

24. Then transfer this measurement onto line G, starting at point h.

25. Mark this point with a pencil and call it s. The measurement between line F and point s is equal to the width of the larger side of the underneath of the bag.

26. Fold the card along the V axis. Mark the ends of line G with a cutter so that the half-width of the front can be transferred symmetrically onto the folded half of the card.

27. Unfold, and join the two marks up with a pencil. We have just drawn line T of the right side of the pattern's front section.

28. To trace the length of the smaller side of the underside section, fold the pattern in two along its V axis. Use the awl to mark through the two layers of card, transferring point q on line P onto the half-folded card. Unfold, and call this point q'.

29. Use a pencil to join up points q and q', drawing a line parallel to line F.

30 and 31. Place the straight template against line T, lining up point a' of the template with the intersection of line qq' and line T. Draw points a', e' and b' of the template onto line T. Call this last point u.

32. Set the compass to measure the distance between point r and the K axis on line F.

33. Transfer this measurement onto line T, starting at point u. Mark point v. The measurement between line F and point v is equal to the width of the small section of the underside of the bag.

34. Join points s and v to draw up the shape of half the bag's underside.

35. Add a ⅜-inch (1 cm) seam allowance under this line sv.

36. With a cutter, mark the measurement of the height of the front onto line G, 7¹⁵⁄₃₂ inches (19 cm) above line F.

37. Fold the front section on its V axis. With a cutter, transfer this measurement symmetrically onto the other half, making sure to mark through the two layers.

38. Unfold, and join the two marks with a pencil to draw line W at the top of the front.

39. To trace the top line of the pattern's side section, use a cutter to mark a point on line G, 1¹⁄₁₆ inch (2.7 cm) under this line. Call this point x.

40. Fold the side section along its K axis and transfer point x symmetrically onto the folded section, marking through the two card thicknesses.

41. Unfold, and use a pencil to join the two marks, drawing line Y, which corresponds to the top of the bag's side.

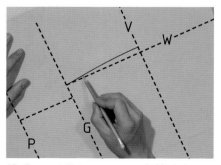

42. Draw a slight curve onto half of the top front, between line G and the V axis. This curve cuts the V axis ⅜ inch (1 cm) above line W.

43. The pattern has now been completed. All that is left to do is to cut it out.

44. Begin by cutting the straight side of the front along line T, starting at the top and working toward the bottom. After this, cut the underneath section followed by the side section.

45. Cut half the top of the front, stopping at the V axis.

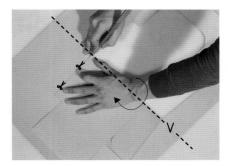

46. Fold the front along its V axis and cut the second half of the top of the front symmetrically.

48. Construct the lining pattern of the bag's base.

49. Construct the front and back shapes, transferring the measurement of the top front.

47. The pattern of this piece has now been finished. Draw on the positions for the handles, buckles and feet (protection).

13¾ inches (35 cm)

1,5cm

50. Construct the pattern for the handles in same way as for the cylindrical bag.

Cutting and assembling the bag

The bag will be made from calfskin.

Flank

Part A

1. The center of the skin (part A) is the best-quality leather. Place the front and back in this section so that the bag is fault free and uniform.

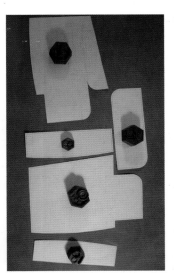

2. The cutting plan is made up of two main pieces, a lining for the base and two shapes for the sides.

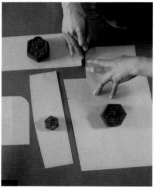

3. Roughly cut out around the pattern using a leather knife.

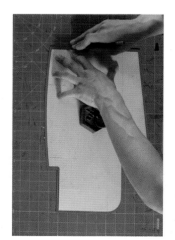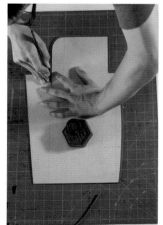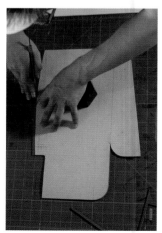

4. Cut again, but this time cut out the pattern outlines very carefully. Work slowly so as to avoid any accidents; leather is much thicker than card and therefore more difficult to cut.

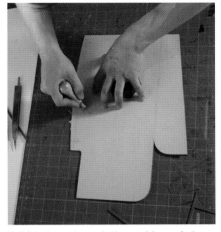

5. With the awl, mark the positions of pieces such as handles and feet (for protection).

6. With the compass, mark the seams using the edges of the pieces as a guide.

7. On the compass mark, use the claw knife to make holes for the seam positions. A roulette can also be used to mark the seam holes at regular intervals.

8. A paring machine is used to thread the edges of the piece. This tool means the leather can be thinned out near the seams, making it easier to assemble.

9. It is also possible to thin the leather with a paring knife.

10. Threading a needle with linen thread in preparation for hand sewing.

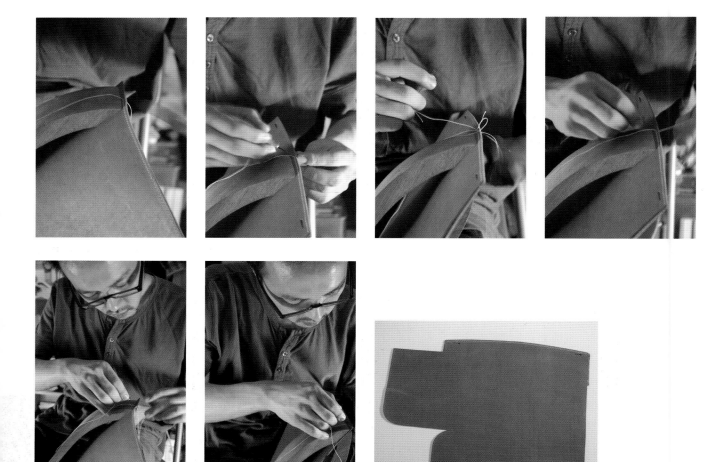

11. Assembling the top piece of the bag with a saddle stitch. The leather pieces are supported by a wooden vise.

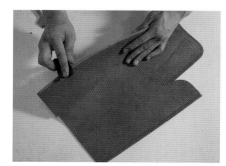

12. Sanding the edges to make them rounder.

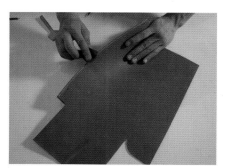

13. Dyeing the cut edges.

14. We have just positioned the buckles. Glue the edges of the handle together. Fold back with the wrong sides together and flatten the seam with a mallet. Assemble with a saddle stitch, stopping 2 inches (5 cm) from each end. Sand, then dye, the edges of the handles. Glue the handles in place on the bag and secure them with a saddle stitch.

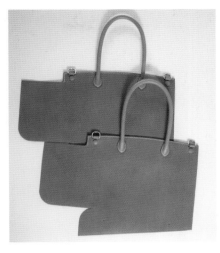

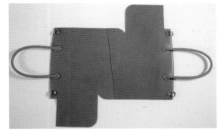

15. Glue the front and the back overlapping each other, seam on seam, and flatten them with a mallet. If the sewing holes have become blocked with glue, or aren't big enough, use an awl to slightly open them up (leather, being rigid, is difficult to pierce with a needle).

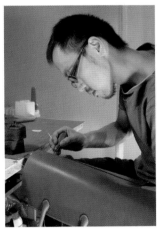

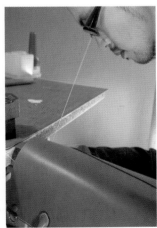

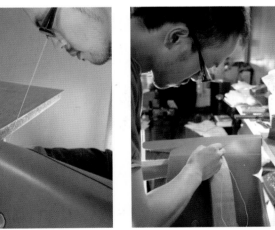

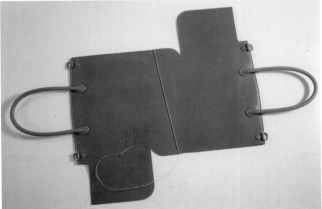

16. Sewing the underside.

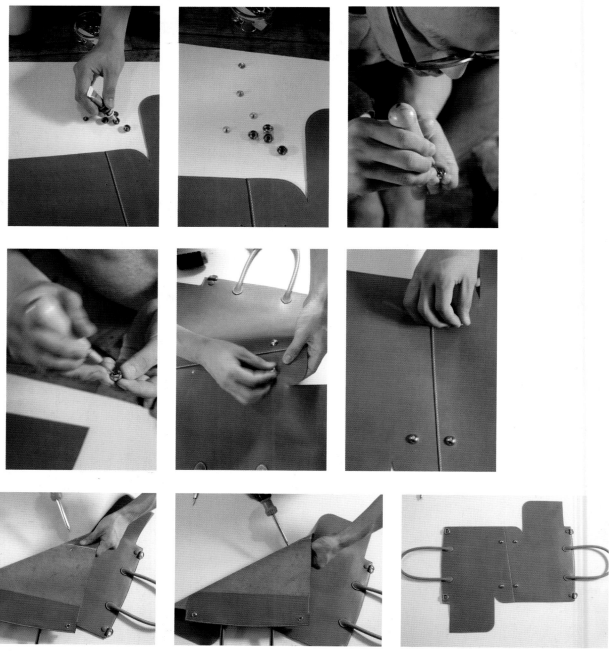

17. Gluing and fixing the feet onto the base of the bag. Pierce their positions with a hole punch and fix the feet into these holes.

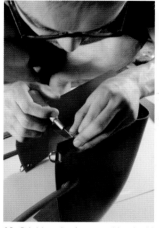
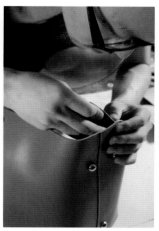
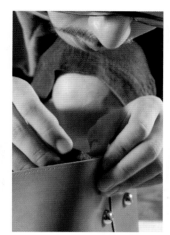
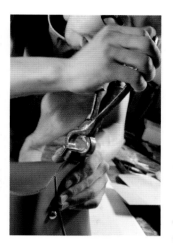

18. Sticking the front and back sides to the gussets. Use a pair of pliers to flatten the seams.

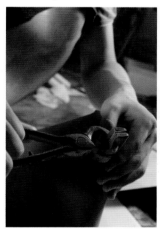
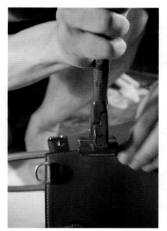
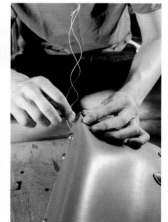
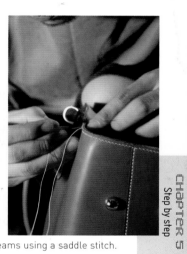

19. Sewing the gussets to the side seams using a saddle stitch.

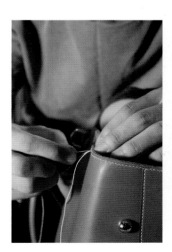
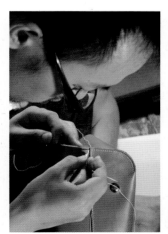
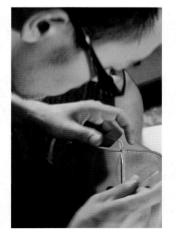
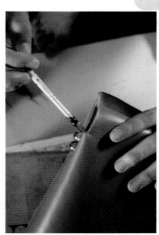

20. Dyeing the seams.

The commercial promotion of a product is essential, and it follows of course that this rule applies to fashion accessories as well. A brand's reputation needs to be well represented. So, in this chapter, we will touch on the principal methods and stages of promotion for brands and their accessories.

The logo is the first sign of a brand's recognition: Ralph Lauren's polo player, Louis Vuitton's LV monogram, Chanel's CC and even Martine Boutron's M&B are all famous symbols that could be likened to a brand's coat of arms.

The same can be said for young, up-and-coming designers and their effect on brands. These young rising stars bring a breath of fresh air and direction to the fashion houses, with John Galliano for Dior, Alber Elbaz for Lanvin and Marc Jacobs for Louis Vuitton, to name but a few. They have a heavy responsibility to the brands they represent, and act as a sort of "headliner" for the label. Their role is closely tied to the promotion of the fashion house they represent.

In addition, advertising campaigns are a vital tool in the brand's promotion. Fashion houses employ a host of photographers, illustrators and video makers, with some collaborations between famous photographers and prestigious brands becoming legendary. These all contribute to reinforcing these luxury brand names. For example, Charles Jourdan and Guy Bourdin, Yves Saint Laurent and Helmut Newton or Marc Jacobs and Juergen Teller.

These type of brands often choose cinema stars to represent them. Examples include, Carole Bouquet with Chanel's jewelry; Vanessa Paradis, Diane Kruger and Anna Mouglalis, who have all advertised Chanel's leather goods; and Scarlett Johansson, who starred in with the 2007 Vuitton campaign.

International groups such as LVMH (Louis Vuitton, Moët Hennessy) and PPR (Pinault, Printemps, Redoute) also collaborate with artists of great repute. They act as patrons on many levels: for example, they employ artists to design their promotional spaces from time to time — Louis Vuitton being a case in point when he called on Bob Wilson to dress his shop window. Louis Vuitton's concept shop on the Champs Élysées in Paris regularly showcases contemporary artists' exhibitions. There are a number of luxury groups who have established contemporary art foundations — The Pinault Foundation, for example, set itself up in Venice and opened a second contemporary art museum. LVMH has invited Frank Gehry, the architect of the Guggenheim Museum in Bilbao, to design his private museum on Seguin Island at Boulogne-Billancourt in the Hauts-de-Seine region of France, which is due to open in 2012. These museums have impressive showcases presenting the brands' products to their best. Louis Vuitton's travel museum at Asnières (Hauts-de-Seine) is a fine exhibition of its brand's image and prestigious past housed in the family home (see Chapter 1, p. 14). In the same way, the Goyard fashion house fuses antique suitcases with its latest creations, to remind us that the brand has existed for decades and figures among the most illustrious names in luxury travel goods.

Brands will regularly participate at art shows in order to have their image associated with major cultural events. This type of communication campaign is vital to a brand's success. The Hyères international fashion and photography festival in France, which rewards young designers, invited Christian Lacroix to decorate the roads in the town during the time of the festival.

Window displays are equally important in reaching the greater public, and great rivalry ensues in attempting to achieve original displays that show the merchandise off to best advantage. Certain designers, such as Alber Elbaz, can construct veritable stage sets. When a designer integrates his work with the decor, as both Karl Lagerfeld and Paul Smith have done in the window displays at the Printemps Haussmann store in Paris, the displays can become pure theater. The presence of live models in window displays has become the norm. To celebrate spring in 2007, designer Isabel Marant lit up a window display with effervescent spermatozoa. This unusual use of the display reinforces the idea of collaboration between art and fashion. At Hermès, Hilton McConnico, who began by staging temporary exhibitions, has created the whole concept of the brand's latest boutique, to be opened in Japan.

Certain brands are very minimal. Birkenstock and their eco shoes are one example. The concept here is so strong that the message is driven home with a recurring theme, or leitmotiv. The same is true with the name of the brand No Name – this is also original and effective, for it radically sets itself apart from other brands. The logo uses a footmark superimposed on the brand name, and this becomes the principal driving force behind its promotional strategy. Mystery arouses curiosity. This is evident with designer Martin Margiela, who refuses to be photographed for the promotion of his brand. This attitude intrigues and attracts the press. Faced with the media over-exposure of top models, he obscures his catwalk models' faces by making them wear masks so that more attention is given to the products. This has created a powerful media message in itself!

Specialized trade shows – such as Première Classe and Tranoï – and professional showrooms contribute in their own way to a brand's promotion. Today, fashion shows are broadcast simultaneously on television and over the Internet, which in turn helps to advertise the brands worldwide.

We should also mention the Comité Colbert. This is an association that represents 75 large, luxury French fashion houses. The committee was created in 1954 by Jean-Jacques Guerlain, the objective of the collective being to promote the members' shared cultural values and highlight the French concept of luxury on a worldwide scale.

In this chapter we look in detail at the means and tools necessary for the promotion of a product. We see at what point the role of the agent, and that of the distribution channels, became vital to the commercialization process, before analyzing the staging of the collections in terms of the visual aspects that contribute to their promotion.

Distribution

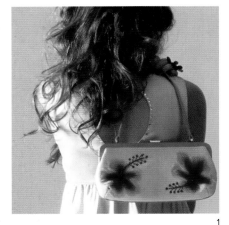

1

2

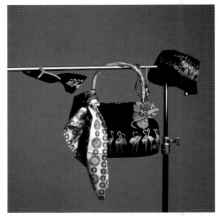

3

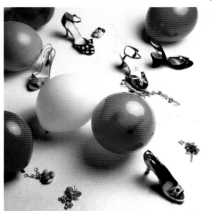

4

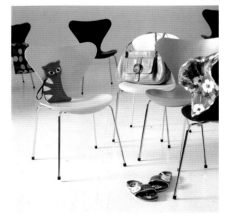

5

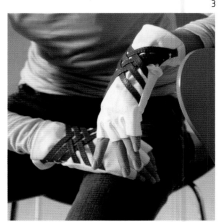

6

The predominance of the accessory according to designer Jean-Philippe Bouyer

"Today, the accessory is an essential and undeniable product in terms of turnover for every level of the range. For the majority of the time, the accessory's turnover is much larger than for prêt-à-porter, in particular for the large luxury brands. (For the more accessible brands such as Zara, Mango and H&M, the development of accessories is still a bit behind.) Fashion trends have propelled the accessory to the status of an indispensable product. Each season new brands are born specializing in jewelry, leather goods, shoes, etc.

These accessories are sold on different circuits: boutiques, chain stores, large distribution, without forgetting, of course, mail order and over the Internet. The channels of distribution will depend on the brand itself. This may involve a global brand with accessory collections or purely an accessory brand. In both cases, depending on the price point, we have the opportunity of using one, or several, methods of distribution. Large brands such as Chanel, Dior, Hermès, Vuitton, etc. present the accessory benefiting from their already existing image. These lines have several avenues of distribution available to them: flagship boutiques and large department stores with their specialist counters, generally dedicated to the accessory; and also duty-free shops. On the other hand, some brands offer only accessories – Goyard with its suitcases and leather goods; Charles Jourdan; Longchamps and his handbags; Christian Louboutin with his shoes and bags, etc., are just a few examples of this. These brands are also promoted in flagship boutiques and at department store counters.

Accessory sales are becoming more and more specialized. The design studios study the collections very closely and this is particularly important within the brands. There is also particular attention paid to the price point. An accessory can now be likened to perfume as a commodity – a product that is within the grasp of a greater number of clients; that can be considered as a part of a dream that someone can buy.

The potential client's profile will determine the means of distribution. For example, with a shoe, the flagship store will be the most favored option. As the market is very competitive, a good deal of planning and rigorous organization will be necessary. Rules of sale are conditioned by the brands' and distributors' respective financial power; the power struggle can therefore vary considerably. Their margins of maneuver are directly linked to their financial capacity and investment."

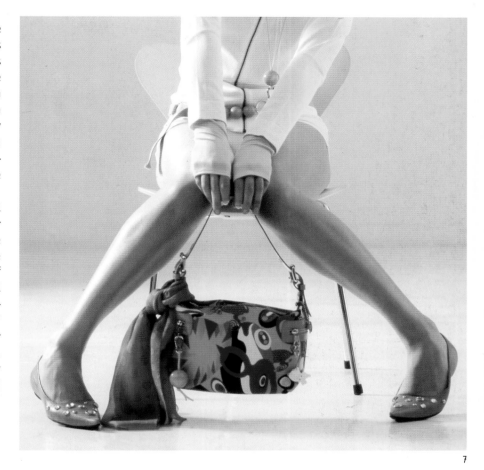

7

Accessory counters

Large department stores place more and more emphasis on their accessory counters. These spaces are dedicated to a brand or a designer, indicating that this is a particularly efficient method of distribution. Nowadays, these counters are generally found on the ground floor of these stores, and, more often then not, they are entirely reserved for accessories and are the most visited areas.

The promotion of visual supports is also taken care of by the large stores. For example, look books are a sort of synopsis of the visuals, representative of the collections. The accessory lends itself perfectly to a still-life style, which is represented on this page using color combi-

nations. Luxury labels can be shown together in the same photo.

It should be noted that department stores will often take advantage of these counters to introduce their own accessory collections into the world of the big brands.

1. *CUTAWAY BACK WITH HANDBAG.* MINT DRESS, BABE BAG AND MALIPARMI RING.

2. *BLACK AND WHITE.* ROBERT NORMAND SANDALS AND DELPHINE PARIENTE BAG.

3. *FLAMINGOS.* LULU GUINNESS HAT, SHOES AND BAG, LE BON MARCHÉ SCARF, MADEMOISELLE DE LA BRINDILLE NECKLACE.

4. *BALLOONS AND SHOES.* SHOES BY RUPERT SANDERSON, LE BON MARCHÉ, LULU GUINNESS; JEWELRY BY ZUWA, RADA AND EXQUISITES.

5. *MOSAIC CHAIRS.* BAGS BY ROWS, PATCH AND OMNIA; IRREGULAR CHOICE MULES AND OMNIA HAT.

6. *WHITE-BLUE GLOVES.* LE BON MARCHÉ TANK TOP AND TEE SHIRT, JEAN YANUK, AGNELLE FINGERLESS GLOVES.

7. *YELLOW FINGERNAILS.* HYBRIS TEE SHIRT, LE BON MARCHÉ SHORTS, MÉDECINE DOUCE BELT, FISCHER FINGERLESS GLOVES, MARC JACOBS' BALLET FLATS, MÉDECINE DOUCE KEY RINGS, FRANCESCO BIASIA BAG, LE BON MARCHÉ SCARF.

1 to 7. Photos by Stephan Schopferer, extracts from Bon Marché's 2005–2006 press releases.

The agent

The ideal agent

An agent is the brand's contractual ambassador in one or more countries. If there is an exclusivity clause in the contract, every transaction that is made in these countries' domestic markets must pass through the agent's office.

Foreign distribution implies two choices that are of equal importance: the choice of accessory, in relation to a particular country; and the choice of agent, depending on the accessory to be promoted. The agent, who must be well integrated into the country and possess an excellent working knowledge of the market, needs to make his or her network of contacts available to the brands he or she represents. The quality of his or her office, showrooms, database and financial and marketing means are a determining factor. It is also important to check the legal status of the company and to find out about the human resources the agent has at his or her disposal, and to check on the solvency of his or her clients.

It is essential that the agent possesses a good understanding of the brands he or she will be representing, as well as their objectives and outcomes.

According to Charles Raith, an accessory agent in Japan, to be able to work in this world, the agent must, first of all, love women, and naturally accessories. He or she must possess a good understanding of fashion culture and be a convincing storyteller, i.e., know how to explain the origins of a product, the materials, manufacturing processes, and so on.

The agent's jobs

The agent must be in tune with current fashion and be in close contact with the key decision makers and the buyers. This work demands great rigor: it is recommended, for example, that the agent keep a dossier for each client that includes all the relevant information concerning the client's profile. In conjunction with this, regular client visits are necessary where new trends, and even samples, are bought to their attention. These repeated points of contact help reinforce links between the agent and the client, building up a good working relationship. This way, the agent can gain quick and efficient access to distribution channels. He or she must be the first to present his products to the market, offer a faultless service, and always remain at the client's disposal.

The agent can work in a variety of ways: he can be exclusive, or not import and distribute the products him- or herself, or, on the other hand, not import the goods, but find clients who are willing to import the products themselves.

The remuneration is therefore very different depending on what kind of contract is established. If the agent imports the goods him- or herself, he or she can then control the brand's image and the retail price, which in turn will ensure a harmonious relationship. In Japan, the professional clientele are very sensitive to retail prices, which must remain the same across the national market. It is therefore recommended for a brand to confine itself to an agent who is experienced and able to control the image and retail prices. Numerous cosmetic brands have to deal

with imports that are in strong competition with their own internal circuit, which undercut them and destabilize the official distribution channels.

The agent's networks

The agent works with a multitude of professionals and essential partners.

In the case of large department stores, the counters focus on a range of brands, with any potential financial risk being their own responsibility. It is the profitability of these spaces (per square foot or meter) that will determine whether the counter is viable or not. These stands will also include a designer's showcase.

Wholesalers are rapidly disappearing due to modern communication means — principally the Internet — and are no longer an essential cog in the distribution machine.

Multibrand boutiques or "select shops" — such as Maria Luisa, L'Éclaireur or Montaigne Market — have a reputation for breaking new ground with interesting products and showcasing fashion accessories.

Flagship stores – or single-brand boutiques – are nowadays the surest way of distributing a product.

The duty-free shops are the most difficult means for relatively unknown brands. Nevertheless, they provide an important distribution network for accessories and cosmetics for the betterknown brands.

The market for company gifts – which is very big in Japan – represents more than 25 percent of the accessory market, with competitive prices in large quantities.

Big holding companies that already possess fashion labels, such as Kashiyama, Itokin and Itochu, are always looking for new ideas, and help other brands to establish themselves by signing contracts that include manufacturing and distribution licenses, in particular in Japan and the United States.

Marketing

Let us take a look at the essential point that is marketing. It is important to define a product in terms of its creation and place in the market. Market research needs to be professionally carried out in order to analyze whether a market does in fact exist for a particular product. Another study is then necessary to define the product's target audience and potential clientele. It is at this point that the agent puts his or her knowledge of the market into practice. He or she instigates and drives the market research, which is led by his or her staff, or by an independent market-research company.

It is vital that an agent knows his or her product well. Part of the brand's marketing budget is reserved for the agents, so that they can promote the brand through their own markets. It is important that the agent and the brand work together on these points, so as to develop the best possible promotion for the brand. It is also imperative that the results of this advertising are regularly monitored in relation to the objectives that have already been established by the brand.

Presentation

1

2

Window concepts

Brands pay particular attention to the design and creation of their boutiques' windows. The creative directors are very involved in researching ideas for this, and, more often than not, they follow their creations very closely. This is very much the case with Alber Elbaz at Lanvin.

Whatever the price level, the window displays represent the brand's image. H&M and Zara, for example, make the most out of their image with the product settings for their windows. Accessories

occupy a large part of their external window display area but are also evident in their inside displays, i.e., on podiums etc. Every label devotes entire window spaces to accessories and visual communication, specifically for advertising campaigns, and it is proven that the strength of a brand's window display has a real impact on customers and turnover.

Certain window displays have acquired a great reputation and deserve a special visit, such as those of the Hermès store on rue du Faubourg Saint-Honoré in Paris, which have been styled by Leila

Menchari for many years now. This stylist uses opulence and originality to make each setting a real event, while at the same time endorsing the quality and luxury of this great fashion house.

A brand's window displays are designed in relation to the visuals used for their advertising campaigns. They often all work together on the same theme in order to increase the impact and coherence of the brand. To keep things fresh, displays are changed very regularly and are unveiled as soon as new products hit the store. Several times a year, the large

stores make special window displays specifically for accessories.

Displays

Each type of accessory requires research for original props and display cases. These elements are chosen in relation to the particular look of a boutique, seasonal themes and, of course, the product that is to be presented. A support can be used to display a necklace, as in the adjacent photo of Loulou de la Falaise's jewelry (Fig. 3).

Martine Boutron wanted to create a special atmosphere with her products (Figs. 1 and 2). The stylist made a display that recreated the feel of a workshop, where a blowtorch and the different tools necessary for jewelry manufacture are used as props for the presentation.

1 AND 2. DISPLAY RECREATING A JEWELER'S WORKBENCH BY MARTINE BOUTRON.

3. LOULOU DE LA FALAISE WINDOW DISPLAY OF JEWELRY ITEMS IN WOOD, SHELL, MOTHER-OF-PEARL, WITH BROOCHES IN PÂTE DE VERRE AND CRYSTAL GLASS, PRESENTED ON CHINESE LACQUERED RED SUPPORT.

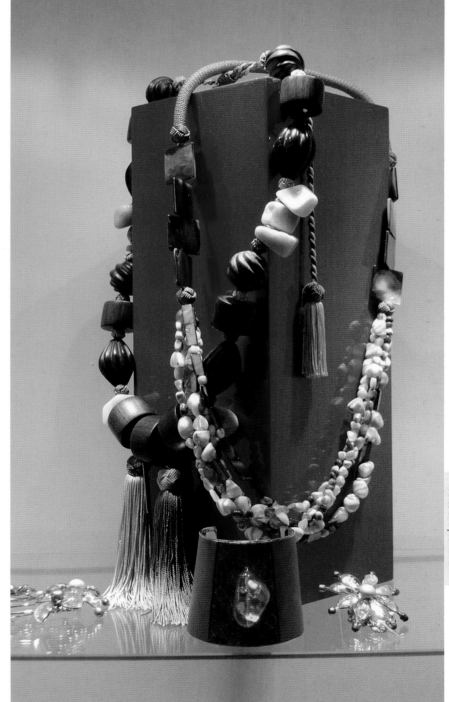

3

Advertising campaign visuals

1

2

3

4

Everyday brands invest more and more in publicity to make their image more noticeable. The sector reserved for accessories is also constantly growing. Accessory visuals are considered and developed in relation to the type of object to be promoted, e.g., spectacles, handbags or shoes, etc. and they also make up an integral part of a brand's press book or catalog. Fashion magazines such as *Vogue, L'Officiel, Elle, Marie Claire* and so on now have special editions that are dedicated to accessories, as well as out-of-series seasonal editions. In these publications, accessories are presented as snapshots, as close-ups at fashion shows, or as "still lifes."

Each season, press books are pro-

5

6

duced for the new collections. These are primarily intended for journalists. In order to set themselves apart from other stylists and to attract the attention of editors, designers call on top photographers to style their products to their best advantage. In Figures 5 and 6, Hélène Zubeldia's jewelry is presented on a model. The choice of obscured lighting and zoom photography on the jewelry helps to accentuate the product.

Photographers and creative directors intensify their efforts to try to come up with original and unusual ideas. Today, celebrities are frequently used to promote particular brands for which they receive subtantial remuneration. Examples of this include Kate Moss for Longchamp and Vanessa Paradis for Chanel. Both were engaged to solely promote the brands' handbag lines.

If, globally, the accessory photo conforms to easily understood stereotypes, important names in photography will forever remain associated with the big brands, such as Guy Bourdin with Charles Jourdan, for example. Peter Lindbergh has also worked on several publicity campaigns, most notably for David Yurman's jewelry. This photographer is internationally known for his artistic fashion and accessory photography, which emulates realism and lacks pretension. We should also mention photographers such as Mario Testino, with the renaissance of the Gucci label in the 1990s, Jean Larivière for Louis Vuitton, and Bruce Weber for Calvin Klein.

1. *Lady Rouge* shoes by Christian Louboutin, Summer 2006. © Olivier Buhagiar.

2. *Miss Marple Red* shoes by Christian Louboutin, Summer 2006.
© Olivier Buhagiar.

3. *Gwenissima* shoes in golden and natural leather by Christian Louboutin, Summer 2006.
© Olivier Buhagiar.

4. *Formetera Rose* shoe by Christain Louboutin, Summer 2006.
© Olivier Buhagiar.

5 and 6. Visuals from Hélène Zubeldia's website.
© Robert Jaso.

Fashion illustrations

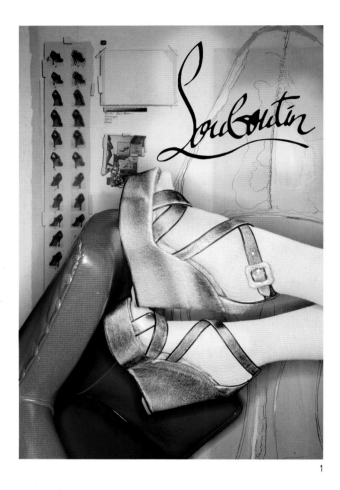

1

Although photography remains the most-used means of communication for advertising, illustration is nonetheless a favored form of expression for the presentation of the products. The association between illustration and photography generally reinforces the identity and original impact of a brand, as we can see with Christian Louboutin's advertisement in Figure 1 where the shoe is reworked by drawing (behind the photo). The individuality of a drawing is sometimes more effective in communicating the spirit of a brand. Andy Warhol started his career as a fashion illustrator, and his accessories drawings attest to this.

Manolo Blahnik uses illustrations to promote his shoes to press magazines. The designer Alexandra Neel has also used illustrations for some of her styles (see Fig. 4).

René Gruau, who was associated with the house of Christian Dior in the 1950s, became well known for his illustrations for the brand's advertising campaigns. Still with Dior, John Galliano uses his personal collages as publicity visuals.

The amount invested by a brand for an illustration, however, is very often lower than that which is spent on a photographic visual. Some designers prefer to gamble on using illustrators to promote their products. An example is Loulou de la Falaise, who invited the illustrator Elie Top to portray her jewelry range for the 2003–2004 Fall-Winter press release, using herself as the muse (Fig. 5).

Fashion journalists will sometimes use illustrators to liven up their articles. In the 1980s, Nicole Pibault collaborated with the magazine *Marie Claire* for a long time, and Antoine Kruk, whose illustrations are shown in Figures 2 and 3, has notably worked with *Stiletto* magazine.

Nacre et Perles de Tahiti, Poteries d'Afrique, Laque de Chine, Pierres du Rajasthan tous les Soleils du monde !!!!

1. *Viva Zeppa* shoes by Christian Louboutin, Fall-Winter 2005–2006.
© Christian Louboutin.

2. Handbag illustration by Antoine de Kruk made especially for this book.

3. Coordinated handbag and accessories illustrated by Antoine de Kruk for this book.

4. Alexandra Neel, illustration for a press presentation invitation card, Spring-Summer 2005.

5. Illustration representing Loulou de la Falaise by Elie Top.

Appendixes

Accessory directory

Shops and suppliers

Windsor Button (buttons)
35 Temple Place
Boston, MA, 02111
USA
617-482-4969
www.windsorbutton.com

Rudsak (leather products)
1400 Ste-Catherine Street West
Montreal, QC, H3G 1P8
Canada
514-399-9925
www.rudsak.com

Rudsak
315 Queen Street West, Unit G.01
Toronto, ON, M5V 2X2
Canada
416-595-9661
www.rudsak.com

Facèré Jewelry Art Gallery (jewelry)
1420 Fifth Avenue, Unit 108

Seattle, WA, 98101
USA
206-624-6768
www.facerejewelryart.com

Aaron Faber Gallery (jewelry)
666 Fifth Avenue
New York, NY, 10103
USA
212-586-8411
www.aaronfaber.com

Mood Fabrics (ribbons, trimming, etc.)
6151 W Pico Boulevard
Los Angeles, CA, 90035
USA
323-653-6663
www.moodfabrics.com

Bead Freaks (beads)
4412 Main Street
Vancouver, BC, V5V 3R3
Canada
604-872-2210
www.beadfreaks.ca

Swarovski (gems and crystals)
30 Rockefeller Plaza Spc G
New York, NY, 10112
USA
212-332-4300
www.swarovski.com

Drawing suppliers

New York Central Art Supply
62 Third Avenue
New York, NY, 10003
USA
212-473-7705
www.nycentralart.com

Blue Rooster
1718 North Vermont Avenue
Los Angeles, CA, 90027
USA
323-661-9471
www.blueroosterartsupplies.com

Curry's
90 Yonge Street
Toronto, ON, M4Y 1X5
Canada
416-967-6666
www.currys.com

Wallack's
603 Bank Street
Ottawa, ON, K1S 3T4
Canada
613-238-8871

Studio and boutique equipment

Roxy Display
18 Kennedy Boulevard
East Brunswick, NJ, 08816
USA
732-246-7058
www.roxydisplayinc.com

PGM-Pro Inc.
5041-5047 Heintz Street
Baldwin Park, CA, 91706
USA
626-338-1990
www.pgmdressform.com

Sundries

Button World
389 5th Avenue
New York, NY, 10016-3354
USA
212-768-4771?

Beadworks
619 East Passyunk Avenue
Philadelphia, PA, 19147
USA
215-413-2323
www.beadworksphiladelphia.com

The Bead Factory
810 South Maple Avenue
Los Angeles, CA, 90014
USA
213-624-2121
www.beadsfactory.com

Bead Junction
389 Roncesvalles Avenue
Toronto, ON, M6R 2N1
Canada
416-533-8555
www.bead-junction.com

Rainbow Minerals
2255 Gladwin Crescent
Ottawa, ON, K1B 4K9
Canada
613-733-8440
www.rainbowminerals.com

Useful addresses

Council of Fashion Designers of America
1412 Broadway, Suite 2006
New York, NY, 10018
USA
www.cfda.com

Fashion schools

Atelier Chardon Savard
BTS Stylisme de mode
15, rue Gambey
75011 Paris

Chambre syndicale de la couture parisienne
Formations aux métiers artistiques
45, rue Saint-Roch
75001 Paris

École Duperré
BTS Mode-Textile DMA Arts textiles (DSAA Mode
et Environnement)
11, rue Dupetit-Thouars
75003 Paris

ENSAAMA Olivier de Serres
BTS Art textile et Impression
63-65, rue Olivier-de-Serres
75015 Paris

Lycée Auguste Renoir
Arts appliqués (spécialisation industrie de l'ha-
billement, prépa BT)
24, rue Ganneron
75018 Paris

Lycée Choiseul
BTS Arts appliqués stylisme de mode
78, rue des Douets
39095 Tours

Lycée Elisa Lemonnier
20, avenue Armand-Rousseau
75012 Paris

Studio Berçot
29, rue des Petites-Écuries
75010 Paris

Académie royale des Beaux-Arts d'Anvers
Blindestraat 9
BE-2000 Anvers

La Cambre
École supérieure d'Arts visuels
21, abbaye de la Cambre
1000 Bruxelles

Central Saint Martin's College of Art
and Design
School of Fashion and Textiles
107-109 Charing Cross Road
London WC2H 0DU

Edinburgh College of Art
Lauriston Place
Edinburgh EH3 9DF

London College of Fashion
20 John Princes Street
London W1M 0BJ

Royal College of Art
(MA course only)
School of Fashion and Textiles
Kensington Gore
London SW7 2EU

University of Newcastle upon Tyne
Department of Fine Art
5 Kensington Terrace
Newcastle upon Tyne NE4 7SA

Academy of Art University
79 New Montgomery Street, 4th Floor
San Francisco, CA, 94105-3410
800-544-2787
www.academyart.edu

California College of the Arts
1111 Eighth Street
San Francisco, CA, 94107-2247
415-703-9500
www.cca.edu

Columbus College of Art and Design
60 Cleveland Avenue
Columbus, OH, 43215
614-224-9101
www.ccad.edu

Drexel University
3141 Chestnut Street
Philadelphia, PA, 19104
215-895-2000
www.drexel.edu

Fashion Institute of Technology
227 West 27th Street
New York, NY, 10001-5992
212-217-7999
www.fitnyc.edu

Massachusetts College of Art and Design
621 Huntington Avenue
Boston, MA, 0211
617-879-7000
www.massart.edu

Otis College of Art and Design
9045 Lincoln Boulevard
Los Angeles, CA, 90045
800-527-6847
www.otis.edu

Parsons The New School For Design
66 Fifth Avenue
New York, NY, 1001
212-229-8900
www.newschool.edu

Rhode Island School of Design
2 College Street
Providence, RI, 02903
401-454-6100
www.risd.edu

Savannah College of Art and Design
42 Bull Street
Savannah, GA, 31402
912-525-5100
www.scad.edu

University of Cincinnati
2600 Clifton Avenue
Cincinnati, OH, 45221
513-556-1100
www.uc.edu

Canada

Alberta College of Art and Design
1407-14 Avenue Noth West
Calgary, AB, T2N 4R3
403-284-7600
acad.ab.ca

Emily Carr University of Art and Design
1399 Johnston Street
Granville Island Vancouver, BC, V6H 3R9
604-844-3800
www.ecuad.ca

Nova Scotia College of Art and Design
5163 Duke Street
Halifax, NS, B3J 3J6
902-444 9600
nscad.ca

Ontario College of Art and Design
100 McCaul Street
Toronto, ON, M5T 1W1
416-977-6000
www.ocad.ca

Sheridan Institute of Technology and
Advanced Learning
PO Box 2500, Stn Main
Oakville, ON, L6L 7T7
www.sheridaninstitute.ca

University of Guelph
50 Stone Road East
Guelph, ON, N1G 2W1
519-824-4120
www.uoguelph.ca

RECRUITMENT SITES FOR FASHION PROFESSIONALS

www.abc-luxe.com
www.fashionjob.fr
www.ks-interim.com
www.modefashion.com
www.modemonline.com
www.profilmode.com

24 Seven Inc.
120 Wooster Street
New York, NY, 10013
USA
212-966-4426
www.24seveninc.com

Floriane de St-Pierre
134, rue du Faubourg-Saint-Honoré
75008 Paris

Interim Nation
75, boulevard de Picpus
75012 Paris
Tel: 01 43 45 50 00
www.interim-nation.fr

Janou Parker
4, rue du Faubourg-Saint-Honoré
75008 Paris
Tel: 01 45 23 18 54

Manpower Couture
42, rue Washington
75008 Paris
Tel: 01 56 59 32 70

Modelor
18-20, rue Daunou
75002 Paris
www.modelor.fr

Proforce Personnel
300 Saint Sacrement, suite 208
Montreal, QC, H2Y 1X4
Canada
514-905-0606
www.proforce.ca

Kate Sasson conseil
21, rue Cambon
75001 Paris
www.katesasson.com

Rag Trade Jobs
88-90 Foveaux Street, Level 3, Fortune House
Surry Hills, NSW 2010
Global
Tel: 02 9211 8212
www.ragtradejobs.com

LIBRARIES

Les Arts décoratifs
63, rue Monceau
75008 Paris
Tel: 01 53 89 06 40

Bibliothèque des Arts décoratifs
107, rue de Rivoli
75001 Paris
Tel : 01 44 55 57 50

Bibliothèque nationale de France
Bibliothèque François-Mitterrand
11, quai François-Mauriac
75013 Paris

Bibliothèque Publique d'Information
- Centre Georges-Pompidou
19, rue Beaubourg
75004 Paris
Tel: 01 44 78 12 33

Musée Galliera - musée de la Mode de la Ville
de Paris
Centre de documentation - bibliothèque
10, avenue Pierre-Ier-de-Serbie
75115 Paris
Tel: 01 56 52 86 00

National Gallery of Canada
380 Sussex Drive
Ottawa, ON, K1N 9N4
Canada
613-990-1985
www.beaux-arts.ca

New York Public Library
Fifth Avenue at 42nd Street
New York, NY, 10018-2788
USA
917-275-6975
www.nypl.org

MUSEUMS

USA

Cooper-Hewitt, National Design Museum
2 East 91st Street
New York, NY, 10128
212-849-8400
cooperhewitt.org

The Getty
1200 Getty Center Drive
Los Angeles, CA, 90049–1679
310-440-7300
www.getty.edu

Kent State University Museum
P.O. Box 5190, Rockwell Hall
Kent, Ohio, 44242-0001
330-672-3450
dept.kent.edu/museum/general/general.html

The Metropolitan Museum of Art
1000 Fifth Avenue
New York, NY, 10028-0198
212-535-7710
www.metmuseum.org

Mint Museum of Art
2730 Randolph Road
Charlotte, NC, 28207
704-337-2000
www.mintmuseum.org

The Museum of Modern Art
11 West 53 Street
New York, NY, 10019-5497
212-708-9400
www.moma.org

The Textile Museum
2320 S Street NW
Washington, DC, 20008-4088
202-667-0441
www.textilemuseum.org

Canada

The Bata Shoe Museum
327 Bloor Street West
Toronto, ON, M5S 1W7
416-979-7799
www.batashoemuseum.ca

Royal Ontario Museum
100 Queen's Park
Toronto, ON, M5S 2C6
416-586-8000
www.rom.on.ca

PRINCIPAL TRADE SHOWS

Accessories
Modamont (Paris)
Première classe

Leather
Anteprima (Milan)
Le cuir à Paris
Linea Pelle (accessoires and prêt-à-porter)
Salon du cuir

Yarn
Expofil (Paris): September and March
Indigo

Knitwear
Expofil (Paris)
Moda In (Milan)
Pitti Filatil (Florence)

Prêt-à-porter
Atmosphère (Hotel St James)
Tranoï
Who's next

Finished products
Intersélection

Fabrics
Moda In (Milan)
Première Vision (Paris)
Texworld (Paris)
Tissu Premier (Lille): January

Bibliography

Books

Maggy Baum, Chantal Boyeldieu, *Dictionnaire des textiles*, Paris, Editions de l'industrie textile, 2003.

George Beylerian, Andrew Dent, *Material Connexion: The Global Resource of New and Innovative Materials for Architects, Artists and Designers*, New York, John Wiley & Sons, 2005.

François Boucher, *Histoire du costume en Occident de l'Antiquité à nos jours*, Paris, Flammarion, 1983.

David Bowie, Karl Lagerfeld, Mario Testino, *Dreaming in Print: A decade of Visionnaire*, New York, Edition 7L (Steidl), 2002.

Farid Chenoune (dir.), *Le cas du sac: histoires d'une utopie portative*, Paris, Le Passage, 2004.

Collectif, *Artenergie*, New York, Charta, 1998.

Collectif, *Belgian Fashion Design*, New York, Ludion, 1999.

Collectif, *Dictionnaire international de la mode*, Paris, Editions du Regard, 1994–2004.

Collectif, *Embroidery*, New York, Damiani, 2006.

Collectif, *Fabrica 10: From Chaos to Order and Back*, Milan, Electa, 2004.

Collectif, *Head, Heart and Hips: The Seductive World of Big Active*, Verlag, Berlin, 2004.

Collectif, *Modemuseum: The Fashion Museum*, New York, Ludion, 2003.

Collectif, *Shopping*, New York, Hatje Cantz, 2003.

Collectif, *Technologie du vêtement*, Québec, Guérin, 1999.

Collectif, *The Fashion Generation*, New York, Hatje Cantz, 2006.

Collectif, *Total Living*, New York, Charta, 2002.

Collectif, *Uniform: Order and Disorder*, New York, Charta, 2001.

Maria Luisa Frisa, Stefano Tonchi, *Excess: Fashion and the Underground in the '80s*, New York, Charta/Fondazione Pitti Immagine Discovery, 2004.

Christine Garaud, Bernadette Sautreuil, *Technologie des tissus*, Paris, André Casteilla, 1984.

Pierre Hirsch, *Lexique textile français-anglais*, Metz, Librairie de l'industrie textile, 1994.

Sue Jenkyn Jones, *Le stylisme, guide des métiers*, Paris, Pyramyd, 2005.

Dorling Kindersley, *Le grand livre de la couture*, Paris, Hachette, 1997.

Antoine Kruk, *Shibuya Soul*, Archimbaud, 2006.

Didier Ludot, *La petite robe noire*, Paris, Assouline, 2001.

Stéphane Marais, *Beauty Flash*, Paris, Edition 7L (Steidl), 2001.

Pierre Marly, Jean-Claude Margolin, Paul Biérent, *Lunettes et lorgnettes*, Paris, Hoëbeke, second edition. 1999.

Isaac Mizrahi, *The Adventures of Sandee the Supermodel*, S&S Editions Comic Book Series, New York, 1997.

Paul-Gérard Pasols, *Louis Vuitton*, La Martinière, 2005.

András Szunyoghy, György Fehér, *Grand cours d'anatomie artistique*, Cologne, H. F. Ullmann, 2007.

Françoise Tellier-Loumagne, *Mailles, les mouvements du fil*, Genève, Minerva, 2003.

Heidemaria Tengler-Stadelmaier, *La couture pratique*, Hoenheim, V. A. Burda, 2002.

Walter Van Beirendonck, *Mode 2001: Landed-Geland Part I*, New York, Merz, 2002.

Walter Van Beirendonck, *Mode 2001: Landed-Geland Part II*, New York, Merz, 2002.

Nadine Vasseur, *Les Plis*, Paris, Le Seuil, 2002.

Veerle Windels, *Young Belgian Fashion Design*, New York, Ludion, 2001.

Fashion trade publications

Bloom
California Apparel News
Daily News Record (DNR)
Fashion Daily News
Fashion Reporter
Journal du textile
Selvedge
Texnews (www.texnews.fr)
Textile View
Tobe Report
View textile
Women's Wear Daily (WWD)

Fashion magazines

20 ans (French)
Another Magazine (English)
Another Man (men's – English)
Arena homme (men's – English)
Biba (French)
Citizen K (French)
Collezioni (Italian)
Crash (French)
Deutsch (German)
Doingbird (Australian)
Elle (international)
Glamour (international)
GQ (men's – international)
Harper's Bazaar (international)
ID (English)
Jalouse (French)
L'Officiel (French)
L'uomo Vogue (men's – Italian)
Le Figaro Madame (French)
Marie-Claire (international)
Milk (children's – French)
Muteen (French)
Neo2 (Spanish)
Numéro (French)
Nylon (American)
Oyster (Australian)
Pop (English)
Purple (French)
Quest (German)
Self-Service (French)
Sleek (German)
Stiletto (French)
Tank (English)
Ten (English)
Ten Men (men's – English)
V (American)
V men (men's – American)
Visionaire (American)
Vogue (international)
W (American)
Wad (French)
Zoo (German)

Acknowledgments

I would like to thank:

The team at school C-6-12 and the students.

Vincent Le Coz, freelance editor.

Benoît Bonté, Victoria Cahouet, Tomoe Kamiya, Masaya Ito, Steve-Régis N'Sondé, Martine Adrien, Marie-Thérèse Coudert.

External contributors: The designer Sak (unic13sak@gmail.com); Antoine Kruk for his illustrations. David Courtin, Fréderic Cabrera, and Stephan Schopferer for his photos.

Textile professionals:

Alber Elbaz for his preface, and the following brands and companies: Jeanne Lanvin, Louis Vuitton, Loulou de la Falaise, Yazbukey, Sonia Rykiel, Didier Ludot, Christian Louboutin, Elena Cantacuzène, Hélène Zubeldia, Philippe Roucou, Kazu Huggler, Martine Boutron, Alexandra Neel, Alexis Mabille, Pierre Marly, Jacques le Corre, Betony Vernon, Céline Robert, Charles Jourdan, Sak, Marc Rozier, The International Shoe Museum at Romans and Louis Vuitton's travel museum at Asnières;

Didier Ludot for his information on vintage and fashion history, Edouard Schneider, Françoise Plaud for her competition and presentation on the House of Jeanne Lanvin, Loulou de la Falaise for being there, Elisabeth Guers and Jean-Philippe Bouyer for their information and text on professional shoe designers and advertising, Satoru Hosoi for making handbag prototypes, Odile Gilbert and Rebecca Leach;

Le Bon Marché for their visuals.

And, in particular, Anne le Bras, for the interest she has shown in my work, for her collaboration, advice and time dedicated to the making of this book.

Credits